FORM AND COLOR IN GREEK PAINTING

Also by Vincent J. Bruno
The Parthenon (Norton Critical Studies in Art History)

VINCENT J. BRUNO

FORM AND COLOR IN GREEK PAINTING

W · W · Norton & Company · Inc ·

NEW YORK

FIRST EDITION

Library of Congress Cataloging in Publication Data

Bruno, Vincent J
 Form and color in Greek painting.

 Bibliography: p.
 Includes index.
 1. Painting, Greek. 2. Shades and shadows.
 3. Texture (Art) 4. Color in art. I. Title.
ND 110.B78 759.938 76–28793
ISBN 0–393–04445–9

1 2 3 4 5 6 7 8 9 0

In memory of Otto Brendel

Contents

List of Illustrations

Preface

In the fifth century B.C., a handful of Greek artists altered man's concept of the pictorial field, utterly transforming the art of painting. Starting from the archaic two-dimensional picture plane, these artists developed a new technology for the representation of a three-dimensional environment, something like a stage on which figures could move and turn in space in an atmosphere of light and air. For hundreds of years the Greeks, like the Near Eastern cultures before them, had followed a painting tradition as old as mankind, applying areas of opaque, solid color to a picture plane that was conceived as a flat, unbreakable surface. Within a few generations, from about the period of the Persian Wars onward, there unfolded a process in which the two-dimensional picture plane was shattered, perspective and shading were invented, and human figures were for the first time rendered as objects moving in space.

This transformation represents one of the most interesting events in the history of art, and for European painting it was among the most decisive. Once shading had been developed in classical Greece, it was impossible for painters to return to an archaistic tradition of two-dimensional representation without providing a basis for controversy over the question of alternative methods of showing form; and from Roman times onward, there was a definite symbolism attached to what was understood to be the classical Greek solution to the problem. In the Italian Renaissance it appears to have been a conscious aim on the part of Alberti and his circle to employ ancient descriptions of the technical and stylistic achievements of classical masters as the starting point for a new science of three-dimensional representation. This was only one of many episodes in art history in which groups of European artists identified themselves with classical aesthetic ideals by various means, adopting in their work certain aspects of the ancient Greek approach to form.

The Renaissance interpretation of classical Greek form is characterized by what perhaps may be defined as a system of restraints in the depiction of chiaroscuro and in the use of color to suggest the third dimension. The classical formula, as we have come to accept it, is one that maintains an enforced order and balance between inherently chaotic and contradictory elements: line, in the sense of contour; chiaroscuro; and color. In this interpretation, forms, while clearly modeled in terms of dark and light, continue to emphasize contour line and relatively flat local color areas. A formula of this kind may be found, for example, in the works of Uccello, Piero della Francesca, and Botticelli. The question is: How accurate a reflection of ancient Greek styles is this Renaissance and modern interpretation?

Without a single trace preserved of the works of the classical masters, our knowledge of painting in the fifth and fourth centuries B.C. is based necessarily on suppositions. The Renaissance definition of classical form in painting was mainly the result of artistic intuition, supported by some familiarity with the ancient literary tradition and an exposure to Roman reliefs. Today, with our more detailed knowledge of ancient art and literature, tantalizing problems confront us, particularly since some of the very passages in Pliny that form the basis of the traditional Renaissance interpretation seem to be contradicted in a number of essential details by other ancient authors. For the student of ancient literature, it is clear that the situation in the classical period itself was far from simple, and that practically every ancient statement to be found on shading and color was surrounded by controversies that were already well established in the Greek sources that Pliny cited. Under these circumstances, our efforts to get at the realities of classical painting in ancient Greece are often baffled.

One possible means of coming to terms with at least some of the contradictions in the literary sources is to apply to the interpretation of ancient writings the information on painting techniques available in actual examples of painting excavated at Greek and Hellenistic sites. In other words, we must start afresh, by comparing what we read in ancient sources with what we know to exist in ancient monuments. Fragments of Hellenistic paintings dating from the third and second centuries B.C. have long been known at sites such as Delos in the Cyclades, Pagasae in Thessaly and Alexandria in Egypt. However, these examples have more recently been supplemented by important new discoveries, which may be dated somewhat earlier. During World War II at Kazanlak in Bulgaria, an army group, in the course of constructing a foundation for an antiaircraft battery, discovered a painted tomb dating from the late fourth or early third century B.C. whose tholos frieze represents Greek figural types well known in other media. This frieze dramatically broadens the range of original materials available to the student of ancient painting. After the war, near the village of Lefkadia in Greek Macedonia, Photios Petsas, then the ephor of Macedonia, reopened excavations at a site already known for its painted chamber tombs, although the most important of the pictorial representations previously discovered at the site had been lost long ago as a result of vandalism (see the Introduction, note 4, for a list of published photographs of the lost painting). At Lefkadia, Petsas excavated a magnificent chamber tomb with a façade rich in painted decorations and of a quality of execution far above the level of the earlier finds. This chamber tomb may be firmly dated in the second half of the fourth century B.C. With these new groups of highly interesting wall paintings added to the Delos and Pagasae examples, we do, indeed, come a great deal closer to the painting traditions of the classical period itself, and the opportunity to reopen our discussion of some of the troublesome points in the literary sources seems to be at hand.

This treatise, in its original form, was a doctoral dissertation which I prepared under the supervision of Prof. Otto Brendel at Columbia University. As part of the work, I submitted to my committee a folio of the water colors I had made in the course of my studies at various sites in Greece and Bulgaria, where the original examples are to be found. Some of these water colors have been selected to illustrate the present volume, supplemented by photographs wherever possi-

ble. They are not to be considered strict copies of the originals in the ordinary sense of the term, for they are not measured drawings made to scale. Rather, they represent only selected details of the originals, rendered in order to show more clearly the brushwork and the balance of color characterizing different methods of ancient shading, since these subtleties are often lost in photographs. The sketches also have the advantage of omitting the various surface encrustations and other damages that confuse our view of the originals, especially in photographs. By concentrating on limited areas of the best-preserved sections of each of the examples, I have tried to record and emphasize in the sketches the actual methods by means of which ancient painters achieved effects of chiaroscuro.

Since many of the original monuments are suffering from a process of fading and other damage resulting from the exposure to light and air, serious efforts have been made to reproduce the color of the sketches as faithfully as possible. For these efforts I am especially grateful to George Brockway and James Mairs of W. W. Norton & Company for their personal interest in the preparation of this volume. My gratitude is also due to Dr. Norman Cantor and to the Research Foundation of the State University of New York for a grant applied to the cost of processing the color illustrations.

At the time that I began my studies of the extant examples of Greek painting, J. J. Pollitt (also a Brendel student) had just completed his doctoral dissertation, "The Critical Terminology of the Visual Arts in Ancient Greece." This work is now published in Pollitt's recent book, *The Ancient View of Greek Art*. For the sake of convenience, my footnotes carry page references to both titles. In the Pollitt dissertation, as I entered upon my project to examine original works of Greek painting, I found an up-to-date discussion of each of the problem terms or phrases connected with the study of the ancient literary source material. Pollitt set forth a complete analysis of the problems surrounding the meaning of each important term, explaining the ambiguities resulting from earlier, often inaccurate translations and interpretations while at the same time providing a well-considered re-evaluation of the various possible meanings of the term in the context of art history and criticism. As I became more and more familiar with the realities of ancient painting at archaeological sites in Greece, Pollitt's dictionary became my most valuable research tool, for I found that by reviewing the various possibilities of interpretation covered in his analysis of problem passages in the literature, I could reach firm conclusions on the particular meanings that should be emphasized in the light of the ancient examples. This joining of efforts between Pollitt and myself, between linguist and painter, was not, of course, a coincidence, but a part of Otto Brendel's design, his marshaling of available forces to solve problems in our knowledge of ancient art. Thus the project, the results of which are offered in the following pages, was not an isolated undertaking, but part of a complex of activities surrounding a gifted and inspiring teacher, Otto Brendel. Brendel's idea in itself was perfectly sound. Any shortcomings in the results and in their presentation must be viewed as strictly my own. Without allowing either of them to share any blame for the defects of my work, I would like here to acknowledge the very great debt I owe to Otto Brendel, to his patient guidance, and also to J. J. Pollitt, whose informative analysis of the ancient texts enormously facilitated my research.

I would like also to make the following acknowledgments: to the University of Texas at Arlington for an additional Organized Research Grant to assist in the preparation of color plates for this volume; to Mrs. Katie Louchheim, former assistant undersecretary of state for public affairs, for helping me in making the arrangements to visit the tholos tomb at Kazanlak, Bulgaria; to Prof. Photios Petsas of the Greek Archaeological Service for his generous support and kind hospitality at Lefkadia and other sites in northern Greece; to Profs. Charles Bruneau and Ulpiano T. Bezera de Menesis of the French School at Athens for discussing with me and permitting me to study materials in the workrooms at Delos; and to Prof. Frank Edward Brown of the American Academy in Rome, Prof. Blanche Brown of New York University, and Prof. Brunhilde Ridgeway of Bryn Mawr for reading the manuscript and making valuable suggestions for additions and changes. Last but not least, I would like to thank H. Stafford Bryant, Jr., and Carol Flechner, both of W. W. Norton & Company, for their many kindnesses and expert assistance in the final preparation of the book.

Since this book was finished, some articles on aspects of form and color in ancient painting have appeared. Two of these refer to passages in my earlier Columbia dissertation, on which the present work is based. They are Eva Keuls's "Skiagraphia Once Again" (*AJA*, 79 [1975], 1–16) and Elizabeth G. Pemberton's "A Note on Skiagraphia" (*AJA*, 80 [1976], 82–84). The passages to which these authors refer have not been substantially altered in the present version; I have not attempted to take into account in this volume Professor Keuls's new interpretation of *skiagraphia* as a system of color divisionism comparable in some ways to modern impressionism. While I hold to the idea originally expressed in my dissertation that a coloristic method of rendering shadows was developed in the classical period, I am not certain that such a method may be associated with the term *skiagraphia*. However, I do agree that a system of shading did, indeed, develop that utilized blues, greens, and other colors in the depths of the shadows rather than simple darks, as the extant monuments suggest, and any attempt to find in the writings of ancient critics an awareness of a method of shading based on color is obviously a step in the right direction. I should also add that in her recent article "Die 'Vier Farben' der griechischen Malerei" (*Antike Kunst*, 17 [1974], 92–102), Ingeborg Scheibler, in discussing the four-color problem in Greek painting, touches upon many of the points covered in this work and arrives independently at some similar conclusions.

List of Abbreviations

AAA: Athens Annals of Archaeology.

AJA: American Journal of Archaeology.

AM: Mitteilungen des deutschen archäologischen Instituts, Athenische Abteilung.

Arias and Hirmer: P. E. Arias and A. Hirmer, *A History of One Thousand Years of Greek Vase Painting* (New York, 1962).

ARV²: J. D. Beazley, *Attic Red-Figure Vase Painters,* 2nd ed. (Oxford, 1963).

BCH: Bulletin de correspondance hellénique.

Charbonneaux: J. Charbonneaux, R. Martin, and F. Villard, *Hellenistic Art* (New York, 1973).

CQ: Classical Quarterly.

CVA: Corpus Vasorum Antiquorum.

CW: Classical Weekly.

EAA: Enciclopedia dell'arte antica, classica e orientale.

Ferri: S. Ferri, *Plinio il Vecchio* (Rome, 1946).

JdI: Jahrbuch des deutschen archäologischen Instituts.

JHS: Journal of Hellenic Studies.

MAAR: Memoirs of the American Academy in Rome.

Micoff: V. Micoff, *Le Tombeau antique près de Kazanlak* (Sophia, 1954).

MonPiot: Monuments et mémoires publié par l'Académie des inscriptions et belles lettres, Fondation Piot.

Monumenti: Monumenti della Pittura Antica Scoperti in Italia.

Overbeck: J. Overbeck, *Die antiken Schriftquellen zur Geschicht der bildenden Kunst bei den Griechen* (Leipzig, 1886).

Pfuhl: E. Pfuhl, *Malerei und Zeichnung der Griechen* (Munich, 1923).

Pollitt, *Ancient View:* J. J. Pollitt, *The Ancient View of Greek Art* (New Haven, 1974).

Pollitt, *Critical Terminology:* J. J. Pollitt, *The Critical Terminology of the Visual Arts in Ancient Greece,* Ph.D. diss., Columbia University, 1963.

Pollitt, *Sources:* J. J. Pollitt, *The Art of Greece, 1400–31 B.C.,* Sources and Documents in the History of Art Series (Englewood Cliffs, N.J., 1965).

RE: Pauly-Wissowa, Real-Encyclopädie der klassischen Altertumswissenshaft.

Reinach: A. Reinach, *Recueil Milliet* (Paris, 1921).

RM: Mitteilungen des deutschen archäologischen Instituts, Römische Abteilung.

Robertson: M. Robertson, *Greek Painting* (Geneva, 1959).

Rumpf: A. Rumpf, *Malerei und Zeichnung: Handbuch der Archäologie* (Munich, 1939–1953), VI, pt. 4'.

Sellers: K. Jex-Blake and E. Sellers, *The Elder Pliny's Chapters on the History of Art* (London, 1896; rpt. Chicago, 1968).

Swindler: M. Swindler, *Ancient Painting* (New Haven and London, 1929).

Technical Studies: Technical Studies in the Field of Fine Arts, 10 vols. (Cambridge, 1942; rpt. New York, 1975).

Thieme-Becker: U. Thieme and F. Becker, *Künstler Lexicon* (Leipzig, 1907–1950).

Introduction

This treatise is an investigation of two topics of general importance to the history of classical painting, each of which has been the subject of continuing controversy in recent art-historical literature. One topic concerns the development of three-dimensional form by means of shading; the other concerns the use of color, in particular the presumed restriction of color adopted by classical painters, who, according to an often-cited passage in Pliny,[1] limited themselves to a palette consisting of four basic pigments: red, yellow, white, and black.

That these two aspects of painting in classical Greece may have been somehow interconnected has not until now been shown. Such a connection in the actual techniques of classical painting is an essential part of what I hope to demonstrate. A dramatically new and different approach to color—and in the light of archaic practice, the elimination from the palette of blue and green must certainly be viewed as a dramatic departure[2]—seems, indeed, to coincide in the history of Greek art with the invention and development of shading, an equally dramatic and revolutionary change. As art-historical phenomena, each of these two changes was evidently viewed by ancient critics as a characteristic feature of classical style. Under the circumstances, it might seem natural to assume that so conspicuous a change in the use of color must have been caused by the dictates of the revolutionary new painting methods adopted in connection with shading. Yet there are reasons why the two problems are not usually brought together in archaeological and philological discussions. Most important, our knowledge of both matters at present rests entirely on the fragments of art-historical writings of the later authors of the Greco-Roman world. And in the ancient literary tradition, these two important changes that affected painting in classical Greece are not specifically linked in any way. Since these two matters involve the technology

1. Pliny, *NH*, XXXV, 50. Full references for the topics of shading and the four-color palette in Greek painting will be provided in the notes to the following chapters. However, I would like to cite here the recent discussion and documentation of the four-color problem by Martin Robertson in his new book, *A History of Greek Art*, (Cambridge, Mass., 1975), pp. 260, 500, whose main conclusion concerning the occasional use of a four-color palette throughout the classical and Hellenistic periods seems to accord quite well with the view I develop in Part II of the present volume. Cf. Pollitt, *Ancient View*, under the notes to ch. 7, pp. 110 f., and I. Scheibler, "Die 'Vier Farben' der griechischen Malerei," *Antike Kunst*, 17 (1974), 92–102.

2. Blues and greens are dominant colors in archaic wall painting in both Etruria and Lycia. Excellent color reproductions of archaic paintings at Tarquinia are available in Section I of the *Monumenti*. For the tomb paintings recently excavated by M. Mellink at Kizilbel and Kara Burun in Lycia see reports as follows: *AJA*, 75 (1971), 245 ff.; *AJA*, 76 (1972), 257 ff. and pls. 58–60; *AJA*, 77 (1973), 293 ff. and pls. 43–46; *AJA*, 78 (1974), 351 ff. and pls. 67–70; *AJA*, 79 (1975), 349–355 and pl. 61. Blue is also a dominant color in an archaic painted wooden plaque from Pitsas, near Corinth. A color plate of this plaque is published in *EAA*, VI, facing page 202.

of painting, their analysis presents special problems. The ancient phrases relating to techniques in the representational arts, especially to color, are notoriously difficult to translate into modern terms. It has even been suggested, as we shall see, that today's artists are different from the Greeks of the classical era in the manner in which the former perceive and respond to the experience of color. Thus, problems of interpretation have till now defeated many attempts to reach even a tentative agreement on the meanings and implications of crucial literary passages. Before any new suggestion may be put forward concerning the probable interdependence of classical innovations on the level of form and color in painting, the two topics must be examined individually, as in the past, in order to clear up some of the confusion resulting from the character of the evidence with which we are concerned.

For these reasons, the present work is divided into two separate parts, one on three-dimensional form, the other on color. Each part is in turn divided into a number of chapters on the various questions that have been the major causes of earlier disagreements. There follows a chapter of tentative conclusions, summarizing the results of both discussions. In this final chapter, the reader will find some suggestions on the possibility of weaving together the various broken threads of our knowledge concerning the history of change in painting as classical masters in fifth-century-B.C. Greece succeeded in breaking away from archaic flatness to create a new vocabulary of color and form.

For the purpose of these investigations, examples of ancient Greek painting from several sites have been brought together in the illustrations: the painted marble stelae from Pagasae-Demetrias and western Macedonia now in the archaeological museums at Volos and Verria (plates 1–5a);[3] the paintings on the façade of the chamber tomb excavated by Photios Petsas at Lefkadia in Greece (plates 5b–9);[4] the tholos tomb at Kazanlak, Bulgaria (plates 10–14);[5] and some fragments of mural paintings from ancient Greek dwellings at Delos (plates 15–16).[6] Except for the Volos paintings, which are on stone, all of these examples

3. A.S. Arvanitopoulos, "Grapti Stelai Demetrias-Pagasae," *Archaiologike Ephemeris* (1928), 1 ff.; Rumpf, p. 156; Swindler, pp. 346 ff.

4. Photios Petsas, *O Taphos Ton Lefkadion* (Athens, 1966). The site is sometimes called Niaousta or Niausta, e.g., by Rumpf, p. 150, where the lost painting of a horse and rider from a neighboring tomb is described (cf. *ibid.*, pl. 50, 5). For the lost painting of Niausta see also K. F. Kinch, *Beretning om en Archaeologiska Reise i Makedonien* (Copenhagen, 1893); M. Rostovtzeff, "Ancient Decorative Wall Painting," *JHS*, 39 (1919), 154; K. F. Kinch, "Le Tombeau de Niausta, tombeau macedonien," *Danske Videnskabernes Selskab. 7 Reeke Historiski-Filosofiske Skrifter*, Afd. IV, 3 (Copenhagen, 1920), 283 ff.; M. Andronikos, "Ancient Greek Paintings and Mosaics in Macedonia," *Balkan Studies*, 5 (1964), 296 ff. Another painted tomb was recently excavated near Lefkadia by K. Rhomaiopoulou: "A New Monumental Chamber Tomb with Paintings of the Hellenistic Period near Lefkadia (West Macedonia)," *AAA*, 6 (1973), 87 ff. (see the color photo on the cover). The tomb of Lyson and Kallikles, also near Lefkadia, is painted with a representation of an architectural order decorated with shields, armor, and hanging garlands. The tomb contains no figure painting and is chiefly interesting as an antecedent of the Pompeian second style: C. I. Makaronas and S. G. Miller, "The Tomb of Lyson and Kallikles," *Archaeology*, 27 (1974), 248–259.

5. Micoff; A. Vasiliev, *The Ancient Tomb at Kazanlak* (Sophia, 1960); Robertson, p. 172; L. Zhivkova, *The Tomb at Kazanlak* (Sophia, 1974), with recent bibliography, p. 121 (in Bulgarian). Cf. the German edition, L. Zhivkova, *Das Grabmal von Kazanlak* (Recklinghausen, 1973).

6. M. Bulard, "Peintures murales et mosaïques de Délos," *MonPiot*. 14 (1908), ch. 3; J. Chamonard, *Exploration archaeologique de Délos*, VIII, Pt. 2, *Le Quartier du théâtre* (Paris, 1924), pp. 387 ff. The painted figures on the fragments of friezes, first published by Bulard, such as the battle scene and the mythological scene in his plates IX and IX B, seem to have vanished, the result, it is thought, of long exposure to light in the Delos Museum. Other fragments of similar friezes, perhaps even of the same

are wall paintings executed on white polished plaster—some apparently *al fresco*, and others not. For a discussion of the media of the wall paintings and other examples, see the Appendix.

The fourth-century-B.C. vases by the Lipari Painter,[7] interesting for their prominent use of blue, and the Centuripe urns,[8] with figures painted in lighter colors against a deep-red background, are examples of polychrome techniques on terra cotta which seems to preserve or imitate certain characteristics of wall painting. These monuments, together with the white-ground vases of classical Greece, will be included in our discussion on occasion, for purposes of comparison.

A preliminary glance at the illustrations shows that ancient Greek artists were able to choose between a number of strikingly different methods of depicting form in the context of three-dimensional pictorial representation. In ancient Greek art, as in today's art form may be expressed in almost pure outline and with little added color, as in Attic white-ground lekythoi (plate 13b) and in certain badly faded Attic stelae of the late fifth century B.C. in the Athens National Museum.[9] But, as in one of the less-well-known stelae from Pagasae at Volos (plates 1b and 3), form may also be shown by using a method of shading in which interior nuance entirely dominates the contour line. Color may be transparent in some examples and opaque in others; its handling may vary from monochrome to a full, unrestricted palette, as in the paintings on the façade of the chamber tomb at Lefkadia (plates 5b–9). Thus, the array of painting methods to be observed in the archaeological materials seems, indeed, to suggest a history. Some methods stand apart as coherent and carefully developed techniques belonging to the mainstream of art history in Greece. These techniques show few signs of local workshop idiosyncrasies, but seem rather to have been learned methods, methods most likely inherited from the famous schools of painting at major Greek centers, where, as one of the symptoms of the classical revolution, a whole new technology of painting was developed. In the chapters that follow it will be my main purpose to try to align the art-historical suggestions that may be gleaned from a study of these examples with some of the central facts about classical painting techniques contained in ancient literary sources.

friezes, were stored in boxes at nearby Mikonos, and have only recently been rediscovered. These fragments are in an excellent state of preservation, and though the examples showing compositions of human figures were reserved for a forthcoming study by members of the French School at Athens, I was fortunate in receiving permission to make the drawings of fragments of the garland friezes shown in plates XV and XVI (see the Preface). A new excavation on Delos has produced additional examples of figurative painting in recent years (see U. T. Bezerra de Menesis, in Charles Bruneau, *Guide de Délos* (Paris, 1965), pp. 34 f.

7. D. Trendall, "The Lipari Vases and Their Place in the History of Sicilian Red-Figure," *Meligunis-Lipara*, 2 (1965), 296 ff., and *The Red-Figured Vases of Lucania, Campania, and Sicily* (Oxford, 1967), pp. 652 ff.; L. B. Brea, *Musei e Monumenti in Sicilia* (Novara, 1958), p. 83 (color plate); Robertson, p. 172; Arias and Hirmer, pl. LI (color) and p. 391; F. Villard in Charbonneaux, p. 100, fig. 92 (color).

8. G. M. A. Richter, "Polychrome Vases from Centuripe in the Metropolitan Museum of Art," *Metropolitan Museum Studies*, 2 (1929–1930), 187 ff.; *idem*, "Polychrome Vases from Centuripe in the Metropolitan Museum," *Metropolitan Museum Studies*, 4 (1932–1933), 45 ff.; Arias and Hirmer, p. 392, pl. LII; F. Villard in Charbonneaux, pp. 132 f., figs. 130–131.

9. S. Karouzou, "Bemälte attische Stele," AM, 71 (1956), 124 ff. These stelae are unfortunately so faded that photographs are of little use. In the article cited, Karouzou makes use of drawings illustrated in color that give an accurate idea of the originals.

PART I

FORM

1

Shading Methods in Greek Painting

When we compare the tholos frieze at Kazanlak (plates 10–14) with the paintings of the main zone on the façade of the tomb of Lefkadia (plates 5b–9), it becomes apparent that both sets of paintings, although they date to the late fourth or early third centuries B.C.,[1] participate in recognizably older classical traditions. Obvious differences of composition and design result from the very different architectural environments in which the paintings are placed. In one case we deal with a frieze within a dome, in the other with a series of standing or seated figures separated from each other by the uprights of an architectural system (plate 5b). The quadriga scene in the Kazanlak frieze (plate 10), together with the procession of musicians and servants bearing offerings (plates 11–13a), seem especially familiar. These figures at once invite comparisons with earlier Greek funerary monuments. For example, the figure of a girl carrying a tray of offerings (plate 13a) is very close in costume, gesture, and mood to the girl on a white-ground lekythos by the Woman Painter,[2] who carries a similar tray of offerings (plate 13b). In mood and expression, the head of the deceased woman on the Kazanlak frieze (plate 14a) also strikingly resembles that of the seated figure painted on the

1. On the dating of the Kazanlak and Lefkadia tombs, see Introduction, nn. 4, 5. Robertson, in his new book, *A History of Greek Art* (Cambridge, Mass., 1975), upholds the generally accepted dating of the tombs to the late fourth or early third centuries in his text, but his captions omit mention of the fourth century, giving the date as the third century B.C. (I should add that my reference here is not to the final publication of the Robertson book, which at this writing is not yet available, but to the exhibition copy shown at the annual meetings of the Archaeological Institute of America in December, 1975.) In the most recent archaeological discussion of the Kazanlak tomb in L. Zhivkova (*Das Grabmal von Kazanlak* [Recklinghausen, 1973]), a fourth-century date seems to be preferred, and at Lefkadia there is nothing in the excavated materials to exclude a dating in the fourth century. Cf., Zhivkova, pp. 115 ff.; Micoff, pp. 7 ff.; Petsas, *O Tapbos Ton Lefkadion* (Athens, 1966), pp. 1 ff. Petsas, the excavator of the Lefkadia tomb, also discusses the Macedonian tombs in *Atti del Settimo Congresso Internazionale di Archeologia Classica*, 1 (Rome, 1961), 401 ff. Rumpf, p. 150, places the Lefkadian tomb known for its lost painting of a horseman (see Introduction, n. 4) in the period 330–310 B.C.

2. *ARV²*, p. 1372; *CVA*, Athens, pl. 11, fig. 4, and pl. 12, figs. 1, 2; W. Riezler, *Weissgrundige attische Lekythen* (Munich, 1914), pp. 3 ff., pl. 72; Arias and Hirmer, pl. 201.

lekythos. With their somber grace and introspection, there can be little doubt that in typology, these figures derive ultimately from common prototypes in the grieving, tragic women made popular by Polygnotes, particularly those in his great murals of the Fall of Troy at Athens and Delphi.[3]

At Lefkadia, as at Kazanlak, some of the figures strike poses that clearly remind us of classical Greek figural types, each one having a long history dating from the fifth century B.C. onward.[4] Indeed, the role of a common thematic tradition is so strong and so obvious in all these funerary paintings, that it comes perhaps as a surprise to find that the two groups of pictures are characterized by two entirely different painting methods.

The essential difference between the figural decorations in the tombs at Lefkadia and Kazanlak becomes apparent when one asks by what methods the artists in either monument described the painted form. The methods of showing form seem so opposed, in principle, that we are reminded of the Wölfflinian dichotomy in which two methods of showing form are contrasted in discussions of a "linear" and a "painterly" style.[5] In the Kazanlak frieze, we see a dark and light treatment that is emphatically linear and austere; the figure of a boy who leads the horses of the quadriga, for example (plate 12), is rendered in the simplest calligraphic outlines, freely brushed, with the addition of the most rudimentary kind of parallel hatching. This calligraphic, or draftsmanlike, method is familiar to us from fifth-century-B.C. white-ground lekythoi. The main difference between the calligraphy of the lekythoi and that of the Kazanlak murals is that in the wall painting, the contours are supported by hatching. This hatching is of the kind that departs from the outlines and is essentially conceived as part of them, causing the method of showing form to resemble a drawing method. At Lefkadia, the figures are rendered more subtly with an easier freedom in the modeling of form and in the use of shading. Moreover, the shading has a coloristic emphasis akin to impressionism, as is shown in my sketch of the head of Rhadamanthys (plate 9). At Lefkadia we are faced with the work of an artist who does not express shadows in linear fashion; this is an artist who has learned how to paint.

Otto Brendel was the first to apply Wölfflin's terminology to ancient painting, as part of an analysis of the Romano-Campanian styles.[6] Modifying the terms to fit the special conditions of ancient art, in the course of a comparison between the

3. A series of reconstructions of the murals of Polygnotos, based on descriptions in Pausanias, are found in a series of studies by C. Robert in the volumes of the *Hallesches Winckelmannsprogram* as follows: "Die Nekyia des Polygnot," 16 (1892); "Die Iliupersis des Polygnot," 17 (1893); "Die Marathonschlacht in der Poikile und Weiteres über Polygnot," 18 (1895). The most famous group of grieving or mourning women in Polygnotos's works was a group of Trojan women in the Iliupersis, a theme also taken up in Attic tragedy. General works on the art of Polynotos include E. Löwy, *Polygnot, ein Buch von griechischer Malerei* (Vienna, 1929); C. Weickert, *Studien zur Kunstgeschichte des 5. Jahrhuderts v. Chr.*, Abhandlung der Deutschen Akademie der Wissenschaften zu Berlin, I, *Polygnot* (Berlin, 1950); E. Simon, "Polygnotan Painting and the Niobid Painter," *AJA*, 67 (1963), 43 ff.

4. The types of the four main figures painted on the façade are analyzed by Petsas as follows: the deceased, pp. 114 ff.; Hermes, pp. 124 ff.; Aeachos, pp. 129 ff.; Rhadamanthys, pp. 132 ff. An iconographic study linking the figure of Hermes from this tomb with other examples is also available: S. Karouzou, "Hermes Psychopompos," *AM*, 76 (1961), 91 ff.

5. H. Wölfflin, *Principles of Art History* (New York, 1932), *passim*.

6. O. Brendel, review of M. M. Gabriel, *Masters of Campanian Painting* (New York, 1952), in *Art Bulletin*, 36 (1954), 235 ff.

Telephos painting[7] and the so-called Zeus in the Clouds,[8] both from Herculaneum, Brendel wrote:

Most Campanian paintings represent human figures as three-dimensional objects, and frequently by way of a formalism reminiscent of sculpture rather than of live models. But, as the comparison between these two examples shows, there are different ways of achieving this corporeal illusion. In the Telephos painting, all the main forms are clearly designed and outlined, and modelling is supported by lineal hatching, as in a drawing. In the Zeus painting, on the other hand, the forms are less definitely outlined; they emerge from an almost impressionistic technique of color patches. The gradations from light to dark are not accompanied by regular parallel hatching. In other words, the method of representation in the one case is basically linear, akin to drawing; in the other case coloristic and painterly.[9]

Brendel labels these two methods of showing form "abstract linear" and "impressionistic-painterly," and goes on to point out that the contrast between the two can be traced throughout the Romano-Campanian materials.[10] It is obvious, however, that the same distinction may be applied to our Greek examples.[11] Indeed, as far as the techniques of rendering form are concerned, it is probable that both the Campanian and the Hellenistic paintings employ methods grounded in Greek traditions dating to the classical period itself.

The figures in the Kazanlak tholos frieze are conceived in outline, and the colors of garments and flesh tones are applied in such a way that the outlines remain basic and clear. Shading is often indicated in long stripes of dark and light that parallel the outlines, thereby making them more emphatic, the strokes of darker color actually following the outlines wherever possible. These darker tones are accented here and there by parallel hatching. Moreover, the darks and lights consist of darker or lighter tones of the same color so that each area of color, each garment or object, has a distinctly monochromatic quality.

When we look at a detail of the Lefkadia paintings, on the other hand, for example, the figure of Rhadamanthys (plates 8 and 9), we see at once an entirely different method of handling dark and light. The coloring is everywhere applied in shorter strokes and patches; there is no apparent methodological separation between indications of color and indications of light and dark as at Kazanlak. A dark is not just an area of darker pink or brown flesh tones; it has blues and greens running through it and a complex system of overlapping tones in which every individual stroke is a slightly different color. Color accidents, produced by quick, overlapping brushstrokes, abound throughout the work and are accidents upon which the artist relied. The two

7. Gabriel, *op. cit.*, pp. 7 ff.; G. E. Rizzo, *La Pittura ellenisticoromana* (Treves and Milan, 1929), pp. 41 f., pl. 69; L. Curtius, *Die Wandmalerei Pompejis* (Leipzig, 1929), pp. 2 f., figs. 2–6, p. 229 ff.

8. Cf. Gabriel, *op. cit.*, pp. 32 ff.

9. Brendel, *op. cit.*, p. 236, n. 3.

10. *Ibid.*, p. 237.

11. The term *impressionistic* may not be as appropriate to the painterly method used in the Greek examples as in the Romano-Campanian method. But there is, as we shall see, every reason to suppose that in the history of Greek art (as in the history of art in general) a controversy existed between those artists who favored a more polished rendering of form and those artists who favored a more spontaneous treatment. This point is more fully treated in Chapters 3 and 9. See also the recent discussion in E. Keuls, "Skiagraphia Once Again," *AJA*, 79 (1975), 1 ff.

elements—color and the modeling of form in light and dark—which remain independent of each other in the Kazanlak painting, are here utterly interdependent. Accents of dark are not associated with a system of parallel hatching. They are at the same time accents of color, representing interesting and sometimes unpredictable changes of hue of the kind that reveals a truly sophisticated color sense. The aesthetic of contour, of continuous outline, is gone, and the forms turn easily into depth within an atmosphere of space. While the painting performance hardly equals the level of what Wölfflin would consider "painterly" in modern art (there is no resemblance to Rubens or Rembrandt), it is clearly different from the "drawing style" of the tholos frieze at Kazanlak and includes, by contrast, at least some of the characteristics of Wölfflin's definition of the painterly.[12]

A similar contrast may be noticed among the examples of painted stelae from Pagasae-Demetrias.[13] This group of paintings on gravestones was preserved by a miracle, when the stones were used as building blocks and sealed up in a wall in antiquity, so that when they were excavated, the colors were in many cases still fairly fresh. If we compare the Stele of Archidice (plates 1a and 2) and the Volos Archaeological Museum's uninscribed stele number 355 (plates 1b and 3), we find again a contrast between a strongly "linear" shading method of darkened contours on the one hand and, on the other, a method that causes outlines to disappear in favor of a fall of light over the forms. In the stele in plate 3 (which the Volos Museum labels "Stele of Three Figures"), the color seems quite restrained, so that the effect is almost monochromatic.[14] Yet the technique is a "painterly" one in the sense that the form is felt in terms of interior brushwork, especially by the addition of opaque white, as may be seen in the highlights of face, arm, and draperies of the figure in my sketch. In the Stele of Archidice, form is expressed as delineated shapes defined by outlines and supported by shading along the contours. In other words, in the chamber tombs and in the painted stelae, there is clear evidence that ancient Greek artists knew and practiced more than one method of creating the illusion of dark and light. Later classical artists, as well as the artists of the Hellenistic and Roman periods, working within well-defined iconographic and stylistic traditions, apparently were able to choose between what is essentially a drawing method, in which shading was employed mainly as a support for contour, and a painterly method, in which form was rendered internally, with a greater reliance on color, interior brushwork, and strong highlights.

As soon as we realize that Wölfflin's well-known painterly-linear contrast applies to Hellenistic Greek examples, which in so many other ways show connections with more ancient classical models, the question naturally arises: When, and under what circumstances, did such a dichotomy of methods first become established in Greek painting?

12. Wölfflin, pp. 18 ff.
13. See Introduction, n. 3.
14. D. Rosand ("Palma Giovane and Venetian Mannerism," Ph.D. diss., Columbia University, 1965, pp. 39 ff.) shows that, in the Renaissance, the painterly techniques of the Venetian mannerists, especially Tintoretto, are often monochromatic. Background motifs in the Scuola di S. Rocco paintings, for example, are rendered in whites against dark in a quasi-monochromatic technique, similar to our example. (See L. Coletti, *Il Tintoretto* [Bergamo, 1944], pls. 134–135.)

Our best chance to find an answer to this question lies in the ancient literary tradition, since so basic a methodological contrast would naturally arouse controversy among practitioners of the art, which would, in turn, be reflected in the writings of ancient critics. Assuming that the methods of showing form in the examples available to us reflect more ancient, classical practices, can we find in the literary tradition of the fifth century B.C. descriptions of painting methods that might suggest a historical framework for the development of such contrasting methods?

Among students of ancient art it is known that there are, in fact, two different and apparently contradictory statements in ancient writings describing the invention of chiaroscuro. In Plutarch, chiaroscuro is described in *De Gloria Atheniensium*, and the invention of this phenomenon is attributed to Apollodorus.[15] This is the method which Pfuhl calls *skiagraphia*[16] and which is defined by Pollitt as "drawing or painting with shading."[17] In contrast to this, Quintilian states that another, later artist invented "luminum unbrarumque rationem,"[18] the "law of light and shadow."[19] This was Zeuxis, among the most famous artists of the late fifth century B.C. Sellers assumed in her discussions of the ancient sources that these two descriptions of shading refer to one and the same phenomenon, and that the attribution of the invention of shading to two different artists who belonged to two different generations was simply the result of an error in transcription or interpretation on the part of the authors of late antiquity in whose works the art criticism of the classical period survives.[20] Since the idea that Apollodorus may have invented shading receives support from Pliny's description of the Apollodoran contribution to art,[21] Sellers and others have suggested that Quintilian must have made a mistake in attributing the invention of the law of light and dark to Zeuxis. Pollitt explains the matter with the statement.

Quintilian's source appears to have committed the understandable error of attributing Apollodorus' invention to his more famous pupil [Zeuxis].[22]

Pollitt's statement might carry more conviction had not Apollodorus himself been so famous an artist. While the reputation of Zeuxis was undoubtedly the greater, at least six different ancient authors mention works by Apollodorus,[23] and Pliny's account of his career (XXV, 61) leaves us in no doubt as to his fame throughout the ancient world.

15. Plutarch, *De Glor. Ath.*, ii. Cf. A. Rumpf, "Diligentissime Mulieres Pinxit," *JdI*, 49 (1943) 6–23. Rumpf's views on the invention of shading by Apollodorus are summarized on p. 23.

16. E. Pfuhl, "Apollodorus, O Skiagraphos," *JdI*, 25 (1910), 12 ff. Cf. Swindler, pp. 225 f.

17. Cf. Pollitt, *Critical Terminology*, pp. 285 ff.; Pollitt, *Ancient View*, pp. 251 ff. According to Pollitt, in some ancient passages *skiagraphia* (shadow painting) refers simply to the rendering of cast shadows but in most cases refers to "painting which seeks to stimulate our normal optical experience of light by the blending of light and shade."

18. Quintilian, *Inst. Orat.*, XII, 10, 4.

19. Pollitt, *Critical Terminology*, pp. 288, 540; Pollitt, *Ancient View*, pp. 252, 399.

20. Sellers, XXXV, 60, 12, nn.

21. Pliny, *NH*, XXXV 60–62.

22. Pollitt, *Critical Terminology*, p. 288; Pollitt, *Ancient View*, p. 252.

23. Overbeck, pp. 1641–1646. Cf. Thieme-Becker, II, 32 ff. (Sauer); *RE*, I, 2897, 77 (Rossback); Pfuhl, pp. 674 ff.; Rumpf, pp. 120 ff.; A. de Capitani D'Arzago, *La Grande Pittura greca dei Secoli Ve IV AC* (Milan, 1945), pp. 44 ff.

In the light of our observations so far, I would here propose that an error has been made in the initial assumption by Sellers that Plutarch and Quintilian spoke of one and the same event in the history of Greek painting in the passages under discussion. In reality, the two authors may very well speak of different inventions by two different painters, Apollodorus and Zeuxis respectively. It is not conceivable that two different moments of equal importance in the development of chiaroscuro are, in fact, described? We must, first of all, disabuse ourselves of the idea that ancient art critics were under the impression that chiaroscuro was invented all of a sudden by one man. Surely, they were not so simple-minded. This is an impression stemming perhaps from the terse remarks in the encyclopedic style of Pliny the Elder. But Plutarch and Quintilian were not so naïve, and they express themselves in far more sophisticated terms. The first use of shading would, of course, constitute an event that ancient writers might be expected to record. But is the first use of shading the same thing as the development of a rationale, or law, of dark and light? If one answers this question negatively, it no longer seems so unlikely that a number of generations may well have elapsed between the first use of shading, its handling in the art of Apollodorus, and the subsequent working out of the principles of chiaroscuro by his pupils. Indeed, it seems highly probable that the first use of shading considerably predated the career of Apollodorus. Some method of showing three dimensions was very possibly first attempted in the period of Polygnotos, a period that seems to have witnessed many daring experiments in the technology of all the arts.[24] Certainly, a convincing use of three-dimensional foreshortening occurs in vase painting by the period of the Persian Wars, implying a parallel concern with spatial representation in wall painting of that time. Apollodorus, who "opened the gates of art,"[25] may have been the first to systematize the experiments of the Polygnotan period in a manner that made it possible for later generations to comprehend the full implications of the newly developed concept of three-dimensionality as it affected light and dark. Pliny is describing important and far-reaching developments in his remarks on Apollodorus and Zeuxis, developments of the kind that may be attached to specific names only in the shortest outlines of art history. In reality, it is impossible for the fullest development of a system of chiaroscuro in ancient Greece to have taken place within the lifetime of a single generation of artists. Nor is it conceivable that ancient critics themselves were naïve enough to attribute the entire development to a single master. Pliny's outline must be accepted for exactly what it is, an outline or thumbnail sketch; the appearance of more than one artist's name in the ancient literary tradition in connection with the invention of shading is not a mistake. Instead of attributing an error to Quintilian because his remarks do not agree with Pliny's, we should consider the possibility that the information he gives *supplements* that given by Pliny.

Our proposal, then, might run as follows: Shading, in its earliest beginnings, must have taken the form of tentative and only partially successful experiments by the artists of the early and mid-fifth century B.C. Apollodorus's high success

24. Pliny, *NH*, XXXV, 58. Cf. Lucian, *Imag.*, 7. Swindler, p. 197, discusses the Polygnotan draperies.
25. Pliny, *NH*, XXXV, 61.

and fame as a painter probably rested on the fact that he restricted himself to the simplest shading methods, perfecting them, and imparting to his paintings a more convincingly three-dimensional appearance. The Apollodoran accomplishment and that artist's importance in the art-historical record as it has come down to us from ancient times can only be explained if he was somehow able to synthesize earlier, less successful attempts, so that a systematic relationship between chiaroscuro and color was established in some consistent manner. Such an accomplishment and nothing less (when we consider the rather late fifth-century dates we must assume for the career of this artist) might have struck the imagination of the ancient viewer as anything so dramatic as an "invention." Then Zeuxis, who "walked through the doors" that his teacher, Apollodorus, had opened,[26] must have been able to develop more sophisticated variations of the earlier methods. In his own mature work, he must have departed in some striking manner from the system of shading that had characterized his master's pictures; the likelihood is that Zeuxis invented a kind of chiaroscuro in which the relationship of color to dark and light was definitely altered, in which shading assumed a more dominant role and the nuances of coloring and brushwork became more and more complex, perhaps more "painterly." In any case it seems abundantly clear that in the course of carrying further the inventions of his teacher, Zeuxis would inevitably have had to develop a chiaroscuro that reduced the emphasis on contour line which was so well established as an aesthetic condition of all earlier styles in ancient painting. Zeuxis made dark and light and the suggestion of space take on an unprecedented importance as an element of painting and design, so that one might now think of chiaroscuro as an element requiring a rationale.

If we seek for an illustration of Apollodoran shading among the ancient fragments of painting available to us, this stage of art is probably most truly reflected in the simple and strongly linear style of the paintings of the tholos frieze at Kazanlak. On the other hand, reflections of the more painterly method to be associated with the work of Zeuxis may perhaps be observed in the façade at Lefkadia.[27] While the linear method of shading that I ascribe to Apollodorus undoubtedly began a tradition which was taken up again and again in later generations as a symbol of early classicism, Zeuxis provided an alternative method which allowed the artist to become more exclusively absorbed in the exploitation of light and dark and in the previously unexplored pictorial concept of a unified spatial atmosphere rendered in more naturalistic coloring. From that moment onward, a choice was possible, and a basis for controversy was introduced into both the practice and theory of the art of painting.

The supposition, thus outlined, is supported by the fact that a controversy on the art of painting did indeed arise among the philosophers and critics of the late fifth and early fourth centuries B.C., a controversy that evidently centered on the work of Zeuxis. This controversy, moreover, seems to have been about a choice between alternative methods of applying pigments to a surface in order to

26. *Ibid.* Cf. Pfuhl, pp. 681 ff.; Rumpf, pp. 126 ff.; Swindler, pp. 288 ff. T. Dohrn in Thieme-Becker, XXXVI, 472 f. P. Moreno (*EAA*, VII, 1265) discovers reflections of the style of Zeuxis in the Pella mosaics.

27. Petsas also sees connections between the style of Zeuxis and the paintings of Lefkadia (see Petsas, *op. cit.*, pp. 87 f., 106, 151 ff.).

describe three-dimensional form. Thus we find that Aristotle, who favored the older masters, such as Polygnotos, both on moral and aesthetic grounds, wrote a sentence on technique that reveals his preference for a linear painting method: "colors laid on confusedly or indiscriminately will not produce as much pleasure as simple outline."[28] Perhaps Aristotle had in mind the introduction of unexpected blues and greens in an area of flesh tone rendered in shadow when he spoke of "indiscriminately" applied colors—for example, such tones in the head of Rhadamanthys at Lefkadia (plate 9). One thing is certain, however. When Aristotle refers to colors laid on confusedly, we may not assume that he refers to artists of inferior skill, as has sometimes been suggested. All the indications in his writings on art suggest rather that he is attacking what had become in his day a well-established technique practiced not by second-raters, but by masters of the highest reputation. What Aristotle expresses is clearly a conservatism of taste, a preference for an older, less showy, and less dramatic method of rendering form that was in contrast to something more recent.

28. Aristotle, *Poetics*, 1405[b], trans. from Sellers, p. xxxi, n. 1.

2

Zeuxis and Parrhasios: A Controversy on Art

It seems extremely likely that the invention of shading in Greece in the fifth century B.C. created some theoretical doubts as well as technical difficulties for artists and craftsmen whose earlier traditions had insisted upon the flatness of the picture plane. On the other hand, the fifth century was a period in which new skills and new ideas in many fields of art and science were rapidly acquired and spread. But these new skills and ideas were not developed and absorbed unconsciously. On the contrary, each major new idea appears to have been carefully formulated, as, for example, the concept of ideal proportion in the statues of Polykleitos. In a similar fashion, each new concept, each step along the way toward achieving a three-dimensional pictorial ambiance, seems to have excited heated discussion and controversy among artists and critics alike. Evidently, despite their absorption with the mechanics of new techniques and methods, leading artists in the classical period found time to consider the broader implications of the events taking place not only in painting, but in all the various fields of art during those dramatic years of change.

Certainly, the development of shading meant the conscious sacrifice of an older aesthetic principle. An emphasis on two-dimensional patterns of color had been among the chief aesthetic pleasures of the Greek world of art for hundreds of years. Thick, bright paint tended to flatten out even architectural reliefs, transforming heavy, overhanging eaves of temples into airy and sparkling multicolored textures. In late archaic times it is probable that the rhythmic use of flat color areas was of primary importance in the design of monumental compositions. Although original Greek examples do not exist, we may perhaps imagine the special character of such a design by considering the paintings in the archaic tombs of Etruria—for example, the Tomb of the Lionesses at Tarquinia, which is considered by modern critics to be strongly influenced by Greek practice.[1] On

1. P. Ducati ("Le Pitture delle Tombe delle Leonesse e dei Vasi Dipinti," *Monumenti*, sez. I, Tarquinia, fasc. 1) describes the figure style in the paintings of this tomb as strongly influenced by

entering the burial chamber, we see a rhythm of sweeping curves of opaque and fully saturated earth-red tones. This rhythm is set in motion by the broad bands of red in the outstretched cloak worn by a dancing woman on the left and is taken up in the moving figure of the male dancer on the right. The rhythm takes us swiftly around the walls of the room, the major areas of red bordered and ornamented here and there by narrower bands of blue and green. This color relationship is reversed in the dolphin frieze which decorates the socle below, where blues and greens form the wider bands of color and are accented by narrower stripes of red. The rhythmic color relationships are thus consciously and deliberately applied and varied, counterbalanced in the several parts of the decoration of the chamber. The powerful appeal of the paintings in this chamber depends on our initial response to the big and spirited splashes of pure, deep color with which we are suddenly confronted as we enter. The excitement of the color is only gradually diminished as we begin to take in the details of the composition. It is of paramount importance for us to realize that with the invention of shading, unbroken areas of pure, bright color, upon which archaic compositions, like the murals in the Tomb of the Lionesses, chiefly relied, would ultimately disappear as a major design element. Areas of color would become broken up by lights and darks, and consequently weakened. Strong colors spread over large areas would be replaced by modified and greatly softened tones, colors that would not disrupt the feeling of a three-dimensional atmosphere. Colors would, in a sense, become adulterated by shading as soon as three-dimensionality became the rule.

It is, at any rate, a very similar kind of "adulteration" of color to which Plato refers when he defines the beauty of color and form in the *Philebus*.[2] In this dialogue, although Plato makes no mention of individual painters by name, criticism is clearly aimed at certain identifiable artistic innovations of his period. They are the innovations that tradition accords to Zeuxis. Plato, in the *Philebus*, seeks to establish the nature of something he thinks of as "pure" pleasure, in contrast to the pleasures of everyday life, which, he says, are always mixed with pain. This is a step in the intended proof that, ultimately, wisdom rather than ordinary pleasure brings mankind the greatest happiness. An example of pure pleasure is the pleasure one may experience in the perception of form and color —in other words, aesthetic pleasure. But this kind of pleasure is derived only when the forms perceived discernibly approach pure geometric shapes, those attainable by means of a linear vocabulary of curves and straight lines. Colors

Greek art (text, p. 22, n. e). Cf. M. Pallottino, *Etruscan Painting* (Geneva, 1952), pp. 43 ff. Brendel, in his forthcoming book on Etruscan art, calls the Tomb of the Lionesses "the most Greek-izing" of the archaic Etruscan tombs.

2. Plato, *Philebus*, 51A–53B. The interpretation of this passage as a criticism of contemporary painters in Plato's Athens was originally made by R. G. Stevens, "Plato and the Art of His Time," *CQ*, 27 (1933), 154 f.: "Plato's discussion of color and form in the *Philebus* is a useful pointer to his taste. In a single sentence he shows his dislike of the whole of contemporary painting." Stevens probably errs in making his statement so sweeping. It is likely that Plato, although critical of all artistic innovation on principle (*Republic*, IV, 424B), may have made an exception for those contemporary painters—for example, Parrhasios—who, while employing contemporary rather than archaic methods, sought to uphold the older values of art. There is an excellent and well-documented discussion of Plato and illusionism in ancient Greek painting in P. Moreno, "Il Realismo nella pittura greca del IV secolo A.C.," *Revista del Istituto Nazionale d'Archeologia e Storia dell'Arte*, N.S. (1964–1965), 27–97.

should be pure by restricting them to full, unmixed primaries.[3] Colors that are adulterated by the admixture of other colors are no longer beautiful, according to Plato; nor are forms in which the underlying geometric principles are blurred.[4] Chiaroscuro, insofar as it disturbs our perception of outlines and the integrity of simple colors, takes on the aspect of a dangerous innovation in the context of Platonic reasoning.

As an exponent of a modern point of view which threatened to upset older and more conservative ideals of beauty, the name of Zeuxis logically presents itself.[5] The criticism that Aristotle especially levels directly at Zeuxis serves to identify him as an artist whose successes depended on innovation at the expense of older values. Near the beginning of the *Poetics*, as part of his definition of tragedy, in order to support his statement that action and plot are more fundamental than character, Aristotle makes the following comparison:

While all tragedy has action . . . you can have some [tragedies] without character study. Indeed the tragedies of most modern poets are without this, and speaking generally, there are many such writers, whose case is like that of Zeuxis compared with Polygnotos. The latter was good at depicting character, but there was none of this in Zeuxis.[6]

Aristotle develops this parallel in a way that shows Zeuxis, like the later tragedians, as an artist who lacked certain of the basic interests which made the earlier masters great; these artists of late classicism, according to Aristotle, substituted showmanship and clever effects for substance.

The extent to which the reputation of Zeuxis may have been built on spectacular technical performances is suggested by the importance another ancient writer, Lucian, gives to this aspect of his painting. In his description of a Zeuxis masterpiece, a painting called *The Centaur Family*, Lucian emphasizes the fact that one of the most impressive things about the painting was the rendering of certain transitions of tone and texture between the human parts and the animal parts of the centaurs.[7] Speaking of the female centaur who lies in the foreground of the painting suckling her child, Lucian writes:

The union and junction of bodies, whereby the horse part is fused with the woman part, and are joined together, is effected by a gradual change, with no abrupt transition; the eye as it moves gradually from one to the other is quite deceived by the subtle change.

Lucian goes on to describe the precise sensations of color and texture one is able to enjoy in the rendering of the female centaur's skin and hide. Zeuxis, impressing us with skillfully rendered transitions and realistic sensations of texture, had obviously developed quite sophisticated painterly techniques. In Lucian's description, our attention is focused not on the content of the picture, but on the painting performance and on certain striking illusionistic feats of skill. One may

3. Plato, *Philebus*, 51B–51D.

4. Number as a concept related to the perfection of forms enters this discussion also when it is earlier stated that by introducing number into apparently infinitely varied materials, we impose the appearance of harmony and proportion upon them and render them at the same time pleasing and intelligible (Plato, *Philebus*, 25D–25E). Cf. Pollitt's discussions of harmony and rhythm: *Critical Terminology*, pp. 132 ff., 255 ff.; *Ancient View*, pp. 151 ff., 218 ff.

5. Cf. ch. 1, pp. 27 ff.

6. Aristotle, *Poetics*, 1450ª (trans., Loeb ed.).

7. Lucian, *Zeuxis*, 6 (Leob ed., Kilburn trans.).

suppose that this artist had sacrificed to a degree the importance previously given to pure color and to the clarity of outline, the very ideals which constitute the definition of beauty in Platonic philosophy. It is easy to see that the illusionistic technical innovations related to the development of chiaroscuro and to color blending began at a certain point to attract more attention to naturalistic rendering to the detriment of older and more idealistic values. Bitter criticism was aimed at artists who embraced the new approach to form, and a heated controversy arose between those artists willing to give way to the temptations of naturalistic rendering and those who sought to reinstate the sterner principles of form and color belonging to an older idiom. That older idiom, though seemingly out of date, found strong support among the exponents of an abstract philosophical idealism, and eventually became associated in the minds of the ancients with the highest achievements of Greece's golden age, from the Persian Wars to Pericles. Thus the stage was set for the introduction of coexistent "Wöfflinian" opposites as a condition of the artistic scene.

Zeuxis, according to literary sources, displayed an interest in a fuller exploitation of the technical innovations of his day, while his contemporary, Parrhasios, perhaps the younger man,[8] seems to have expressed in his art an older ideal of formal beauty. Parrhasios seems to indulge in a reaction against the extreme modernism of Zeuxis. Already within the lifetime of Zeuxis it would seem that a basic controversy between two modes of painting had arisen. In subsequent generations, that controversy had become a constant theme of criticism, and artists in both camps were able to establish themselves and achieve success. We must remember that this was the first time in history that artists, in effect, had a choice of method and technical procedure, and their decisions with respect to such alternatives would inevitably affect their styles. Under those circumstances, the procedures themselves became matters of direct concern to the critics as well as to artists.

In the *Republic*, Plato goes so far as to give the controversy arising out of the dichotomy of painting techniques a clearly moral interpretation.[9] Basically, we deal with a controversy between advocates of pure design and advocates of illusionism. Any kind of optical illusion, according to Plato, whether in painting or elsewhere, plays us false in the sense that it takes advantage of a human failing, namely the inherent weakness of our sensory organs, upon which we must rely for knowledge. The sense of sight is already unequal to the task of informing the mind of what is actual and true in the world around us. The weakness of our senses should not be exploited by artists. On the contrary, they should create designs pure enough and abstract enough to appeal directly to the best parts of our mentality. In nature, illusions cannot be avoided. Among the examples given

8. Pfuhl, II, 689; *RE*, XVIII, 4, 1873 ff. The evidence for dating Parrhasios and Zeuxis as contemporaries is discussed in detail by Rumpf, "Parrhasios," *AJA*, 55 (1951), 1 ff.

9. Plato, *Republic*, X, 602C–603B. Pollitt (*Ancient View*, p. 249) includes part of this passage under the term *skiagraphia*, translating it as follows: "And so *skiagraphia* having taken advantage of this weakness in our nature turns out to be nothing short of sorcery and sleight-of-hand and many other tricks. . . ." Pollitt goes on to describe Plato's attitude toward shading as "the earliest documented 'conservative reaction' in the history of art criticism," and outlines the moral and philosophical basis for Plato's sharp criticism of painting that made use of chiaroscuro (*Critical Terminology*, pp. 290 ff.; *Ancient View*, pp. 253 f.).

by Plato are the way objects appear bent when looked at in water, and the way the concave sometimes appears convex, "owing to the illusion about colors to which we are liable."[10] In other words, we are in enough danger of being deceived by our senses without adding to those dangers by surrounding ourselves with overly deceptive man-made illusions. Painting was better when artists were without the technical means to create optical illusions and could concentrate on "ethos" and on pure aesthetic pleasure as it may be derived from geometric shapes and pure, unadulterated color. In the course of this discussion, Plato refers specifically to "deceiving by light and shade, and other ingenious devices," which have an effect upon us "like magic."[11] Thus, illusionism in painting of the kind that had made Zeuxis famous was, we may imagine, to be condemned in Plato's ideal state, and it seems very likely that in this regard Plato reflected the opinion of a much wider group of reactionary and no doubt outspoken critics.

When we turn our attention to what is recorded in the literary tradition about Parrhasios, we receive the clear impression that this artist, more than any other, rescued the ideals of older classical painting. If Zeuxis was famous for cheap illusionistic rendering, Parrhasios was noted for a special quality of beauty which he was able to impart to his forms not, like Zeuxis, through illusionism and chiaroscuro, but by means of a simple outline which gave an exhalted sense of purity to everything that he produced.[12]

The passage in Pliny that describes the style of Parrhasios is, in the words of Eugenie Sellers, "of unique aesthetic interest,"[13] and she was right to bring it so strongly to our attention:

10. Plato, *Republic*, X, 602C–603B. Moreno (*op. cit.*, n. 2) bases his deductions on illusionism in fourth-century-B.C. Greece mainly on the evidence of south Italian vases, and sees a full flowering of an "authentic realistic sensibility in Greek art" in the works of the fourth-century-B.C. painter Philoxenos.

11. *Ibid.*, X, 602D (Jowett translation).

12. Rumpf, "Parrhasios," 2. Pfuhl (pp. 689 ff.) develops the theme of competition between these two artists. Zeuxis and Parrhasios were "very nearly contemporaries," according to Quintilian (*Inst. Orat.*, XII, 14, 4). Pliny (*NH*, XXV, 64, 61) also ascribes them to the same Olympiad, the ninety-fifth or the years just at the turn of the century, ca. 400 B.C. Parrhasios's dates are complicated by the fact that two ancient writers attribute to the artist the designs for the shield of the statue of Athena Promachos, later executed in metal by Mys (Pausanias, I, 28, 2; Athenagoras, 783B). The date for this statue is still a matter of controversy. Pictures of the Athena Promachos on Athenian coins of the Roman Imperial period are interpreted by G.M.A. Richter (*Sculpture and Sculptors of the Greeks*, 4th ed. [New Haven, 1970], p. 214) as revealing a statue of the "severe style"; she thinks that the statue could have been done sometime after the beginning of Kimon's administration in 470 B.C. However, according to A. Furtwängler (*Masterpieces of Greek Sculpture*, new ed. [Chicago, 1964], pp. 31 f.), the information in the ancient literary tradition is not to be trusted in this instance; he advises us to allow for the possibility that the Promachos may not have been made by Pheidias at all, but by one of his pupils or colleagues. In that event, the shield designs could have been an early work of Parrhasios. We should also note that Parrhasios's father, Evenor, was, like his son, one of the most famous painters of his day (Pliny, *NH*, XXXV, 60); the son may have been apprenticed at a very early age and allowed to take part in important commissions when still a youth, as Rumpf points out ("Parrhasios," 2 and n. 11). A bibliography of the ancient and modern literature concerned with the Athena Promachos may be found in A. E. Raubitschek, *Dedications from the Athenian Akropolis* (Cambridge, Mass., 1949), p. 200. Fragments of an inscribed base (Raubitschek, pp. 198 ff., no. 172) belonging to the pedestal of the Promachos have been found. The epigraphical evidence of these fragments suggests a date in the 450s. Cf. A. E. Raubitschek and G. P. Stevens, "The Pedestal of the Athena Promachos," *Hesperia*, 15 (1946), 107 ff. (discussion of the date on 112 ff.). Raubitschek and Stevens suggest that in view of the epigraphical evidence, Parrhasios is probably an error for Panainos.

13. Sellers, n. for XXXV, 67, 16, p. 111; see also Sellers's remarks on this passage in her Introduction, p. xxxiv. The passage (Pliny, *NH*, XXXV, 67) is as follows: "Parrhasios Ephesi natus et ipse multa contulit. primus symmetrian picturae dedit, primus argutias voltus, elegantiam capilli,

Parrhasios, a native of Ephesos, also made great contributions to the progress of art. He first gave painting symmetry, and added vivacity to the features, daintiness to the hair and comeliness to the mouth, while by the verdict of the artists he is unrivalled in the rendering of outline. This is the highest subtlety attainable in painting. Merely to paint a figure in relief is no doubt a great achievement, yet many have succeeded thus far. But where an artist is rarely successful is in finding an outline which shall express the contours of the figure. For the contour should appear to fold back, and so enclose the object as to give assurance of the parts behind, thus clearly suggesting even what it conceals.

Pliny describes a technique emphasizing the outermost contours, a technique in which the artist is able to suggest not only the contours of material bodies, but a special quality of the painted line in which we are permitted to feel the continuation of the forms turning back into space, where they are out of sight to the viewer. Sellers further suggests that Pliny's description implies the ability to create the illusion of an "ambient space of enveloping light and air."[14] All of this is accomplished primarily by means of line, and this linear expression of form represents to the ancient critic the highest accomplishment of painting. Indeed, the most important theorists and painters of the Renaissance—among them Alberti and Piero della Francesca, as they became concerned with similar problems in the technology of rendering form—seem to have studied Pliny's description of the Parrhasian method of contour drawing with particular attention, perhaps seeking to emulate the ancient master's ability to evoke an impression of ambient space through line. Piero della Francesca, whose knowledge of ancient texts seems almost to have rivaled Alberti's, stands in the same relation to the earlier Masaccio as Parrhasios did to Zeuxis: he makes far less use of chiaroscuro and atmospheric effects. Instead he creates an effect of great purity—a kind of intellectual integrity—by means of a concentration on simple contours, solid colors, and geometrically inspired forms, just as Plato and other ancient theorists prescribe.

The implications of ancient statements on the style of Parrhasios suggest some new steps in our proposed outline of the history of the development of chiaroscuro in antiquity. Evidently, the original method of shading perfected by Apollodorus must be considered the starting point for the later methods of both Zeuxis and Parrhasios. In Apollodorus, figures are raised from the background by

venustatem oris, confessione artificum in liniis extremis palmam adeptus. haec est picturae summa subtilitas. corpora enim pingere et media rerum est quidem magni operis, sed in quo multi gloriam tulerint, extrema corporum fecere et desinentis picturae modum includere rarum in successu artis invenitur. ambire enim se ipsa debet extremitas et sic desinere, ut promittat alia et post se ostendatque etiam quae occultat." A more subtle interpretation of this passage is the one by R. Bianchi-Bandinelli (*EAA*, V, 965): "Per primo dette alla pittura le norme della simmetria, per primo i minuti particolari expressivi nei volti l'eleganza dei capelli, la piacevolezze dell' aspetto e, per riconoscimento degli altri artisti, raggiunse la perfezione nelle linee di contorno dei corpi. Questa e la massima raffinatezza della pittura. Il dipingere i corpi e le zone centrali degli oggetti, e certamente prova di grande perizia, ma in cui gia molti raggiunsero la gloria: invece rendere in pittura il contorno dei corpi e saper racchiudere il giro dei piani di scorcio la dove terminal la figura, si trova raramente nel cammino dell'arte. La linea di contorno, infatti deve come girar su se stessa e finire in modo di promettere altre forme al di la di essa e rendere evidenti le parte che cela." The interpretation of this passage is intelligently discussed also by E. Bertrand, *Études sur la peinture et la critique d'art dans l'antiquité* (Paris, 1893), pp. 65 ff. Cf. Ferri, XXXV, 67.

14. Sellers, Introduction, p. xxxiv. An interesting discussion of the ancient passages on Parrhasios is by R. Bianchi-Bandinelli in *La Storicità dell'arte classica*, rev. ed. (Florence, 1950), pp. 53 ff. He also discusses pertinent remarks of Alberti, Leonardo, and Piero della Francesca, p. 55, and n. 60.

means of simple shading; but the forms are perhaps not quite detached from the picture plane. Both Parrhasios and Zeuxis succeeded in freeing figures from any background plane, allowing them to occupy space which is felt to continue around them and behind, but they did so by different methods. In accomplishing this, Parrhasios de-emphasized chiaroscuro, developing a sensitivity of outline capable of suggesting form without an especially prominent use of shading and atmospheric effects. This method of showing form is perhaps best illustrated in Attic white-ground lekythoi, especially those of group R.[15] Simultaneously, Zeuxis accomplished the freeing of his figures from the flat picture plane not by means of outline, but rather by developing a new approach to chiaroscuro and modeling, as we are informed by Quintilian.[16] Quintilian's description of the painting method developed by Zeuxis employs a phrase which, in itself, suggests a striking contrast to the *skiagraphia* of Apollodorus. If Apollodorus's method was drawing with shading, giving relief to the figures, Zeuxis created a system of light and dark that was able to suggest the completely detached three-dimensional forms of the figure. This implies a more radical change in the concept of painting than the *skiagraphia*, which we may ascribe to Apollodorus and Parrhasios. Apollodorus's shading method was reminiscent of the two-dimensionality of the picture plane, merely pushing that plane slightly away into the background so that figures appeared as in a relief. Zeuxis then "walks through the doors" that had been opened by Apollodorus, as we have seen.[17] The method of Zeuxis would represent the final freeing of the forms from the implication of flatness, from the attachment to a background plane. He was responsible for a chiaroscuro that, like Parrhasios's linear method, suggested not only the three-dimensionality of the parts we see, as in a relief, but also the continuation into space of the parts we do not see. A certain space was suggested behind the figures, and they became detached and free to move within the pictorial field.

If we return now to the comparison suggested earlier between the Stele of Archidice (plates 1a and 2) and the Stele of Three Figures (plates 1b and 3), the matter becomes somewhat clearer. Two entirely different methods of showing form through dark and light were employed in these examples. The method used in the Stele of Archidice certainly includes shading. But the shading is restricted to a degree just necessary to support the three-dimensionality suggested by the contours. The feeling of depth in this picture is nowhere communicated through a handling of paint; depth is only implied by the bulk of the figure itself and that bulk is suggested by means of outlines and contours only slightly emphasized by shading. In this work, there is no sign of any elaborate rationale applied to the system of darks and lights, and, above all, there is no real sense of an actual fall of light over this figure. The figure is three-dimensional without seeming to be illuminated. What we see is perfectly simple. Each contour is given a degree of relief. Along its entire length it is followed by a slight darkening or lightening of the local color. We may sense the forms of the figure as they turn back into space,

15. The name "group R" is defined by J. D. Beazley in *ARV*[2], p. 1376. Beazley invented the classification in order to distinguish vases of higher quality in the painting performance from the more ordinary works by the Reed Painter. These more outstanding examples of painting on a white ground have often been cited in connection with Parrhasios. Cf. Rumpf, n. 8.

16. Quintilian, *Inst. Orat.*, XII, 10.4.

17. Pliny, *NH*, XXV, 61. Cf. Pollitt, *Critical Terminology*, pp. 287 f.; Pollitt, *Ancient View*, p. 252.

and feel them to be detached from the plane behind; but we receive no impression of a play of light and dark convincing enough to create a true illusion of light. The apparent direction of the light in fact is emphatically contradicted: on the arm and under the chin, we find that the darks are along the lower outlines, indicating light from above. But then the lap, facing upward, is a darker tone than the rest of the figure. The woman represented is as solidly three-dimensional as a statue in the round. This is partly due to shading, it is true; but the shading is everywhere subordinated to the drawing and the direction of the light is treated abstractly or, it would be more correct to say, pragmatically. Such rendering of form probably belongs to a Parrhasian or even an earlier, Apollodoran tradition.

A reflection of the Parrhasian-Apollodoran method of showing form has sometimes been illustrated, as we have seen, by means of the drawings on the white-ground lekythoi of the late fifth century B.C.[18] Pfuhl saw a relationship between the lekythoi and the style of Parrhasios both in technique and in thematic emphasis.[19] Sorrow or pain, noticeable in the funerary lekythoi, is one of the emotions often expressed in Parrhasian works, at least in those of his works described in ancient sources. These include, for example, a snake-bitten Philoctetes,[20] who was abandoned on a deserted island by his comrades until they learned from an oracle that they could not win the Trojan War without him. Also among his best-known oeuvres was a Prometheus (Parrhasios is said to have had his model tortured in order to better capture the aspect of pain).[21] Among the vase painters of the late fifth century B.C., Aison and Meidias, with his so-called "melting" outlines, perhaps illustrate most clearly the technique of suggesting form through contours as it must have appeared in the compositions of Parrhasios.[22] Pfuhl draws a parallel with the white-ground lekythoi by the Achilles Painter,[23] and also mentions incised drawings on ivory and on bronze mirrors in connection with Parrhasios.[24] All of these examples are executed in a style in which three-dimensional forms are beautifully expressed in line. The quality of line, moreover, in all these various works, has something very special in common: a character which can always be recognized no matter what the actual medium of expression, whether engraving or the painted line. There is an economy of means, an extreme purity of line throughout such compositions, that gives to contour an unexpected presence. The contours create so intense an atmosphere, so commanding an impression, that the slightest variation in the thickness or thinness of an outline, the slightest overlap where one line intersects another, becomes significant and suggestive. The artist feels and controls the contour in such a way that the varying pressures of his hand as his drawing implement moves along a surface results in the complete unfolding of a complex form which seems to come fully to life before our eyes and to detach itself miraculously from its background. At the same time, the simplicity of forms

18. Robertson, pp. 149, 153; M. Cagiano de Azevedo, in *EAA*, V, 963, fig. 1175; Arias and Hirmer, p. 18; Rumpf, p. 116; Karouzou "Scherbe einer attischer weissgrundigen Lekythos," 71 ff.
19. Pfuhl, II, 549.
20. *Anth. Pal.*, XVI, 111, 113; Reinach, pp. 270, 271; Overbeck, p. 1709.
21. Seneca, *Controv.*, X, v, 34; Reinach, p. 272; Overbeck, p. 1703; cf. Swindler, p. 234.
22. C. Dugas, *Aison* (Paris, 1930), p. 91; Pfuhl, II, 690, and figs. 576, 578; Rumpf, "Parrhasios," 3 ff.; Bianchi-Bandinelli, p. 61.
23. Pfuhl, II, 690, and figs. 543 f.
24. *Ibid.*, and figs. 622, 623.

expressed in pure contour line seem to preserve a sense of geometric abstraction. We do not see a contour drawing as overly naturalistic because we become so much aware of the artist's hand and mind as a controlling force. The performance is in every way an abstraction, an intellectual exercise.

Jean Cocteau understood this very clearly in *The Blood of the Poet* when he made a contour drawing of a head come to life on the canvas and speak to the artist, producing in him and in the spectator a feeling of utter shock and inexpressible horror. Our sense of horror results from the fact that the realism of eyes that cast a glance or of lips that move do not accord with the abstract quality of pure outline. A beautiful line dictates its own strict terms which may not be violated. If they are, the result in the spectator is pain or shock as in the case of Cocteau's artist.

Showing form by means of contour alone and the special aesthetic pleasure which belongs to expressive yet pure outline has had a continuing particular appeal in all periods of the history of art. Contour drawing affords a method of training the hand and the eye, as a means of developing the ability to extract essentials of form from the complex impression of atmospheric light and color which we experience every day in nature. The contour method has therefore always been an indispensable part of an artist's education in our schools, a standard technique for developing technique, like the practicing of scales for a musician, and we may easily forget that there was a time when such a method of showing form in three dimensions had to be invented for the first time. Yet that is exactly what happened in the fifth century B.C. in Greece. It seems entirely possible that Parrhasios owed his great fame in antiquity to the fact that in the midst of a period when the new science of chiaroscuro attracted most attention, it was he who saw the full range of possibilities inherent in the magic of contour as a means of showing form and, concomitantly, as a means of suggesting space. Parrhasios seems to have developed a method of fully detaching the figures of a composition from the picture plane without sacrificing that special beauty of outline which was already recognized throughout the ancient world as one of the hallmarks of Greek art, in part no doubt because of the great popularity and widespread fame of vase painting. Despite the invention of chiaroscuro, Parrhasios succeeded in raising the prestige of a linear approach to form when, toward the end of the fifth century B.C., the most original masters were already tending toward a new direction; thus he made available to later generations of artists the tradition of a linear method in monumental painting, supplementing the tradition of the vases, ensuring the continuity of such a tradition in later periods when artists purposefully proposed to preserve what was best and most significant in the heritage of earlier styles. Under these circumstances, the linear style of the Kazanlak tomb and the Stele of Archidice may easily represent a reflection of a Parrhasian tradition.

Turning now to the stele in plates 1b and 3, we are confronted with an entirely different method of showing form. This artist gives us a degree of convincing depth into which we may actually enter, due to a kind of aerial perspective in which there is the continuity of a natural atmosphere. The psychological conviction that we are able to move into depth and take a place among the figures in the picture is reinforced by the fact that the space is filled with light falling from a single source. This artist creates a true rationale of light and dark that is every-

where consistent and therefore psychologically correlated with the real world around us. There is no artificial picture plane to make us aware of an abstract geometric design. Visual laws, rather than formalized precepts have been followed. The classical, geometric structure of the human figure itself remains more or less unchanged. But in this context the figures have lost all their stiffness and artificiality, and the treatment of space and light around them is far different. In the Stele of Archidice there operates a concept of shading that merely adds weight and substance to a drawing. In the untitled stele we have a clear case of the "luminum umbrarumque rationem," developed, according to Quintilian, by Zeuxis: a figure set within an atmosphere of visually rational, psychologically convincing light and shadow.

The competition between the methods of Zeuxis and Parrhasios represents an interesting moment in the history of art. The major breakthrough had already happened a generation or two before. The flat picture plane had been eradicated as an aesthetic condition of painting. Now it was time to stop and take stock of the consequences. Apparently two painting methods arising from different impulses, one to preserve, the other to abolish the vestiges of a two-dimensional background or plane, collided with each other. Each point of view had its supporters, but it seems to have been the method of Parrhasios that the more influential critics favored.[25] The question under dispute was not whether shading per se should be used in forming the painted shapes of objects, for it must have been clear that archaic flatness could never again return to the art of painting. As an indispensable part of the representation of depth, chiaroscuro could hardly be avoided. At issue, rather, was the question: How far should chiaroscuro be carried at the expense of outline and color? Parrhasios, like Zeuxis, was certainly a "modern" in the sense that he must have employed some dark and light effects of order to support the illusion of depth. Socrates, according to Xenophon,[26] finds in the art of Parrhasios also "shadow and light," and the imitation of forms which are "deep and high," by means of his art. Apparently Parrhasios, like Piero della Francesca, was fortunate in finding a method capable of serving the new aims of art while at the same time avoiding any dramatic emphasis on chiaroscuro. His works must have had the appearance of relying mainly on linear definition, while his themes and subjects continued an established classical tradition in which the troubled souls of great heros were analyzed and brought to view.

Zeuxis, meanwhile, braved the worst of the storm by delighting in painterly illusionism and in subjects which were often innovative and without moral content. He evidently tried to carry chiaroscuro to the point where its special laws could be recognized, systematized, and even varied. His paintings achieved a kind of phenomenal naturalism which won for him worldwide fame. But the fact that his reputation grew with the passing of time, enduring for hundreds of years into the period of the Roman Empire, must mean that his work had qualities beyond mere spectacle and skill, for his art enjoyed a certain stature and was assigned a role in the history of styles more or less equal in importance to the much-admired contour technique of Parrhasios.

25. Aristotle's preference for outline drawing, as expressed in the passage quoted above (ch. 1, p. 30, and n. 28), may very well refer to Parrhasios. Cf. S. Karouzou, "Scherbe einer attischen weissgrundigen Lekythos." *Antike und Abendland*, 5 (1956), 71 ff., esp. 74.

26. Xenophon, *Memorabilis*, III, x, 1; cf. Pollitt, *Sources*, p. 160.

3

Symptoms of a Painterly Style: Monochrome in the Art of Zeuxis

One of the most significant details in the ancient literature concerning the art of Zeuxis is contained in a statement by Pliny in which he records, unfortunately without further explanation, the fact that Zeuxis painted monochromes in white.[1] According to Pollitt, there are two possible translations of this phrase.[2] On the one hand, Pliny may be referring to monochromatic drawings in a dark color on a white background. Ancient examples of this technique are the monochromes in red on white marble from Herculaneum in the Naples Museum: the Knucklebone Players,[3] the Centauromachy,[4] and a quadriga.[5] On the grounds that Lucian describes a painting by Zeuxis in which a centaur family—mother, father, and child—is the subject, that centaurs were among the artist's favorite themes, and that Zeuxis painted monochromes, the Herculaneum Centauromachy has been connected with the works of Zeuxis.[6] The reasoning behind this attractive theory is obviously full of difficulties. The Herculaneum monochromes are not monochromes in the true sense: they are simple drawings, and the shading employed is *skiagraphia*, the technique of the Apollodorus-Parrhasios tradition. Monochrome, in the hands of Zeuxis, may have had an altogether different character.

1. Pliny, *NH*, XXXV, 64: "pinxit et monochromata ex albo."
2. Pollitt, *Sources*, p. 155, n. 92.
3. Rumpf, pl. 39, 6; A. Maiuri, *Roman Painting* (Geneva, 1953), p. 104 (in color); Pfuhl. fig. 629; P. Marconi, *Pittura Dei Romani* (Rome, 1929), fig. 5.
4. Rumpf, pl. 41, 1; Marconi, fig. 6; Pfuhl, fig. 631.
5. Marconi, fig. 7.
6. W. Kraiker, "Das Kentaurenbild des Zeuxis," *Berliner Winckelmannsprogramm*, 106 (Berlin, 1950); *idem*, "Aus dem Musterbuch eines Pompeijanischen Wandermalers," in *Studies Presented to David M. Robinson* (St. Louis, 1951), pp. 801–807. Cf. the discussion of Zeuxis in R. Bianchi-Bandinelli, *La Storicità dell'arte classica*, rev. ed. (Florence, 1950), p. 51.

For one thing, it is very unlikely that a writer describing a picture as a "monochrome in white" could have been talking about a drawing on a white background. A better interpretation of Pliny's phrase is that Zeuxis employed a white pigment on a dark ground.[7] That there was a Greek tradition for the technique of painting in white and other light colors on a dark background is proven by the examples from Greek houses at Delos (plates 16a and 16b), and new examples of this technique belonging to the Hellenistic period have been found recently at Knidos.[8]

In painting on a dark background, the use of white implies the use of an impasto, or thickness of paint, for white is always a transparent pigment and must be applied thickly in order to cover a darker tone underneath. Such an impasto effect may be seen in vase paintings that employ whites and other light colors, such as in the works of the Lipari Painter.[9] In applying a white impasto to a dark surface it becomes apparent at once that an effect of shading can be produced merely by varying the thickness of the impasto so as to allow the dark surface to show through in varying degrees. In drawing a white line on a black surface, for example, the flow of pigment from the brush can be controlled so that parts of the line will look white and other parts shaded. Such a line will automatically appear to move in and out of space, the whiter, thicker parts advancing, the transparent, shaded parts receding. With this means of showing form available, conventional hatching may be discarded.

This method of presenting form in three dimensions is precisely the method employed in fragments of a frieze from Delos (plates 16a and 16b). Although not, strictly speaking, a monochrome, details of individual flowers in the frieze show very well what may be considered a necessary condition of all white monochromes painted on a dark background. A flowered garland running through the frieze is a typical device for a raised stringcourse in Greek interiors of the "masonry" style,[10] each loop of the garland acting as a frame for a pictorial motif, such as a running cupid or a wild beast attacking a fawn. More frequent are simple arrangements of flowers and buds as in plates 16a and 16b. The representation of these motifs is definitely three-dimensional in character. But this impression of three-dimensional form is not due to any ordinary system of shading. The effect is based on the principle that when handling light on dark, the thicker the paint the less it is dulled or darkened by the black background beneath. The thicker the stroke, the whiter the paint looks and the more it seems to stand forward.

7. Sellers, p. 109, n. 64:13.

8. Reported in a talk by Iris Love at the annual meeting of the Archaeological Institute of America, December, 1968, at Toronto (summary in *AJA*, 73 [1969], 241). For more on the Delos fragments, see Introduction, n. 6.

9. D. Trendall, "The Lipari Vases and Their Place in the History of Sicilian Red-Figure," *Meligunis-Lipara*, 2 (1965), 296 ff., and *The Red-Figured Vases of Lucania, Campania, and Sicily* (Oxford, 1967), pp. 652 ff.; Arias and Hirmer, pl. L1; L. B. Brea, *Musei e Monumenti in Sicilia* (Novara, 1958), p. 83 (in color). Other examples are the Amazonomachy on an amphora from Pantikapaion in Leningrad (Rumpf, pl. 47, 4), and a krater from Bari (*ibid.*, pl. 47, 7). Cf. D. Rosand, "Palma Giovane and Venetian Mannerism," Ph.D. diss., Columbia University, 1965, pp. 39 ff.

10. V. Bruno, "Greek Antecedents of the Pompeian First Style," *AJA*, 73 (1969), 305 ff. This is a system of decoration in which a plaster imitation of stone masonry is achieved by executing drafted-margin blocks and other three-dimensional stone elements in plaster reliefs. Figurative decoration in Greek examples is usually confined to the raised stringcourse separating the orthostats from the upper zones of the wall.

Conversely, the thinner and the more watery the stroke, the more the dark background shows through and the more those portions of the strokes that are transparent tend to recede.[11] By means of this one variation—a variation in the thickness of pigment in the brushstroke—we are able to follow the precise direction in and out of depth of each petal, stem, and leaf in the design. In plate 16a, for example, the petal closest to us has the thickest paint. A petal going into depth starts out thickly, then gradually becomes thin and transparent as it bends away from us, and finally seems to turn toward us again where there is a thicker accent. Wherever the petals seem to come forward in space there is the addition of a thicker, more opaque stroke. The illusion of form depends upon a double law of three-dimensional representation in painting which all artists learn in school: brightness and opaqueness advance; dullness and transparency recede. Although the two states are interconnected, neither by itself would work as well. A brushstroke that is opaque will automatically be brighter than one that is transparent and that allows the dark background to show through. But if, for example, we were to imitate these exact tones by mixing them on a palette, applying them to a white surface, the effect of receding and advancing forms would be nowhere as successful, for in that case the elements of transparency and opaqueness will have been eliminated. A contrast between transparency and opaqueness is essential to the illusion of depth that we are able to produce with pigments on a flat surface. For this reason, artists interested in illusionism and space invariably prepare the painting surface with a darkish tone. The canvases of Titian and Rembrandt, for example, are always underpainted in dark red, gray, or brown. In the painting of the Flagellation of Christ in the Borghese Gallery sometimes assigned to Titian,[12] the canvas is painted black and the figure is executed almost entirely in white monochrome, the forms built up by the increasing opaqueness of the highlights as they move in and out of space.

If we now return to the uninscribed stele (plate 3), we see that the finesse of the whole performance depends on this knowledge of opaqueness and transparency. The artist is able to distinguish between direct highlights at the tops of the forms closest to the eye and the reflected lights within shadow areas, farther away from the eye. This distinction, as subtle as it is effective, could not have been achieved by ordinary *skiagraphia*. The highlights are thick touches of impasto, but the reflected lights in the shadows, such as the flicker of light along the side of the face, result from an underpainted flesh tone allowed to show through between the darker strokes of the shading. They have the effect of a light transparency that keeps its place in depth because it is transparent, in contrast to the opaque highlights on the high part of the form.

Thus, the knowledge and technique of the monochromist, which allows the artist of the floral frieze from Delos to accent forms with opaque touches of white, is an essential part of "painterly" chiaroscuro. In the painterly method, opaque highlights contrasted with transparent shadows, full of reflections, become the main instrument of showing form. Under these circumstances, outlines dissolve

11. This probably explains Pliny's surprise over the fact that Pausias painted a black bull without white highlights, yet managed to suggest the whole length of the animal's body in depth (*NH*, XXXV, 126 f.); cf. O. Brendel, "Immolatio Boum," *RM* (1930), 217.

12. According to Rosand, probably a school piece.

altogether. The lighting becomes so powerful that we forget about the contours. One is aware only of lighted masses in depth. It is easy to see how someone working in this manner would become involved in a controversy with an artist like Parrhasios, whose fame was based on skill in rendering form through contours; and nothing would seem more natural than that Zeuxis, in the course of perfecting his revolutionary method of rendering dark and light, should experiment with painting monochromes in white. The note in Pliny to the effect that he did so seems highly significant, therefore, if, on the basis of the art-historical context, his phrase is read as signifying "white on dark" rather than the opposite. In my opinion, if the phrase is read to mean "dark on white," as has been suggested, the matter is rendered completely incomprehensible. Read correctly, however, three major facts concerning the art of Zeuxis in the ancient sources emerge as interrelated and symptomatic aspects of his career: his fame as the main architect of a highly developed painterly system of chiaroscuro (Quintilian); his use of monochrome in a manner that trained his hand in the rendering of highlights by means of an opaque and painterly impasto (Pliny); and his skill in the handling of illusionistic effects of tone and texture of the kind that are obtainable only by means of scumbling and other procedures associated with a painterly style (Lucian). And when we read the glowing ancient account of the linear style of Zeuxis's equally famous rival Parrhasios, it seems obvious that the basic contrast between the works of these two masters was destined to provide a foundation for controversy, a controversy between painterly and linear methods that soon became irrevocably established as one of the main realities of the art-historical process in many subsequent periods of history.

PART II

COLOR

4

Greek Color Sensitivity

Statements on color in the writings of ancient Greek and Latin authors raise notorious difficulties of interpretation. Most of these difficulties have to do with the naming of colors, a process which in all periods and in all languages is never easy to analyze. Naming a color involves the summing up of a sequence of many and varied sensory experiences. Modern psychology has shown that there is hardly any abstraction more difficult to form than the selection of a color name appropriate to a series of purely sensory experiences that must seem in some way related. Kurt Goldstein's "Color Sorting Test"[1] is intended to reveal the inability of persons suffering from brain damage or from certain forms of mental illness to assume what Goldstein calls "the abstract attitude." It would seem that the ability to form abstractions and to behave in a manner that involves the concept of a procedure as something separate from individual sensory experiences can be easily upset—and even eradicated entirely—by certain forms of brain injury and disease, especially those conditions resulting in damage to the cortex of the brain. Patients suffering in these ways seem to develop intricate means of concealing their symptoms, but the color test devised by Goldstein and his colleagues quickly reveals their condition. The patient is presented with about eighty skeins of wool which differ in hue and brightness sufficiently so that each basic color of the spectrum is represented in at least ten different shades. The patient suffering from certain kinds of brain damage is unable to pick out all the reds, for example, or to select a group of skeins according to some principle of color. If asked to name the color of a specific skein, the patient will be able to produce a color name only with the greatest difficulty, preferring to say, "that is strawberry colored," or "cherry colored," rather than to form the ultimate abstraction by calling it by its generic color name, red.

Because the naming of colors can be both difficult and controversial, the attempt to understand ancient pronouncements on color on the basis of our own experience of nature proves to be an extremely complex task. More than once

1. K. Goldstein, in *Language and Language Disturbances* (New York, 1948), pp. 167 ff. Cf. Goldstein's article, "The Effect of Brain Damage on the Personality," *Psychiatry*, 15, 3 (1952), 245 ff. (I wish to thank Dr. Carole Campana for suggesting this reference.)

such attempts seem to have resulted in the conclusion on the part of modern scholars that the ancient Greeks were somehow deficient in color perception or color sensitivity. Maurice Platnauer, in an often-quoted article entitled "Greek Colour-Perception," after discussing the various contradictory color descriptions to be found in ancient writings, came very near to proving to himself that the Greeks were actually color blind.[2] He concluded instead

that colors made a much less vivid impression upon their senses (which might account for their painting of statues); or . . . that they felt little interest in the qualitative differences of decomposed and partially absorbed light.[3]

This is simply an elaborate way of saying that the Greeks did not notice or enjoy the experience of color, and that when they did notice it, astonishingly enough, they seem to show what can only be described, according to Platnauer, as bad taste. Platnauer's conclusions have more recently been re-echoed by Harold Osborne,[4] who reinforces them with additional proofs—passages drawn from ancient writers, passages designed to illustrate the insensitivity of the Greeks to the delights of color. In Osborne's work, the theory of Greek insensitivity to color is carried even further, however. In this version, the ancient Greeks are accused of a definite lack of appreciation of or interest specifically in color hues, as against other qualities of color such as intensity: "I am unable to recollect any passage [in ancient literature] betraying specific appreciation of color," writes Osborne, "except in the sense of brilliance or brightness." His conclusion is that the Greeks were "not given to careful discrimination of color hue" and, indeed, that there is little evidence that they gave any attention whatever to hues, "except possibly within the violet-purple band."[5]

Osborne himself seems to dislike the colors of the violet-purple band—or, at any rate, to feel that persons who prefer them to the other colors must be in need of special psychiatric care—for at the beginning of his discussion (page 274) he writes: "To our seeming there is something odd about the color responses of a people who . . . admired purple beyond all other colors. Such indications at any rate provide a motive for looking further [for abnormalities]." It may be true that the Greeks admired purple in certain contexts, but a glance at the extant monuments will show that they did not use it to any great extent in their architectural schemes and decorations. Of all the colors in the spectrum, purple alone does not appear as a color in wall decorations until fairly late in Hellenistic art. It makes its appearance in the second century B.C. as a prominent color in the so-called first style of Romano-Campanian painting, but even then it does not dominate the other hues. Purple, however, was a status symbol—especially in clothing —perhaps because the pigment was associated with the idea of Oriental court life and luxury; therefore, references to purple in the literary tradition are common.

2. M. Platnauer, "Greek Colour-Perception," *CQ*, 15 (1921), 153–162. More recent works on this topic are A. Kober, "The Use of Color Terms in the Greek Poets," Ph.D. diss., Columbia University, 1932 (extracts from this dissertation were published in Kober's "Some Remarks on Color in Greek Poetry," *CW*, 37 [1934], 189–191); D. C. Young, "The Greeks' Colour Sense," *Review of the Society for Hellenic Travel*, 4 (1964), 42 ff.

3. Platnauer, 162.

4. H. Osborne, "Color Concepts of the Ancient Greeks," *British Journal of Aesthetics*, 8, 3 (July, 1968), 269 ff.

5. Osborne, 278, 283.

But it was not one of the colors employed decoratively either in architecture or in painting of the classical period, and those who consider it the most admired color among the Greeks are probably deceiving themselves.

If one accepts the arguments of Osborne and Platnauer, one would be forced to conclude that the Greeks were inferior to us in color perception and appreciation, and the alleged color deficiency of the Greeks follows as a logical assumption. This would be the same as saying that the Greeks as a race suffered from some form of brain damage or physical deficiency—a completely unacceptable approach. In other words, something must be wrong with the way modern critics have interpreted the ancient literary tradition on color.

Goldstein's experiments make us realize how difficult it may be to classify colors, to find words that correspond to the different qualities of colors. A path may be found to a better understanding of the matter by re-evaluating not only the words employed to describe experiences of color, but the special context in which each color term appears. Even among physical scientists, there has been a controversy over the naming and ordering of colors in the spectrum ever since the discoveries of Sir Isaac Newton. Newton systematized the colors of the spectrum by separating the brightest, or what he called "simple," colors from "compounded" or "intermediate" colors. This is a matter which will interest us later in another context, when we discuss the concept of "primary" colors in classical antiquity. Using "brightness" as his gauge, Newton counted seven simple or "primary" colors: red, orange, yellow, green, blue, indigo, and violet. But, as his critics later pointed out, the spectrum itself is in fact a continuous gradation of colors blending into one another, and a selection and naming of individual hues within that continuum may be made in accordance with a variety of color principles. There are no steps in the spectrum physically corresponding to the different colors.[6] A prism-shaped glass collects and separates the rays within a beam of light and reflects each type of ray to a different place on the screen, forming a spectrum. Between the shortest and the longest rays, the red and the violet, there is an unbroken gradation of hues blending into one another. The number of distinguishable hues, and the rule by which some are named "primary" and others "compound" or "secondary," may vary according to the interpretation. For Newton, the primary colors were the brightest and purest. But even according to this standard, there can be controversy over the number and names of colors one may list. Some people with good color vision, for example, do not make any distinction between blue and indigo and hence do not include blue among the primaries.

Another difficulty arises from the fact that different names may be applied to the same color under different circumstances because of various cultural or poetic traditions. We call wine red although it may more often look dark purple, and the grapes from which the wine is made, which may be in fact a dark blue or indigo color, are called purple or black, but never blue or indigo. There are, indeed, special difficulties in naming the colors in the blue-to-indigo band.

6. E. N. Da Costa Andrade, in *Encyclopaedia Britannica*, 14th ed., VI, 53. Newton employed the image of a spectrum reflected from a glass prism as a means of measuring the colored light rays making up a ray of "white" light. In a letter dated February, 1672, he tells the story of how he stumbled upon this doscovery while grinding glass lenses for telescopes (*Isaac Newton: opera que extant omnia*, IV [London, 1783], 295 ff.).

Bearing in mind the various kinds of difficulties that may beset us in our discussions of color even under laboratory conditions, let us now return to the problem of the alleged color blindness of the Greeks.

When we confront the views of Platnauer and Osborne with the accumulated archaeological facts demonstrating the use of color in the Greek world, it becomes obvious that any question of whether or not the Greeks were lacking in the ability to discriminate and appreciate hues arises solely from linguistic problems. The archaeological evidence proves that the Greeks lived in a world that continually surrounded them with man-made color differentiations, some subtle, some bold, and often with differentiations of hue which held special meanings. In archaic art, for example, each part of an architectural decoration was given its own special color; each part of a pictorial representation received a hue which was deemed appropriate to it. Thus the sculptured frieze of the Treasury of the Siphnians at Delphi shows four distinctive shades of red, each one employed consistently throughout the frieze for different objects, one for hair, one for the insides of shields, one for the reins of horses, and so on.[7] Such conscious discrimination of color hues amounts to a *de facto* demonstration of Goldstein's "abstract attitude": it presupposes the ability to rationalize and select hues of color according to an ordering principle. Assuming that Goldstein's findings are correct, if the Greeks could not perform these discriminatory functions regarding color hues, they would have been unable to function in their environment. Still less would they have been able to create that environment. While it cannot be denied that the literary tradition offers puzzling contradictions over questions of naming and describing colors, it would hardly be possible to explain these contradictions by relating them to a hypothetical physical or psychological handicap, such as an inability to make distinctions of hue or an insensitivity to colors.

It should be remembered that much of the evidence compiled by Platnauer and Osborne is drawn from poetry and tragedy. It is true that in these areas of literature, color names often seem to contradict the obvious. The same word is employed, we are told by Platnauer, for darkened blood and for a cloud, for the glint on metal and for a tree, and this is supposed to convince us that the Greeks were confused by experiences of color. But a statistical analysis of color names in poetry is bound to be misleading: if the cloud is a dark and threatening storm cloud on a lonely sea, or if the tree is an olive tree silvered by the light of early dawn, the suggestion of an unexpected color in the poetic context only heightens the exactness of the image. Out of context the color name per se seems nonsensical or contradictory, to be sure.

Archaeology confirms, of course, some of the worst fears of Platnauer-Osborne theorists: the Greeks, for example, undoubtedly painted statues, and they seem to have taken rather more pleasure in the sheer brightness of certain colors than some of us do today. At any rate, they made much use of pure, bright colors in decorating their architectural surroundings. A statistical analysis of the colors employed in wall decorations in the houses of an important Greek town of

7. *Fouilles de Delphes*, IV, fasc. II; C. Picard and P. de la Coste-Messelière, *Art archaïque: les trésors ioniques* (Paris, 1928), pp. 93, 108.

the classical period, Olynthus,[8] shows that an overwhelming majority of the rooms were painted in fully saturated shades of red and yellow, often set off by zones of black or by rich textures. If a similar tabulation were to be made in a modern city, in Britain or the United States, it seems reasonably certain that the outcome would be very different. There would be a greater use of the so-called pastel shades, a far greater use of white, and few in number would be the walls painted in the brightest red. It is hardly likely, however, that an impartial judge would declare our modern cities to show a greater appreciation of color than the cities of ancient Greece. The difference is one of taste, not one of the degree of sensitivity to color.

The linguistic difficulties that arise from the naming of colors in ancient literature do, of course, constitute a serious problem for art-historical research on color in ancient Greek painting. A prejudiced view in regard to Greek color perception is not likely to answer these questions, however. Problems of linguistics, in an art-historical context, are problems of detail.[9] As we proceed with the analysis and description of the data before us, uncertainties of interpretation over the naming of colors, though they will occur frequently, must not be construed as the symptoms of a presumed pathological condition of general validity. Rather, each case of confusing or contradictory color description ought to be viewed as a separate problem of detail, to be taken up within its own special context. Seemingly contradictory color descriptions in ancient writings may have arisen for a variety of reasons: faulty translation, incorrect transcription of ancient manuscripts, or mistaken interpretations. A great number of these individual cases exist not only in poetry, but in scientific writings, and many of them are relevant, as we shall see, to discussions of the art-historical problems of ancient painting. But the theory that the Greeks were less sensitive to color than modern man is obviously erroneous. As we turn our attention to the major problems surrounding the use of color by classical painters, we must set aside all such views and proceed upon the assumption that while the symbolism of color may vary for different people at different times, the perception of color and the behavior of color mixtures on the artist's palette was essentially the same for ancient masters as it is for artists today.

8. D. M. Robinson, *Excavations at Olynthus*, VIII (Baltimore, 1938), 301 ff. Olynthus became an important center in the last third of the fifth century B.C., when it assumed the role of the capital city of the Chalcidian League. It was destroyed by the Macedonians in 348 B.C. Most of the wall decorations analyzed and tabulated in the statistical survey on page 301 of volume VIII of the excavation reports may be dated to the end of the fifth and the first half of the fourth centuries B.C.

9. Individual cases are discussed in detail (see ch. 10). Greek names for colors are listed in J. H. Heinrich Schmidt, *Synonymik der griechischen Sprache*, III (Leipzig, 1879), 1–54. On colors used in Greek painting, see G. Lippold, in *RE*, 14, 1, 892–894; P. Zancani Montuoro, in *EAA*, II, 770 ff.

5

⌒⌒⌒

The Four-Color Palette
of the Greeks

Fundamental to any discussion of the use of color in ancient Greek painting is the concept of a restricted palette. In fifth-century-B.C. art and literature, the artist's means of expression seem to have been governed by a rule of absolute simplicity. But in the art of painting we have concrete evidence of this, for we are told by a number of ancient writers that among the famous painters of classical Greece there were certain masters who gained special recognition for having adopted a method of painting limited to the use of only four basic colors.

Explicit statements to this effect are made in the writings of two Roman authors, Cicero and Pliny the Elder, each one quoting from older sources. Pliny goes so far as to name the colors employed by artists working in accordance with the four-color limitation: white, yellow, red, and black.[1] Moreover, from the context of their remarks, both Pliny and Cicero make it very clear that ancient critics considered the tradition of the four-color palette to be one of the most significant aspects of the history of Greek painting. Indeed, for Cicero, the adherence to a four-color principle was an art-historical fact that he felt obliged to include in even the shortest sketch of the history of Greek art.[2]

Although the four-color palette was a matter of crucial importance in the history of ancient art, we are faced with a number of perplexing difficulties in interpreting ancient descriptions of this phenomenon. How did the ancient masters respond to color in the context of a limited palette? Who were these artists? What was the date of the earliest use of the four-color scheme? The ancient sources give us seemingly contradictory information on these questions. Indeed, even the list of colors as it appears in Pliny must be regarded as uncertain,

1. Pliny, *NH*, XXXV, 50: "Quattuor coloribus solis immortalia ills opera fecere—ex albis Melino, e silaciis Attico, ex rubris Sinopide Pontica, ex nigris atramento—Apelles, Aetion, Melanthius, Nicomachus, clarissimi pictores, cum tabulae eorum singulae oppidorum venirent opibus."

2. Cicero, *Brutus*, 18, 70: "similis in pictura ration est, in quam Zeuxim et Polygnotum et Timanthem, et eorum qui non sunt usi plus quam quattuor coloribus, formas et lineamenta laudamus; at in Aetione, Nicomacho, Protogene, Apelle iam perfecta sunt omnia."

as we shall see, and the disagreements contained in the ancient literary tradition naturally cast doubts on all attempts to reach workable conclusions concerning the actual function of the four-color palette in the hands of classical painters. Yet, when we consider the appearance of the painted form in our more recently discovered examples of Greek painting, such as the figures of the Petsas tomb at Lefkadia, many of the difficulties encountered in the past may begin to strike us as more apparent than real; for as we learn more about the realities of ancient color in the greatly increased variety of available fragments, it becomes evident that classical Greek methods of rendering form present few mysteries and must have varied but slightly from our own. Thus, the task before us involves a thorough re-examination of the four-color problem, to be undertaken in the light of this new evidence.

We must bear in mind that authors like Pliny and Cicero were anything but experts on the technical aspects of painting. Their statements on color were evidently quotations from treatises written by practicing artists.[3] At the outset, therefore, one must be prepared for the likelihood that many of the details concerning technical color problems, as they were recorded by the artists of an earlier age, might have proved less than perfectly understandable to writers of the Roman period.

It is easy to imagine that the later authors of antiquity would be capable of making serious omissions and other distortions in the course of selecting short passages from a body of technical material, some of it dating back to the very dawn of history. This would be particularly so for a writer like Cicero, who quotes details from the history of art only in order to illustrate a point he wishes to emphasize in connection with an entirely different topic, the history of oratory. Because of the varied literary purposes each of them may have had in quoting from earlier treatises, the comparison of statements by Pliny and Cicero on a matter as technical as the four-color palette is quite likely to create controversy where none may have existed in the minds of the ancients themselves. And, of course, this is exactly what happens.

In beginning our re-examination of the literature on the four-color palette, let us consider the general significance of color limitation to a certain number of colors—in this case, four. In ancient thought as in modern thought, a restriction to three or four colors to be used on an artist's palette suggests the idea of a set of what artists today call primary colors. *Primary*, in the context of the artist's palette, implies that we deal with a set of basic colors by means of which all the innumerable variations of color and tone in nature can be obtained by a process of mixing and blending. Today, in the physical sciences, *primary* refers to the behavior of rays of colored light in the spectrum. A "primary" color, whether in the form of a ray of light projected on a screen or in the form of a pigment on an artist's palette, is a color that cannot be obtained by mixing other colors. Primary colors are thus in a very special category. They exist apart from and in contrast to secondary colors, which may be obtained by means of mixing the primaries.

3. The justification for assuming that Greek technical writings on art were known to Latin authors like Pliny and Cicero are summarized by O. Brendel, "Prolegomena to a Book on Roman Art," *MAAR*, 21 (1953), 53, n. 109. The basic study is that of B. Schweitzer, *Xenocrates von Athen* (Königsberg, 1932). Cf. Pollitt, *Sources*, pp. xi ff., xvii ff.; the most detailed analysis in English is that of E. Sellers in Sellers, Introduction, *passim*.

For pigments, the behavior of colors with respect to the law of primaries is today most often illustrated with reference to the six brightest colors: red, orange, yellow, green, blue, and purple. The primary colors are red, yellow, and blue; red and yellow mixed together make orange; red and blue mixed together make purple; blue and yellow mixed together make green. These results are absolutely dependable and easily verifiable; there is no way to change them. Newton must have been aware of all this, for when he made the series of discoveries that led to the modern scientific analysis of light, he described the light rays of the spectrum in such a way that he created an analogy with pigments, although it was clear to him from the start that the actual behavior of different light rays in combination with each other did not at all parallel the behavior of pigments. Nevertheless, from Newton on, the scientific approach to the analysis of the spectrum has depended on the analogy with the behavior of pigments, for light rays have continued to be separated into groups according to an analogous system of classification. In his first treatise on color, Newton recorded that different color light rays in the spectrum could be mixed with other rays to make colors different from either component, "as you see blue and yellow powders, when finely mixed, appear to the eye green."[4] Newton concluded that there were two sorts of colors in light as there are in pigments—the one, "original and simple"; the others, compounded of these. Thus he listed the colors of the spectrum under two separate headings: simple and compound colors. In more recent discussions, the terms *primary* and *secondary* have often replaced Newton's terms *simple* and *compound*.

Newton's critics in later periods have had many occasions to point out that light rays behave differently in combination with each other than do pigments, and that the analogy with the behavior of pigments and the division into the categories of primary and secondary colors has proven to be somewhat cumbersome for some aspects of the physical scientist's approach to the study of light and color. Indeed, Newton had trouble with it himself. Newton at first regarded all the brightest colors of the spectrum as primary: red, orange, yellow, green, blue, indigo, and violet. At that point in his research Newton thought of the compound colors as those hues intermediate between two of the purest and brightest hues. As experiments continued and the matter was further studied, the number of primaries was eventually reduced to three, but they are quite different from the three colors considered primary in painting. The general consensus among modern physicists is that red, green, and violet may be considered "primary" with respect to the mixing of light rays on a white screen. It seems, for example, that when blue and yellow light rays are mixed, the result may be either white or pink, but not green, as in the case of pigments. For pigments, however, there has never been any possibility for confusion. Only red, yellow, and blue are simple and primary in the sense that they are unobtainable by mixing other pigments. This law holds true for ancient as well as for modern pigments as I have myself ascertained by experimenting with some lumps of pigment from Corinth dating from the second century B.C.[5] Since that is true, the modern student is left in a

4. *Isaac Newton: opera que extant omnia*, IV (London, 1782), 302.

5. M. Farnsworth, "Ancient Pigments: Particularly Second Century B.C. Pigments from Corinth," *Journal of Chemical Education*, 28 (1951), 72–76. Cf. Farnsworth's article "Second Century B.C. Rose Madder from Corinth and Athens," *AJA*, 55 (1951), 236 ff.

quandary, for if the four-color palette of the ancient Greeks is to be understood as basically a palette of primaries, why does the list of its several colors, as it is preserved in Pliny, omit blue, substituting black as the only complement of red and yellow. If we substitute black for blue, the whole system of primaries breaks down. Without blue, all the colors of the purple band normally obtained by mixing blue and red must also disappear; likewise all the greens that can only be obtained by mixing blue and yellow are also left out. Omitting blue means in effect that one has omitted the entire range of cool colors, from green through blue to purple, so that the palette is left solely with the capability of producing colors in the warm-color range, from red through orange to yellow. So drastic are the results of omitting blue that we may wonder if there is not some error in the assumption that the four-color palette should be considered as a palette of primary colors in the modern sense. Perhaps some other principle applies to it. But there is ample evidence among our fragments that the ancient artist was indeed familiar with the handling of red, yellow, and blue as complements to produce the intermediary hues of orange, green, and purple. And the ancients themselves, in the writings that survive, create the clear impression that the four-color palette was expected to function as a palette of primaries in the modern sense of the term.

Classical antiquity was familiar with the concept of four basic colors in a variety of contexts. Four colors in ancient times were related with four elements, the four seasons, and the four directions in the heavens, and such tetrads, in what appears to have been a Mesopotamian tradition, were often linked also with four of the planets. In the context of Eastern religions, four basic colors are designated for use in the tabernacle: blue, purple, carmine red, and white.[6] In all these traditions involving a system of four color coordinates in antiquity, blue appears to be an essential color, so that its omission from the list of the artist's primaries must strike us from the outset as something not only impractical, but strange. It is, at the very least, a fact that requires a detailed explanation.

References to a palette restricted to four primary colors begin in Greek literature in the metaphysical poetry of Empedocles[7] and Democritus,[8] both writing in the mid-fifth century B.C. They arise in connection with the physical theories of the atomists, the so-called pluralists of the pre-Socratic school. For these early scientists there were four primary elements analagous to the four primary colors of the artist. From four basic elements, all the varied phenomena of the natural universe were believed to be derived by a process of mixing, as with colors. Empedocles, the earlier of the two writers and a very near contemporary of the painter Polygnotos, was evidently the first to draw the analogy between physical

6. G. Scholem, "Farben und ihre Symbolik in der judischer Überlieferung und Mystik," *Eranos Jahrbuch*, 41 (1972), 1–48. (I wish to thank Brunhilde Ridgeway for suggesting this reference.)

7. H. Diels and W. Kranz, *Die Fragmente der Vorsokratiker* (Berlin, 1903), A92; R. K. Sprague, ed., *The Older Sophists* (Columbia, S.C., 1972), contains English translations of all the pre-Socratic fragments contained in the original Diels-Kranz edition; E. Bignone, *Empedocle* (Turin, 1916; rpt., Rome, 1963), pp. 416 f., frag. 23 (for a discussion of the passage and bibliography see pp. 154 ff.). Cf. M. C. Nahm, *Selections from Early Greek Philosophy* (New York, 1964), p. 132, Empedocles frag. 121. Better than Nahm for the nonspecialist in ancient philosophy is G. S. Kirk and F. E. Raven, *The Pre-Socratic Philosophers* (Cambridge, Eng., 1957), pp. 320 ff. for Empedocles.

8. Democritus, quoted by Theophrastus, *De Sensu et Sensibilibus*, 73; cf. Nahm, pp. 200 f.; Kirk and Raven, pp. 400 ff.

elements and the colors of the palette. Four elements,[9] whose atoms or particles of matter, separated by hate and attracted by love, combine to form all the creatures and things of the universe, are compared to the four basic colors of the artist, who produces all the many tones in nature by mixing these simple colors. Empedocles, in the few writings of his that survive, did not actually specify that the painter used only four colors, but Aëtius,[10] writing in the first or second century A.D., and Stobaeus,[11] writing in the fifth century A.D., separately state that Empedocles looked upon four colors as primary, corresponding to the atomists' four basic elements.[12] Since the correspondence of four elements and four primary colors is repeated by Democritus, we may assume that there was in existence a philosophical background for the notion of four primary colors as a condition of nature, and this at approximately the time when, according to one ancient explanation,[13] the four-color palette first came into use among Greek artists.[14] Although there are textual problems and difficulties of interpretation regarding the sources for our knowledge of both Empedocles and Democritus,[15] there can be very little doubt that the first explicit statement concerning a set of four primary colors belongs, in Greek thought, to the period of early classicism. The question of date hinges upon the reliability of Theophrastus as a transcriber

9. The names of the elements may vary. For Empedocles they are earth, fire, air, and water (Kirk and Raven, pp. 326 ff.). In pre-Socratic thought, the faculty of perception is composed of material elements. The soul perceives compounds (flesh, bone, man, etc.) because it contains the principle of harmony or proportion—in other words, mixture. Cf. A.-E. Chaignet, *Histoire de la psychologie grecs* (Brussels, 1966), I, 85.

10. Aëtius, *Placita*, I, 15, 3. Cf. H. Diels, *Doxographi Graeci* (Munich, 1879), p. 313.

11. Stobaeus, *Eclogarum physicarum et ethicarum*, I, 16. Cf. Diels, p. 181.

12. Cf. J. I. Beare, *Greek Theories of Elementary Cognition* (Oxford, 1906), pp. 14 f. Empedocles himself, in the writings that survive, does not explain the characteristics of specific colors in detail except for white and black, and these he seems to regard not as colors but rather as light and dark. However, Democritus developed the four-color theory in detail, and some ancient sources (e.g., Stobaeus and the *Placita Philosophorum*) ascribe the four colors also to the earlier writer, Empedocles. This ascription of the four-color theory to Empedocles by certain ancient authorities has been regarded as an error by modern scholars (e.g., Diels, p. 222). Yet it seems natural that Empedocles would have conceived of the four-color principle as part of his thought on perception. In fragment 71, Empedocles states that colors (like everything else) are produced by mixtures of the four elements. At the same time he was certainly aware that in painting artists were discovering the process of mixing a few basic colors to obtain other hues and gradations of light and dark. Hence his analogy between combinations of elements and combinations of colors, blended by love on the one hand and by "proportion" on the other to achieve variety.

13. Cicero begins his list of four-color artists with Polygnotos. Pliny, *NH*, XXXV, 58, places Polygnotos "before the 90th Olympiad," which took place in 420–417 B.C. But Pliny's system of dating involves difficulties, and there is reason to believe that Polygnotos's career occurred several decades earlier. Cf. C. Robert, "Archaeologische Märchen aus alter and neuer Zeit," in *Philologische Untersuchungen*, 10 (Berlin, 1866), 66 f.; Sellers, p. 105, n. to paragraph 60. Swindler, pp. 197 ff., compares the drapery style of Polygnotos, as it is described in Lucian (*Imag.* 7), to vase paintings of 470–450 B.C. Most scholars place Polygnotos's career mainly between the end of the Persian Wars and the building of the Parthenon. For additional bibliography see Rumpf, 91–103, nn.; E. Simon, "Polygnotan Painting and the Niobid Painter," *AJA*, 67 (1963), 43 ff.

14. This explanation is upheld by L. Kranz, "Gleichnis und Vergleich in der Fruh griechischen Philosophie," *Hermes*, 73 (1938), 99 ff.

15. It has been assumed by Diels and other modern scholars that none of the later doxographers in whose writings the thoughts of Empedocles and Democritus are preserved had access to original sources, as did Theophrastus. The three most important remnants of the writings of Empedocles are contained in Diogenes Laertius's *Lives of the Philosophers*, in John Stobaeus's *Eclogues*, and in the *Placita Philosophorum*. Diels traces all of these back to the eighteen books of Theophrastus of which *De Sensu et Sensibilibus* is essentially all that has survived. Cf. W. Veazie, *Empedocles' Psychological Doctrine*, Archives of Philosophy, no. 14, ed. F. E. Woodbridge (1922), 18.

of pre-Socratic thought, for it is now generally believed that Theophrastus was the main source for the later doxographers.[16] As head of the Peripatetic school and successor to Aristotle, Theophrastus no doubt had as complete a knowledge of fifth-century-B.C. literature as it was possible to obtain in fourth-century Athens. Although his value in transmitting the metaphysical doctrines of the pre-Socratics may be limited, as C. H. Kahn has emphasized,[17] it is difficult to imagine that Theophrastus would deliberately invent elaborate details, such as a list of the primary colors, and then attribute this invention to an earlier writer. It seems justified to postulate, therefore, that in the field of metaphysical poetry, the doctrine of the four colors, on the evidence of Theophrastus, is at any rate attributable to Democritus and perhaps to the predecessor of Democritus, Empedocles. As part of the thought of the pre-Socratic philosphers, the concept of four basic or primary colors, in some way equivalent to the basic elements of matter, could not have failed to attract the notice of fifth-century painters. Thus, when we read in the Roman authors Cicero and Pliny statements to the effect that a four-color palette was employed by classical painters, it would seem reasonable to suppose that these statements refer to a tradition that has its roots in the mid-fifth century B.C., when Empedocles and Democritus were at the height of their careers. In the history of painting, this would correspond roughly, as we have said, to the period of Polygnotos and his circle—the period from about the end of the Persian Wars to the reign of Pericles.

If we look at the problem in the light of the analogy of Empedocles, we may see more clearly why the list of pigments Pliny named as those belonging to the ancient four-color palette seems so different from the modern list of primary colors. The ancients were at that very moment involved in the discovery of chiaroscuro, the earliest use of which could not very well predate the careers of Polygnotos and Empedocles. To our minds, the mixing of colors by an artist to produce an atmosphere of chiaroscuro is a thing that all of us take for granted. But for the ancients of the mid-fifth century B.C., such a phenomenon in painting was absolutely new. We, today, in considering a list of primary colors, may restrict our list to only the brightest complements—red, yellow, and blue—in accordance with a scientific tradition established by Newton and his followers. The ancients, however, having just invented shading, would undoubtedly have considered it necessary to add white to such a list if they were concerned about producing with the primaries all the varied and subtle tones in nature. In modern times, it never occurs to us to add white to our list or even to think of it as a "color," for in the scientific analysis of the spectrum, which provides us with our main color orientation, white is thought of not as a color but rather as the absence of color. In the ancient context, each color was thought of as the equivalent of a physical element, as one of several substances on the artist's palette that was necessary in producing an effect of the complete range of tones and colors in nature. For the ancient painters, white must have been the equivalent of light. Without white, no system of chiaroscuro would be possible; so it became a

16. C. H. Kahn, *Anaxagoras and the Origins of Greek Cosmology* (New York, 1960), pp. 18 ff. Doubts concerning the reliability of Theophrastus in this regard have been expressed by a number of authors, among them Veazie, p. 16, and G. H. Clark, "Empedocles and Anaxagoras in Aristotle's *De Anima*," Ph.D. diss., University of Pennsylvania, 1929.

17. Kahn, p. 19.

necessary part of the painters' basic equipment. The ancients, too, knew the colors of the spectrum in the form of the rainbow, as we know, but they did not hesitate to name white and black as colors in a variety of contexts. For the ancient artist, it was only recently discovered that by adding white to the standard group of colors, to a combination of red, yellow, and blue, a flesh tint could be obtained that was more natural in appearance than the flat, symbolic tones of red and white employed throughout archaic times. To mix all the innumerable variations of gray and buff that we normally see in our surroundings, where the pure, bright colors to be seen in the spectrum or the rainbow very rarely if ever occur, the ancient artist had only recently learned that white, again, is an essential ingredient. In addition, he was probably just finding out that white must be included in the process of modeling a figure in an atmosphere of light and dark. Eventually white must have been considered the equivalent of light and black the equivalent of dark. Thus in ancient terms, the palette of primary colors, if it contained all the elements necessary to allow the artist to reproduce nature, would have to have contained at least five pigments: the complements red, yellow, blue, plus white and black. In practice even the modern painter will, of course, include white and black in a palette of the primaries, though he may not actually name them. Thus, the exclusion of blue seems to contradict the whole spirit of the idea of a palette restricted to primary colors as it presents itself to our minds in the analogy of Empedocles and in practical experience. We can only surmise that there is some hidden significance in the omission of blue in Pliny's list, a significance which we have yet to comprehend and explain.

Eventually it will be necessary to form some theory or to invent some explanation for the absence of blue in the ancient list. We may decide, for example, that the absence of blue represents a curious and unexpected aesthetic choice—a kind of color abstraction on the part of a select group of artists of classical times. For the moment, however, let us set the problem of blue aside in order to examine the basis for yet another dilemma in our knowledge of the history of the restricted palette.

6

Pliny versus Cicero: An Apparent Contradiction

Pliny's four-color artists[1]—Apelles, Aetion, Melanthius, and Nicomachos—belong within the fourth century B.C. Nicomachos is the earliest of the group,[2] his career falling mainly within the first half of the century; the other three were active during the middle and latter half of the century. Aetion flourished in the 107th Olympiad, according to Pliny,[3] or ca. 395–352 B.C., but his most famous picture, the *Marriage of Alexander and Roxanne*, could not have been painted until some time after the wedding took place in the year 327 B.C.[4] Apelles, by far the most famous artist of the four, is said by Pliny to belong to the 112th Olympiad, ca. 332–329 B.C.[5] Concerning his use of color, it is perhaps most significant that among his many other accomplishments he was the inventor of a special dark varnish that softened the hues in his pictures, evidently making them somehow more convincingly naturalistic.[6] Melanthius was a contemporary of Apelles, both artists having been pupils of the same master, Pamphilos.[7]

In contrast to this, Cicero's list of four-color artists begins with Polygnotos, who belongs, as we know, to the earliest part of the classical period—in fact mainly to the period of the so-called severe style, before the middle of the fifth

1. Pliny, *NH*, XXXV, 50.
2. Rumpf, 146; *idem*, in Thieme-Becker, XXV, 477; Pfuhl, p. 755; Pliny, *NH*, XXXV, 109.
3. Pliny, *NH*, XXXV, 78.
4. Pfuhl, p. 771; L. Curtius, *Zur Aldobrandinischen Hochzeit, Vermachnis der antiken Kunst* (Heidelberg, 1950), pp. 119 ff.; Rumpf, 147 f.
5. Pliny, *NH*, XXXV, 79. Cf. Rumpf, 147; B. Sauer, in Thieme-Becker, II, 23 ff.
6. Pliny, *NH*, XXXV, 97; see Appendix. Cf. P. Mingazzini, "Una copia dell'Alexandros Keraunophoros di Apelle," *Jahrbuch der Berliner Museen*, 3 (1961), 7 ff.
7. Pliny, *NH*, XXXV, 76; Lucian, *Herodotus or Aëtion*, 4–6.

century B.C.[8] The list continues with the names of Zeuxis and Timanthes, neither of whom appear in Pliny's group; and while the activities of Zeuxis and Timanthes may extend, perhaps, into the early part of the fourth century B.C.,[9] there is hardly any doubt that they belong to a generation that precedes that of Nicomachos, the earliest of the four-color artists named by Pliny. These, then, are the given facts as far as ancient literature preserves them. The question is: How can we reconcile them to each other?

Pliny's account of the four-color artists makes no mention of the earlier group of masters. If we had only the information recorded in Pliny's seemingly exhaustive encyclopedia of ancient knowledge, it would be necessary to conclude that the four-color phenomenon was not a characteristic of the beginning of the classical revolution but that it belonged to its later stages. On the other hand, Cicero's account, in which the four-color palette begins with Polygnotos, accords better with what we have observed to be the logical point in Greek aesthetic history for the origin of the concept of a limited palette, as we find the notion mentioned and described in the writings of the pre-Socratic philosophers Empedocles and Democritus, both of whom emphasized an analagous relationship between primary colors and primary elements.

The contradiction in dating between Pliny's account of the four-color palette and that given by Cicero would be serious enough, but the dilemma becomes even more difficult to resolve when one ponders the statement by which Cicero closes his brief discourse on the history of art. His final remark has most often been taken to mean that the use of a four-color palette did not in fact continue into the fourth century at all, as stated by Pliny.

To clarify the matter, let us examine Cicero's statement more closely. The text of his brief sketch of the history of art is as follows:

What critic who devotes his attention to the lesser arts does not recognize that the statues of Canachus are too rigid to reproduce the truth of nature? The statues of Calamis again are still hard, and yet more lifelike than those of Canachus. Even Myron has not fully attained naturalness, though one would not hesitate to call his works beautiful. Still more beautiful are the statues of Polyclitus, and indeed, in my estimation, quite perfect. The same development may be seen in painting. In Zeuxis, Polygnotos, Timanthes and others, who used only four colors, we praise their outline and drawing: but in Aetion, Nicomachus, Protogenes, Apelles, everything has been brought to perfection.

8. Cicero, *Brutus*, 70: "Quis enim eorum qui haec minora animadvertunt non intellegit Canachi signa rigidiora esse quam ut imitentur veritatem? Calamidis dura illa quidem, sed tamen molliora quam Canachi; nondum Myronis satis ad vertitatem adducta, iam tamen qua non dubites pulchra dicere; pulchriora etiam Polycliti et iam plane perfecta, ut mihi quidem uidere solent? Similis in pictura est; in qua Zeuxim et Polygnotum et Timanthem et eorum qui non sunt usi plus quam quattuor coloribus formas et lineamenta laudamus; at in Aetione, Nicomacho, Protogene, Apelle iam perfecta sunt omnia." (Loeb ed., trans. G. L. Hendrickson [Cambridge, Mass., and London, 1952], p. 67).

9. There are two Greek painters named Timanthes in the literary tradition, one active in the second half of the fifth century B.C. (Pliny, *NH*, 64 f., 72 f.) and another active in the middle of the third century B.C. (Plutarch, *Arat.*, 32, 3; Overbeck, p. 2102). It seems clear, then, that in linking the name Timanthes with the names of Polygnotos and Zeuxis, Cicero must be referring to the fifth-century artist. A number of ancient authors mention a famous painting by the fifth-century Timanthes, the *Sacrifice of Iphigenia* (Overbeck, pp. 1734 ff.), reflections of which have been noted, perhaps incorrectly, in Romano-Campanian works on the same theme (C. L. Rhaghianti, *Pittori di Pompeii* [Milan, 1963], p. 79). For Zeuxis's dates see Pfuhl, II, 681; Rumpf, 126 ff.; and works cited in ch. 2, n. 12.

The last phrase in Cicero's statement, "at in Aetione, Nicomacho, Protogene, Apelle iam perfecta sunt omnia," is the key to our problem. This phrase is commonly interpreted by modern translators as follows: In the work of Aetion, Nicomachos, Protogenes, and Apelles, all of them famous artists of the fourth century B.C., the art of painting was "brought to perfection." But Cicero has already attributed the four-color palette to a group of artists belonging to the fifth century B.C.—in other words, to the period of early and high classicism. Therefore, it is to be assumed that in Cicero's mind, the later group of artists were able to achieve what he calls perfection precisely because they abandoned the restriction of a limited palette. This interpretation is the main source of our difficulty.

Rackham, Pliny's translator in the Loeb edition, is so much convinced by this particular reading of the Cicero, that he is led to make the rather drastic assumption that the entire list of four-color artists in Pliny's account should be considered erroneous.[10] Opposed to Rackham are a number of authorities, for example J. J. Pollitt, who maintain that the list in Pliny is essentially correct, and that Cicero wrongly interpreted the matter under the misapprehension that the four-color palette must have been the primitive limitation of an earlier rather than a more mature stage of the development of Greek painting. Following Pliny, Pollitt would conclude that the four-color palette was somehow the invention of the more technically accomplished artists of the late classical and early Hellenistic periods, and that it should definitely not be associated with Polygnotos and the severe style.[11]

The possibility that we may reconcile the apparent contradiction between the statements in Pliny and Cicero was long ago suggested by no less an authority than Sellers. In commenting on the divergent statements in the two ancient writers, she wrote as follows:

These words [of Cicero's] do not necessarily contradict the statement of Pliny or prove that the later painters used more than four colors. The *perfecta omnia* need mean no more than that they had learnt endless combinations of the four colors, whereas the older painters used them pure or knew but of few combinations. The color effects produced by Apelles and his contemporaries being far more elaborate than anything attempted in the period of Polygnotos, it is natural that the employment of only four colors should in their case be dwelt upon with special admiration.[12]

As Sellers points out, there is nothing in the passage by Cicero that forces us to the conclusion that the second group of artists, who achieve perfection, did so by

10. H. Rackham, in Pliny, *NH*, Loeb ed., IX, 298, n. a.

11. One of Pliny's main sources for the history of art was Xenocrates, for painting as well as for sculpture, as he himself tells us (*NH*, XXV, 68). The opinion (probably due to the influence of Xenocrates) that the high point of Greek art occurs in the period of Lysippos in the late fourth century B.C. is reflected throughout Pliny's work. On this topic see Pollitt, *Sources*, pp. xi, xiv f.; Sellers, pp. xx ff. Pollitt reasons that as a practicing sculptor of the Sicyonian school in the early third century B.C., Xenocrates would have favored his immediate predecessors belonging to the same school over artists of the earlier periods or of different schools.

12. Sellers p. 96, n. to par. 50. Swindler also assumed that the four-color palette was in use from Polygnotos to the late fourth century B.C., referring to the Alexander mosaic from the House of the Faun in Pompeii, which she accepts as a copy of a late-fourth-century original by Philoxenos of Eritrea (Pliny, *NH*, XXXV, 110), and a four-color composition, executed entirely in shades derived from red, yellow, white, and black (the mosaic will be discussed in further detail in Chapter 8). At the same time, she sees Polygnotos as an artist who "made advances" in the matter of colors "and had a far richer palette than the primitives of the Sixth Century."

discontinuing a practice begun by artists in an earlier stage of the history of classicism. Sellers's observation shows that, on the contrary, this crucial passage can be understood to imply the *continuation* of the four-color palette. We may then understand that certain artists of the later period were able to achieve new success in the art of painting, not by following a more complex color system—though by then, no doubt, a more sophisticated color technology was certainly available —but rather by deliberately restricting themselves to an aesthetics of color that had characterized the work of famous predecessors.

In his most recent discussion of the four-color palette,[13] Pollitt finds it difficult to accept the suggestion that the history of the four-color palette extended all the way from Polygnotos in the early classical period to the Hellenistic age. Since the Alexander mosaic in the National Museum at Naples (see Chapter 8 for discussion and references) represents conclusive proof for the use of the four-color palette in the early third century B.C., Pollitt would discount the remark in Cicero that attributes the use of the four-color palette to Polygnotos and the masters of the high classical period, raising the objection that not every painter in the whole of classical antiquity could have been a participant in the four-color tradition. But we may see the four-color palette as a practice of long duration in Greek art without assuming that every Greek artist practiced it. As Robertson points out,[14] artists of the later period may have used the four-color harmony in some works and not in others. If we follow Sellers's interpretation of the ancient texts, keeping Cicero's list of four-color artists as well as Pliny's, we may conclude that the four-color palette was an invention of those artists, like Polygnotos, who first experimented with the problems of three-dimensional representation —transparency, calligraphic contours, and perhaps even shading. For these artists, who initiated a revolution in painting technology, a restriction of color may easily have been necessary in order to simplify experiments with form. Thus, the four-color palette, the restriction of color to certain basic tones, was a practice that for later generations of Greek artists somehow symbolized the achievements of the earliest classical masters. Under those circumstances, in late classical and Hellenistic times, individual artists might seek to remind the world of the accomplishments of their famous predecessors by imitating a characteristic consonance of color.

In considering this, it may help to remember that Cicero's remarks on painting are, after all, presented as the counterpart to what is essentially an outline of the history of sculpture. The historical theory applied to sculpture should somehow prove applicable to painting also, and since his treatment of the development of sculpture is more detailed than his account of painting, a comparison of his statements may throw some light on the precise meaning of his cryptic phrases

13. Pollitt, *Ancient View*, p. 110, n. 1. The passage in French, as translated by J. Martha (Ciceron, *Brutus*, Collection des Universités de France, 3rd ed. [Paris, 1960], p. 24), reads as follows: "Parmi les personnes qui ont des regards pour des oeuvres d'un ordre moins relève, quelle est celle qui ne se rende compte que les statues de Canachos ont trop de raideur pour reproduire la réalité vivante; que celle de Calamis, avec de la dureté, sont cepedant plus souples que celle de Canachos; que selle de Myron, si elles n'atteignent pas encore tout à fait la vérités de la nature, sont pourtant des oeuvres qu'on n'hesiterait pas à appeler belles; que plus belles encore sont les statues de Polyclète, veritables chefs-d'oeuvres, du moins à ce qu'il me semble. De même en peinture: Zeuxis, Polygnote, Timanthe et les artistes qui n'ont employ que quatre couleurs, sont cité avec éloges pour leur modèle et le trait de leur dessin, au lieu que dans Aetion, Nicomasque, Protogène, Apelle, tout déjà est parfait."
14. M. Robertson, *A History of Greek Art* (Cambridge, Mass., 1975), p. 500.

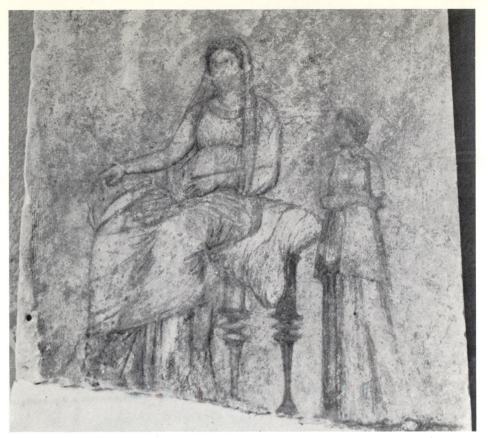

1a. Stele of Archidice (detail). Painted stele, Volos. Volos Archaeological Museum (cat. no. 20). Photograph by Alison Frantz.

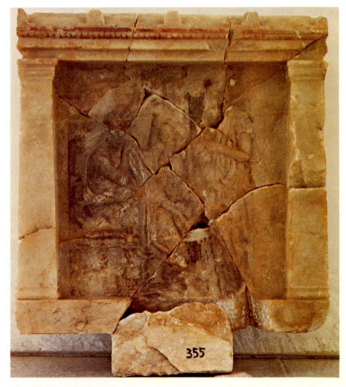

b. Uninscribed painted stele. Volos Archaeological Museum (cat. no. 355). Photograph by Milton W. Brown, courtesy of Blanche R. Brown.

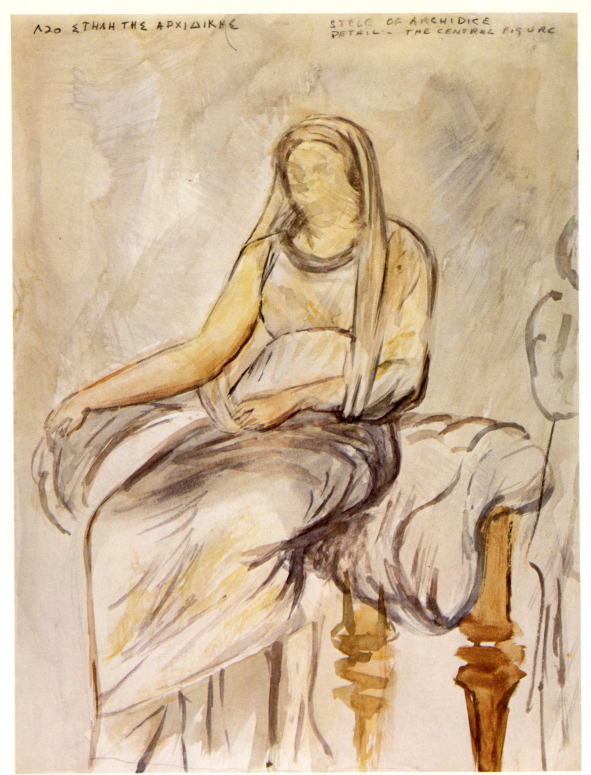

ΛƧο ΣΤΗΛΗ ΤΗΣ ΑΡΧΙΔΙΚΗΣ STELE OF ARCHIDICE
 DETAIL - THE CENTRAL FIGURE

2. Stele of Archidice (detail). Water-color sketch by the author.

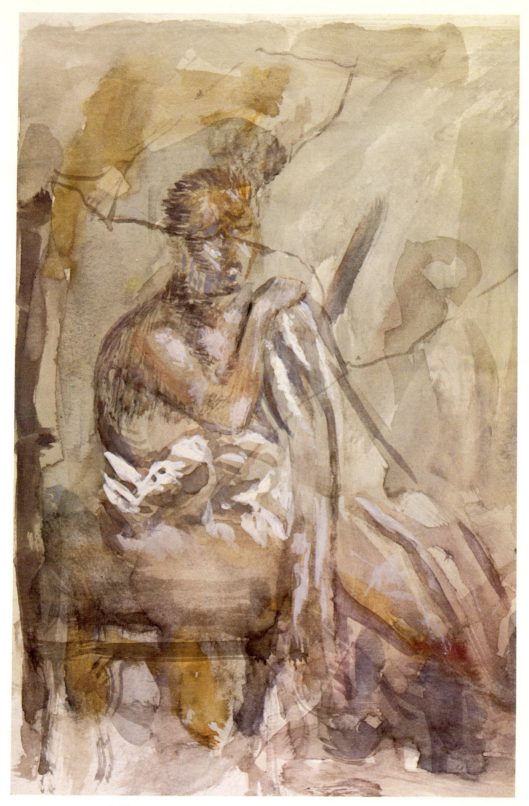

3. Uninscribed stele (detail). Water-color sketch by the author.

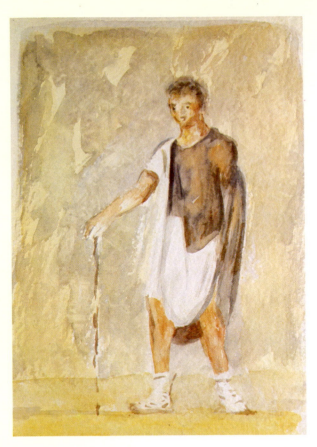

4a. Stele of Olympos. Volos Archaeological Museum (cat. no. 354). Water-color sketch by the author.

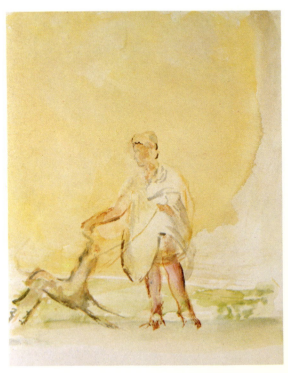

b. Stele of Protos. Volos Archaeological Museum (cat. no. 352). Water-color sketch by the author.

5a. Stele, found near Verria. Verria Archaeological Museum. Photograph courtesy of Katerina Rhomaiopoulou and the Greek Archaeological Service at Athens.

b. Façade of a chamber tomb, Lefkadia. Reconstruction, courtesy of Photios Petsas and the Greek Archaeological Service at Athens.

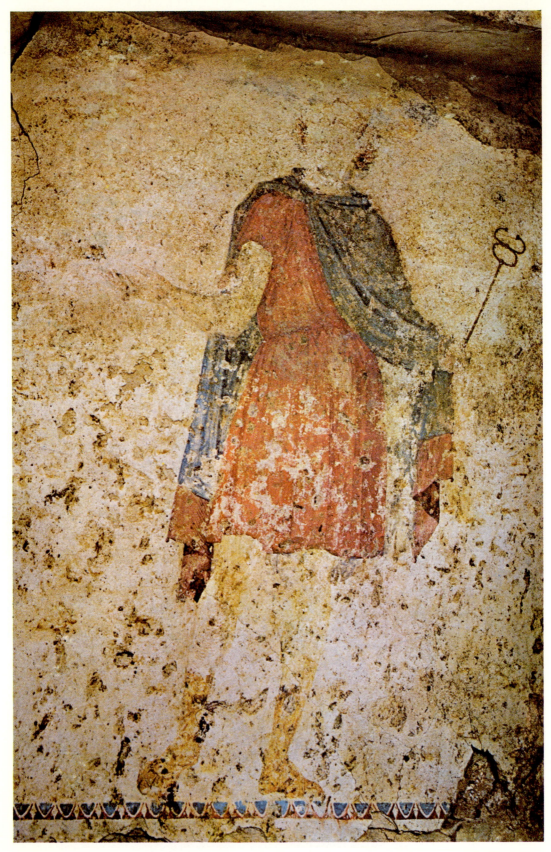

6. Hermes, from the façade of the chamber tomb at Lefkadia.

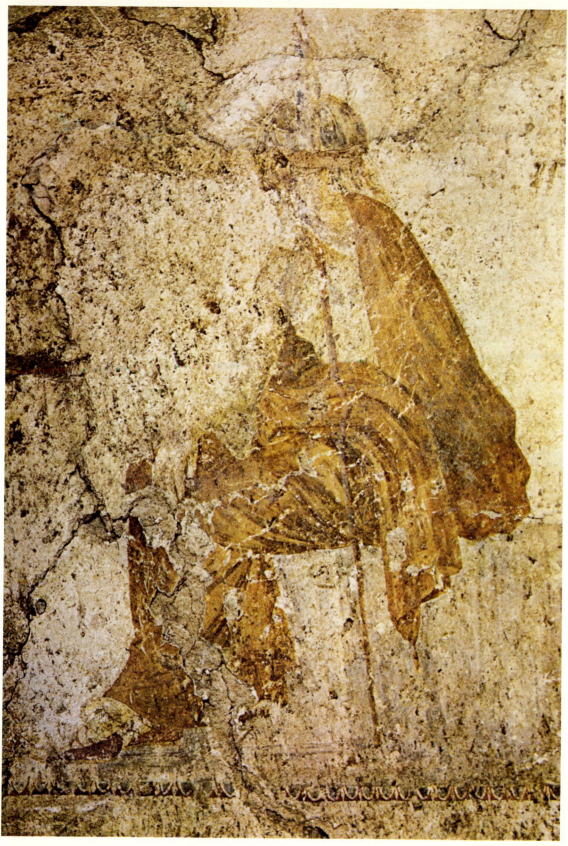

7. Aeachos, from the façade of the chamber tomb at Lefkadia.

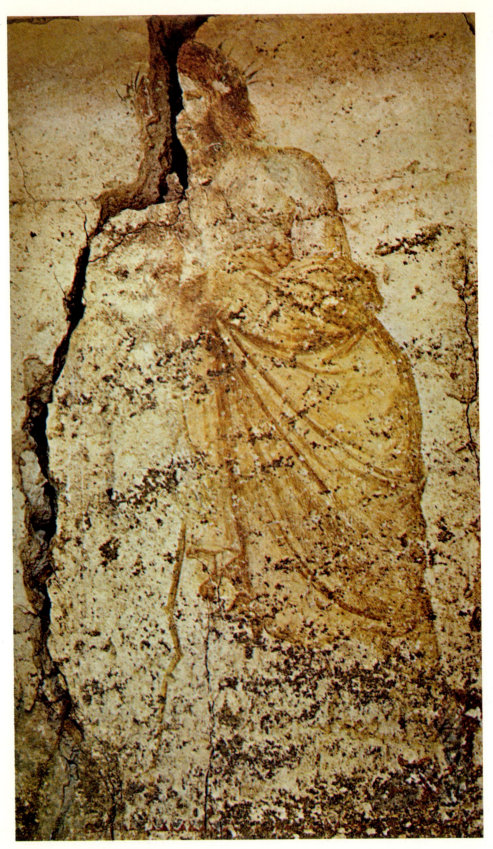

8. Rhadamanthys, from the façade of the chamber tomb at Lefkadia.

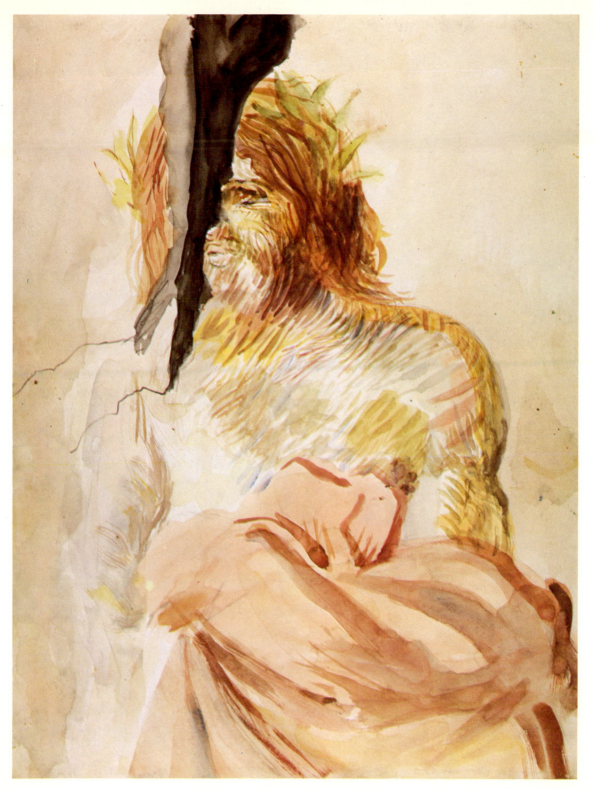

9. Head of Rhadamanthys. Water-color sketch by the author.

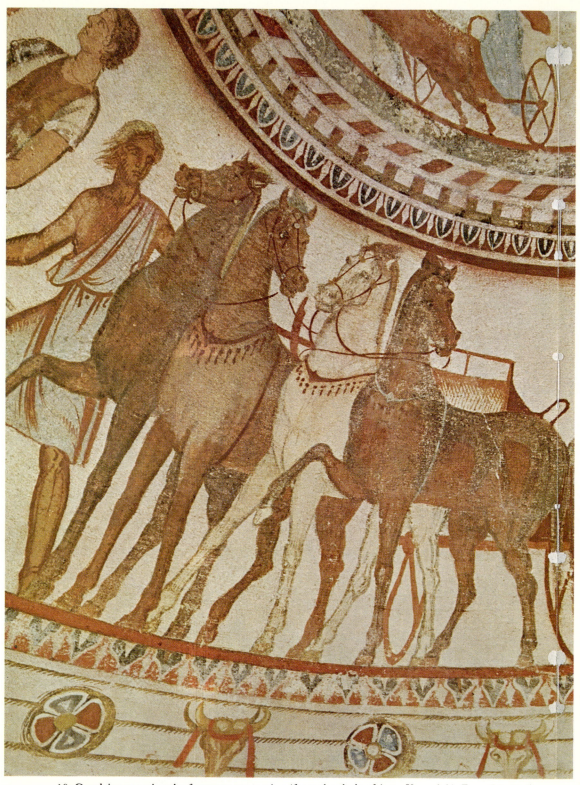

10. Quadriga entering the funerary procession (from the tholos frieze, Kazanlak). From Liudmila Zhivkova, *The Painted Tomb at Kazanlak*, pl. 1.

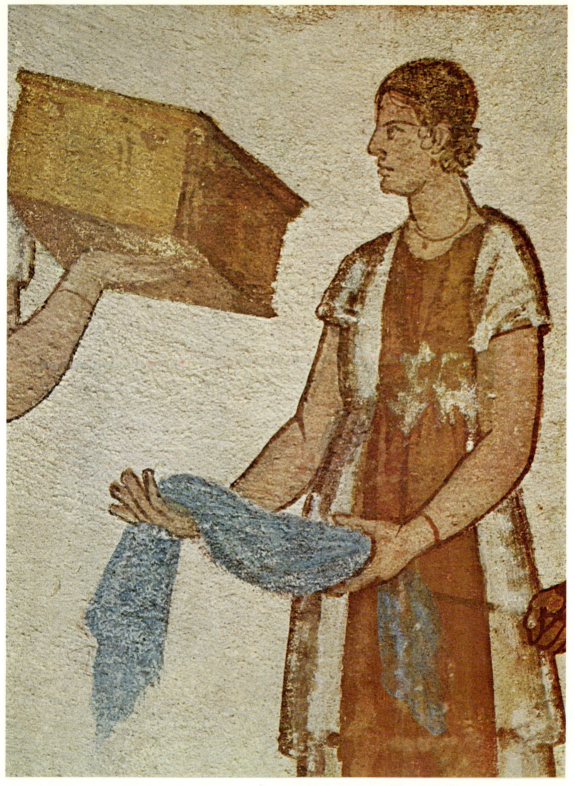

11. Processional figure carrying a blue cloth (detail of tholos frieze, Kazanlak). From Liudmila Zhivkova, *The Painted Tomb at Kazanlak*, pl. 33.

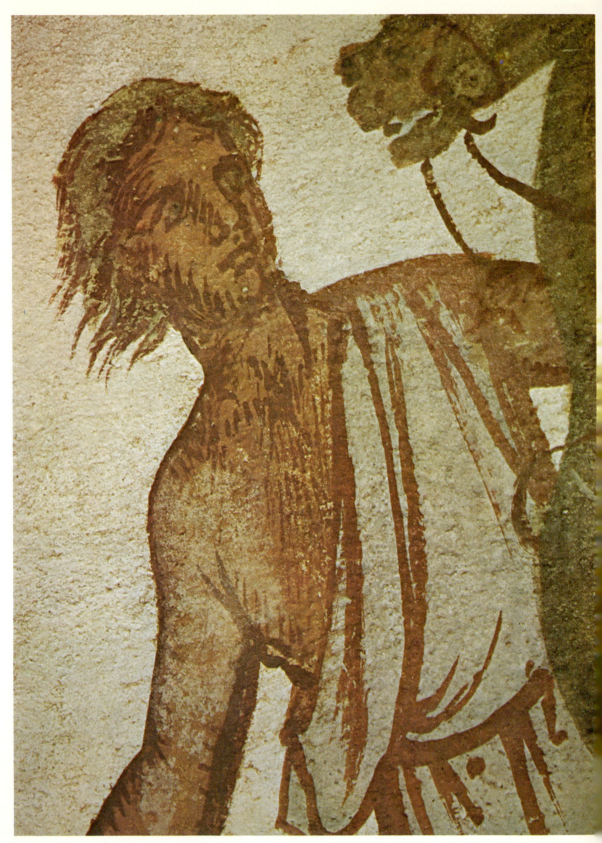

12. Processional figure leading the horses of the quadriga (detail of tholos frieze, Kazanlak). From Liudmila Zhivkova, *The Painted Tomb at Kazanlak*, pl. 11.

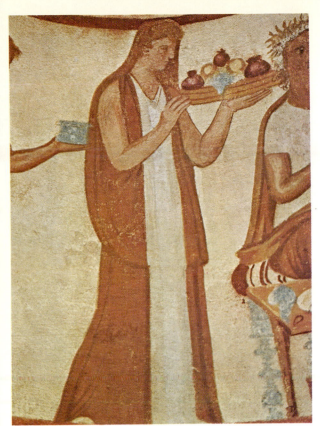

13a. Offerings bearer (detail of tholos frieze, Kazanlak). From Liudmila Zhivkova, *The Painted Tomb at Kazanlak*, pl. 27.

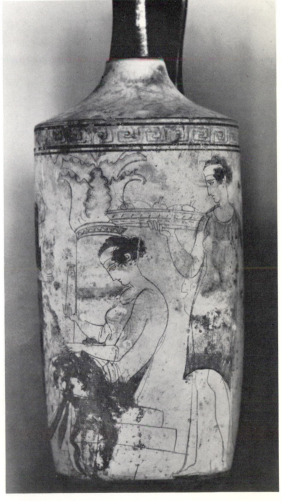

b. White-ground lekythos by the Woman Painter. Athens, National Museum. Courtesy of Harry N. Abrams.

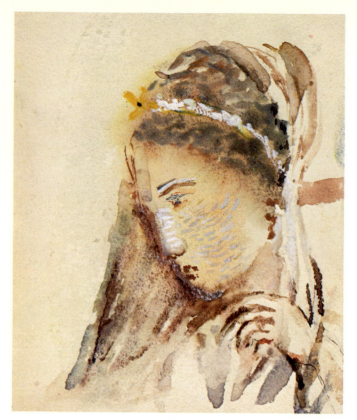

14a. Head of seated woman (detail of tholos frieze, Kazanlak). Water-color sketch by the author.

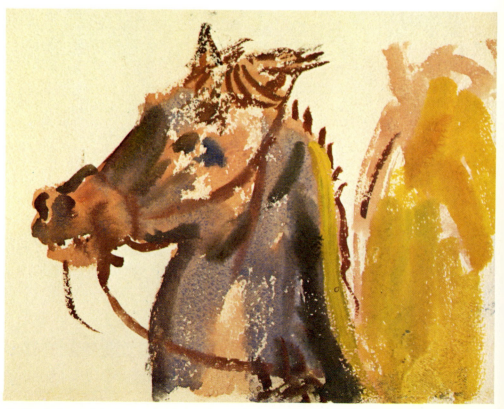

b. Head of a quadriga horse (detail of tholos frieze, Kazanlak). Water-color sketch by the author.

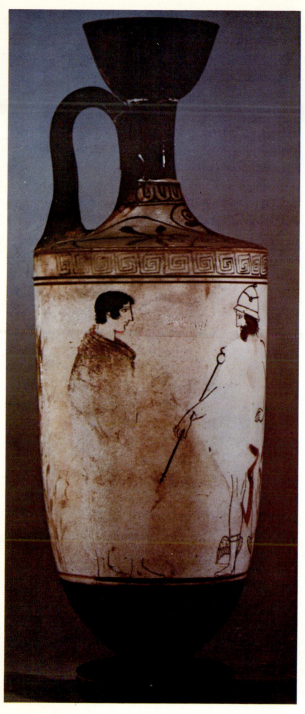 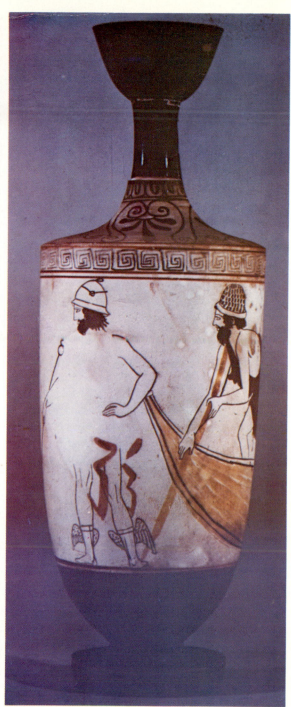

15a. Attic white-ground lekythos: Hermes and a young man. Courtesy of the Berlin Antiquarium, Charlottenberg.

b. Attic white-ground lekythos: Hermes and Charon. Courtesy of the Berlin Antiquarium, Charlottenberg.

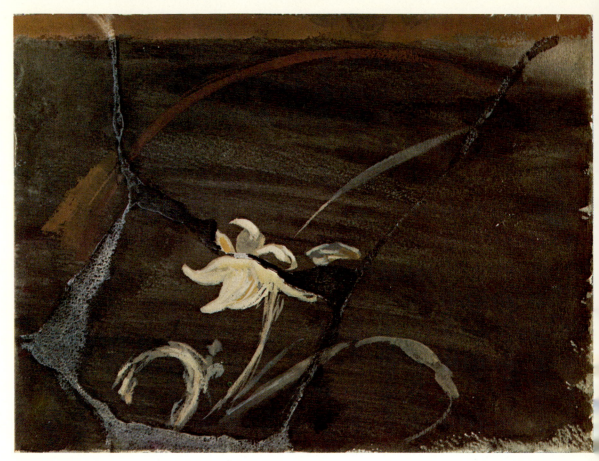

16a. Fragments of a black-background garland frieze from an ancient house at Delos. Delos Museum. Water-color sketch by the author.

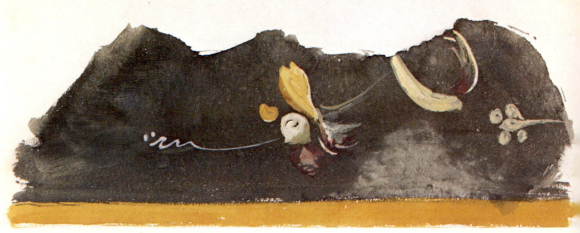

b. Fragments of a black-background garland frieze from an ancient house at Delos. Delos Museum. Water-color sketch by the author.

concerning the four-color palette and who used it.

Cicero's account of sculpture begins with Kanachos,[15] back at the very start of the fifth century B.C., in the late archaic period. The name of Kanachos was known to the ancients because of his statue, the Apollo of Thebes (executed before 494 B.C.), the fame of which was based on the fact that it held a stag on the palm of its hand that was fitted with a mechanical device which caused the legs of the animal to move, simulating walking. A relief in Berlin and a bronze figurine in London are probably copies, and they show a frontal figure of the ordinary kouros type, without contrapposto, holding the famous attribute of the walking stag in the outstretched right hand, as in ancient descriptions.[16] Cicero describes the style of Kanachos as "rigid," a term he obviously meant to apply to the stiff, motionless pose of the archaic kouroi. After his treatment of Kanachos, Cicero goes on with what purports to be a brief history of a gradual improvement in sculpture. The rigidity and stiffness of archaic art, illustrated by Kanachos, is first modified by Myron and then finally eradicated in the works of Polykleitos.

In the briefly sketched history of painting that follows upon Cicero's discussion of sculpture, the archaic stage is neither mentioned nor illustrated, as it was in the preceding history. The development of painting is described in only two steps, not in three. The earlier group of artists, Polygnotos, Zeuxis, and Timanthes, paint in a manner that is not yet perfectly in accord with nature. Although they have already passed far beyond the archaic stage (the stage illustrated in sculpture by Kanachos), we are given to understand that their works still retain more than a hint of archaistic rigidity. The work of this first group of painters is already to be considered "beautiful," however, according to Cicero, and they are widely admired for their line and form. This stage in painting may be taken as equivalent to the period in sculpture characterized by Myron, whose statues, Cicero tells us, we should not hesitate to call beautiful even though they have not yet fully attained truth to nature.[17] The second group of painters, Aetion, Nicomachos, Protogenes, and Apelles, goes on to achieve perfection, according to Cicero, but here we may understand what he means by perfection not in some vague or indefinite sense of the term, but in the particular sense already described in connection with the parallel examples in sculpture. Like Polykleitos, the painters of Cicero's second group are seen as having achieved perfection because they succeeded in eradicating from their work all traces of those archaic habits still noticeable in the earlier group. The rigidity of the severe style has vanished forever, and the painted figure now moves in space in a completely convincing manner.

The clear implication throughout Cicero's passage on art is that Greek artists

15. Overbeck, pp. 403–409. E. Simon, "Beobachtungen zum Apollon Philesios des Kanachos," in *Charites* (Bonn, 1957), pp. 38 ff.

16. Carettoni, in *EAA*, IV, 380 ff. (with bibliography). For the Berlin relief and the London bronze, see *EAA*, IV, figs. 360, 362. Cf. Sellers, pp. 60 f., n. 5, 7 (on Pliny, *NH*, XXXIV, 75). A bronze copy was made by Kanachos for Miletus, the original version at Thebes having been executed in wood. The Miletan copy of the statue was carried off by the Persians in 494 B.C. (Herodotus, VI, 19; Pausanias, VIII, 46, 3), a date providing a *terminus post quem* for the original; it was restored to the sanctuary of the Branchidae near Miletus by Seleucus Nikator (Pausanias, *loc. cit.*). The statue was still employed as a motif on Imperial coins of Miletus (Sellers, p. 60). Although there was a later sculptor named Kanachos, a pupil of Polykleitos (Pausanias, VI, 13, 6), the context makes it clear that Cicero refers to the creator of the archaic Theban Apollo.

17. Cicero, *Brutus*, 70: "nondum Myronis satis ad veritatem adducta, iam tamen quo non dubites pulchra dicere."

achieved perfection in the fifth and fourth centuries B.C. as the result of a gradual process, in the pursuit of a continuing trend. We may object to the naïveté of Cicero's art-historical orientation, but it is certainly clear that in his mind, no abrupt change of program could have taken place during the course of the development he had in mind. When we come to the matter of the four-color palette we see that it is hardly pertinent to the central theme of the passage. The avowed purpose of the passage is to characterize the history of art in the most general, obvious terms possible. These are facts that, according to Cicero, everyone knows about the history of art, and his point is to show his contemporaries how ignorant they should consider those Romans who did not have at least an equivalent knowledge of the history of oratory. The development to which Cicero refers in the history of art concerns the naturalistic representation of the human figure, and what interests him especially is the apparent ease and fluidity of movement in space which the artists of a more mature stage in history were able to impart to both painted and sculptured figures. The remark on the four-color palette is in fact intruded by Cicero upon his main analysis. The principle of the restricted palette is not really at stake and plays no part in the process by which perfection is achieved. If anything, it is a restriction characterizing the severe style, the stage he describes as "beautiful," lying midway between the "rigid" on the one hand and the "perfect" on the other. The statement on four-color artists is simply interjected as an interesting detail, or rather a surprising, though familiar, fact, remarkable enough to be worth repeating.

This would constitute the strictest interpretation of the passage as it is preserved, and there is nothing in the logic or reasoning in the passage to suggest that Cicero necessarily excluded either one group or the other from participation in the four-color tradition. On the contrary, since Pliny states that the tradition continued as late as the works of Apelles and his circle, it would seem natural to suppose that Cicero, too, understood the tradition as a continuing one. Cicero, however, places the emphasis of the four-color palette as properly characteristic of the earlier group, so that there seems to be little doubt that this phenomenon should be thought of as the basic method of those artists, like Myron and Polygnotos, who were initially responsible for taking the first really drastic steps in abolishing archaic formulas. In other words, the four-color palette must have been the original invention of the very artists who were the major participants in the discovery of chiaroscuro. Under these circumstances we may easily conclude that the four-color method held a certain symbolic attraction for artists of the later periods of classical antiquity, and that from time to time painters might decide to imitate the tradition of the four-color limitation in order to recall the grandeur of a golden age of artistic achievement. The names of such artists were evidently set down in a list, one that must have included those painters representing a sequence of careers from the severe style to early Hellenism. Thus, the lists of four-color artists in Pliny and Cicero are not contradictory. The names in Cicero and Pliny probably represent nothing more mysterious than different quotations from a longer list. If we view the phenomenon of the four-color palette from this point of view, it will soon become apparent that its symbolism was bound to play, as time went on, a major role in the history of classical art.

7

Austere and Florid Colors

We have reviewed two proposals concerning the four-color palette of the Greeks. The first is that the four-color palette of classical painters means a palette of primary colors—a palette consisting of those few pigments that cannot themselves be obtained by mixing other colors, but that, when mixed in various combinations, will produce all the many variations of hues and dark and light tones the painter may need for the representation of the visual experience in nature. The second proposal, briefly restated, is that the four-color palette was initially a characteristic approach to color belonging chiefly to a group of famous masters of the fifth century B.C., the great men of the early classical period who were responsible for making the tremendous strides that led to the development of a system of chiaroscuro, bringing to an end the application of pigments in flat areas as part of a two-dimensional orientation in painting. In accordance with the indications of the literary tradition, we may further assume that the four-color palette produced some very special and highly symbolic concordance or harmony of color in painting, so that it could be easily recognized and meaningfully reintroduced by the artists of succeeding generations whenever a particular painter might deem it appropriate to remind his audience of a past achievement in connection with some new artistic purpose of his own. It now becomes a matter of the highest importance for us to be able somehow to visualize that special consonance of color and to reconstruct, at least in imagination, the actual appearance of a four-color picture, for the fact that so central an issue was made over the list of four-color artists in the literary tradition must mean that the works of such artists stood dramatically apart from other paintings as a conspicuous and easily recognized group. Whatever it was that made the actual appearance of paintings executed according to the four-color principle so special must have been something instantly seen and easily recognized by the average observer. Yet what, after all, can have been so obviously different about the coloring in a painting restricted to a set of primaries? Theoretically, at least, the primary colors are capable of producing a full range of hues. How, then, may a painting worked out by means of a palette restricted to primaries look different from other pictures? This is a question that demands an answer, and it brings us back to our initial

concern over whether the palette of the ancients had some unexpected restriction involving an aesthetic rather than a purely methodological aim.

When one analyzes the rather concrete meaning that the concept of a restricted palette had in the thought of Roman writers, there are certain implications that seem to stand out. It is really quite remarkable that Cicero and Pliny, two writers of such different literary aims, one a fighting patrician of the late Republic, the other a comfortable official of the Roman Empire in the Julio-Claudian dynasty, both insist on making so special a point concerning the four-color palette. Both take a definite stand with regard to the four-color palette and to the period of Greek art in which each sees it as having importance, for in each case the practice of color restriction emerges as something better and more admirable than the practice of employing a more elaborate range of hues.

It is in Pliny that we find expressed most clearly this decided preference for the four-color method. His list of four-color artists is followed by the remark that although the materials with which these masters worked were of the simplest kind, each one of their paintings had acquired a value roughly equivalent to the wealth of an entire city. He then goes on to describe the situation current in the Rome of his day:

Now that even purple clothes our walls, no famous picture is painted. We must believe that when the painter's equipment was less complete, the results were in every respect better.[1]

Cicero makes a similar point—not explicitly, but by implication. One must remember that Cicero, unlike Pliny, lived through a period in Roman history in which a way of life was coming to an end. In the years just before writing the *Brutus*, Cicero had had to face the fact that the power newly acquired by Julius Caesar seemed to be growing to the point where Caesar would soon become an absolute dictator and that the old regime, with its measure of political freedom and especially its virtual lack of censorship, was probably all but lost. Cicero's feelings were, of course, more strongly than ever in sympathy with the traditional values, and even when he deals with a topic quite divorced from politics, those feelings of attachment to older values emerge to color all his thoughts. His remarks on the history of art in the *Brutus* are part of a discourse on the history of styles, ostensibly limited to the field of oratory. Ancient and orthodox oratorical techniques are praised by Cicero and held to be still valuable, even though they may seem in the eyes of the ordinary critic to be old-fashioned and out of date. In a way it is the argument for the relevance of history, so familiar to the modern student. In recent years, Cicero complains, the genius of Cato the Elder has been cast in the shade by the specious eloquence of the modern school, just as the taller and more grandiose structures built by reigning politicians obstruct our view of the quiet beauty of older buildings. How ignorant are the Romans, he declares, who admire the Greeks for their Attic simplicity, yet fail to recognize this very virtue in their own forefathers. In oratory, Cicero continues, the Romans are more impressed by technique than they are by content.[2] At this point Cicero

1. Pliny, *NH*, XXXV, 50.
2. Cicero, *Brutus*, 65–68: "As for Cato, who of our orators living today reads him or has any acquaintance with him? And yet, good heavens, what a man! I do not now refer to the citizen, the

embarks upon his journey into art-historical analysis that takes him eventually to the mention, as though by accident, of the famous four-color palette.

The passage opens with the remark that the art of oratory, though the highest of all the arts, is the one which has received, traditionally, the least attention: "Sed maiore honore in omnibus artibus quam in hac una arte dicendi versatur antiquitas."[3] Oratory is also the one field of cultural history of which the Roman public is least well informed, although in contemporary Rome it is one of the most vital of the arts. How strange it is that everyone knows certain basic facts about the history of sculpture and painting, while the knowledge of oratory among contemporary Romans is practically nil. This is the thought that Cicero wished to emphasize when, by way of contrast, he relates a few details about the history of art that he regards as common knowledge. The passage on the history of art is meant as a basic outline which everybody in Rome with a minimal education would have taken for granted. It seems rather astonishing that we find mention of the four-color artists as part of a survey of this kind. Yet if we remember the manner in which the Attic style of oratory has been characterized in the preceding paragraphs on Cato, there can be very little doubt that the concept of color restriction embodied in the tradition of the four-color palette is included here as an example of that same Attic simplicity and austerity which was in the art of oratory, according to Cicero, overshadowed by a more showy style, dramatic and sensational but meager in content in comparison with older masters. The four-color palette as part of an artistic rhetoric in painting was clearly understood by Cicero as directly analogous to conciseness and simplicity of means in oratory; it was also, in his mind, a symptom of the golden age of Greek art.

By implication, the more elaborate color harmonies characterizing the art and decoration of Roman and Hellenistic centers are analogous to the specious effects and flamboyance in contemporary oratory, and they belong to a style that Cicero evidently considered anticlassical. The terms *classical* and *anticlassical* were, of course, never employed by Cicero. Nevertheless, the praise of older forms of art

senator, the commander; we seek now only the orator. Whom will you find more weighty in commendation, sharper in censure, shrewder in aphorism, more subtle in presentation and proof? His orations, more than one hundred and fifty in number so far as I have yet found and read them, are packed with brilliant diction and matter. Select from them the passages which deserve to be marked for special praise; you will find there every oratorical excellence. His *Origines* too—what flower, what lustre of eloquence do they not contain! But ardent admirers he lacks, just as some centuries earlier, Philistus of Syracuse, and even Thucydides lacked them. For just as their concise, pungent, and often obscure brevity was eclipsed by Theopompus with his high-flown, elevated style (as befell Lysias also, compared with Demosthenes) so this language of succeeding writers, built up like some tall structure, has cut off the light from Cato. But observe the ignorance of our Romans! The very men who find such pleasure in the early period of Greek letters, and in the simplicity which they call Attic, have no knowledge of the same quality in Cato. Their aim is to be like Hyperides and Lysias; laudable, certainly, but why not like Cato? They profess to have delight in Attic style, and in that they show sound sense; but I would that they might imitate not its bones only, but its flesh and blood as well" (Loeb ed., trans. G. L. Hendrickson [Cambridge, Mass., and London, 1952], pp. 63 ff.).

3. *Ibid.*, 69: "But early periods of culture awarded greater honour to all other forms of art than to this one art of discourse" (Loeb ed., p. 67) seems a clumsy rendering of the complex meaning of this passage. J. Martha's French translation (Ciceron, *Brutus*, Collection des Universités de France, 3rd ed. [Paris, 1960], p. 24) expresses an entirely different aspect of its meaning: "Mais l'art de la parole est, de tout les arts, celui où l'antiquité est le moints considérée." Thus expressed, the passage might mean "But in the art of oratory, of all the arts, the standards of antiquity [hence classicism] are considered least important [by contemporary practitioners]."

and oratory in Rome suggests that he and other Romans had to some degree formulated the idea of "classicism," if not the word itself, as Pollitt has explained,[4] and that they applied it to the period from Polygnotos to Pheidias. For Cicero, older forms and techniques of oratory embodied certain expressive qualities, such as simplicity and directness, which he felt should be recognized as having permanent, not transitory, value. Consequently, such forms might continue to be models, and the notion of the imitation of a "classical" prototype is clearly implied, arising as part of his conservative taste in the arts and a reaction against certain forms of change. Brendel and other historians of ancient art have pointed to the revival of a "conservative, neo-Attic taste" in Roman Imperial art.[5] When we juxtapose the statements and implications in Cicero with the explicit attack on rich, Oriental coloring in Pliny, it becomes apparent that to the Roman mind, certain aspects of the Greek artistic heritage came to symbolize the principle of conservative values, not only in areas of aesthetic choice, but in a much broader cultural context. The reference to Cato the Elder in Cicero is rather significant from this point of view. Cato was the first spokesman of conservative criticism and one of the first opponents on principle of the influx of Hellenistic culture into Italy.[6] Considered in this light, it seems fairly likely that a certain consonance of color in painting, the result of a deliberately restricted palette —because it had characterized the art of the very greatest Attic masters such as Polygnotos—was recognizable as a "classical" formula. This formula had acquired in the minds of Cicero and his contemporaries during the period of the late Republic a symbolism with far-reaching political and sociological application, a symbolism that was still very much alive in Pliny's day.

While we can never know with absolute certainty how the principle of a restricted palette was interpreted by the ancient Greek masters who actually practiced it since their paintings are entirely lost, we may perhaps form valid impressions once we realize that we must expect something easily seen and identified—something capable of attaining widespread symbolic meaning. Of particular significance is Pliny's manner of contrasting the colors of the four-color palette with a group of colors that are variously characterized as more expensive, usually foreign in origin, more flamboyant, and more intense and bright—colors that are, in short, symbolic of a kind of luxury considered inimical to older Roman values. These bright and flamboyant colors Pliny groups together under the heading of "florid colors," and he places them in opposition to another group labeled "austere colors."[7] Among the *colores floridi* are purples and crimsons, pigments obtained not from simple earth or clay, but from outlandish Oriental mixtures, including one that is derived, according to Pliny, from "dragon's blood."[8] It seems clear that the distinction Pliny had in mind refers to

4. J. J. Pollitt, *Art and Experience in Classical Greece* (Cambridge, 1973), Introduction, *passim.*
5. O. Brendel, "Prolegomena to a Book on Roman Art," *MAAR*, 21 (1953), 48.
6. *Ibid.*, p. 54.
7. Pliny, *NH*, XXXV, 30, 97, 120; see the list of ancient references and the discussion for the terms *austerus* and *floridus* in Pollitt's *Critical Terminology*, pp. 394 ff., 1189 ff., and *Ancient View*, pp. 321 ff., 373 ff. For a somewhat different interpretation of the significance of ancient writings on this point, see W. Lepik-Kopaczynska, "Colores floridi und austeri in der antiken Malerei," *JdI*, 73 (1958), 79 ff. (see also n. 9, below).
8. Pliny, *NH*, XXXV, 50.

an obvious technical distinction artists have always made between the so-called earth colors and what we may most conveniently term the "artificial" colors or dyes.[9] In modern terminology (which hardly differs from the ancient, as far as it may be reconstructed), the earth colors include red and yellow ocher, burnt and raw umber—in short, all those shades of red and yellow, buff and brown which may be obtained from natural earth or clay deposits. The red and yellow ochers consist of hydrated oxide of iron mixed with various natural substances in earth which produce variations of hue from yellow through orange to red. Each hue may also vary in brightness from almost neutral grayish tones through buffs and pinks and various browns to relatively pure and often quite bright reds and yellows. The reds and yellows, however, are never as bright as crimson, vermilion, the cadmiums, and other less common colors. Umber, likewise, is an iron-oxide pigment with some manganese oxide also present; it is a neutral dark brown, perfect for obtaining shadows, and when mixed with blue it will give a deep and lustrous black. In addition, there is among these "earth colors" an earth pigment of iron silicate which produces an extremely beautiful shade of soft grayish green that was also known to the ancients and which we label today *terra verde* (terre-verte). Essentially, however, we think of the "earth colors" as the warmer shades of reds, yellows, and browns. The great variety of earth colors in the yellow, red, and umber range can be further increased by a simple process of heating—thus the term *burnt umber*, which has a redder hue than natural umber.

Apart from the "earth colors," the pigments and dyes known in antiquity include most of the "artificial" pigments Pliny describes in his lists of *colores floridi*—for example, a deep-red color extracted from the roots of a plant known in Europe as the *Rubia tinctorum*. Today, we call this color rose madder or lake madder. Like vermilion, the madder reds have a brilliance and intensity that place them in a special class, far different in character from the earth colors. A harmony built around a combination of earth reds and yellows can be completely overpowered by the introduction of a vermilion or madder red. Thus, the brilliant or artificial hues and the hues obtained from earth pigments belong to two entirely different worlds of color. The ancients knew this, as Pliny suggests by his distinction between the "florid" and "austere" colors. Ancient painters, like modern abstractionists, were capable of producing dramatic effects by capitalizing on the basic difference between these two color groups or classes. In antiquity, this may be seen in the great figurative friezes of the so-called second style, like the frieze in the Villa of the Mysteries, where bright red backgrounds of polished vermilion set off groups of human figures which are rendered in soft and muted hues mainly in the earth-color category. The very violence and artificiality of the red background in these friezes make the naturalistic handling of the figures in neutral tones seem doubly real, and the figures actually detach

9. Cf. Lepik-Kopaczynska, *Apelles, der berühmteste Maler der Antike* (Berlin, 1962), pp. 23–31. and "Colores floridi und austeri in der antiken Malerei," 79–99. This author interprets the distinction in Pliny between *colores floridi* and *austeri* as signifying a contrast between glossy and mat or opaque colors. I. Scheibler, in "Die 'Vier Farben' der griechischen Malerei," *Antike Kunst*, 17 (1974), 95, n. 18, finds this thesis unacceptable. Lepik-Kopaczynska did, however, first suggest that the *colores austeri* might in certain contexts refer to the hues in the earth-color category, which is also my own conclusion. E. H. Gombrich, in "Controversial Methods and Methods of Controversy," *Burlington Magazine*, 105 (1963), 91, and n. 10, appears to agree with the thesis proposed by Lepik-Kopaczynska.

themselves from the background almost as though they were alive and moving in our own spatial context rather than in the pictorial field.

If we consider the possibility that Pliny's distinction between florid and austere colors may be reduced to the practical separation of the "earth colors" as an isolated group, the concept of restricted color in classical painting takes on an entirely new meaning. Since we know that the four-color palette somehow became associated with an aesthetic philosophy of conservatism and restraint in which there was a taboo against flamboyance and all that was spectacular and showy, it becomes easy to imagine that in formulating a scheme of color limitation, the fifth-century-B.C. master's first intention was to exclude those colors which were excessively bright and ornate in character. This fits in, too, with what was certainly a major preoccupation of the fifth-century painter—namely, the development of depth and shading. It must have been noticed, in the course of the experiments that led to the full realization of chiaroscuro in the second half of the century, that the brighter colors tend to flatten forms and that the earth colors are more appropriate to the successful modeling of form and to the convincing representation of pictorial space. With this consideration in mind, we will attempt to describe the actual consonance and harmony of color in a classical four-color picture, as one that was executed in earth colors, or "austere" colors, only and from which the *colores floridi* were excluded. Yet, before we can form a true impression of what such a painting looked like, we must somehow solve the problem that we earlier left unresolved—the perplexing problem of the omission of blue as the complement of reds and yellows in what is ostensibly a system of primary colors.

8

The Exclusion of Blue
from the Ancient List of
Artists' Primary Colors

Of the many obstacles that beset us in the analysis of ancient writings on color, the one point that has always seemed most difficult to understand is the omission of the color blue from Pliny's catalogue of primary colors. The catalogue itself is in some ways remarkably detailed. It is not merely a list of color names, but contains information on chemical ingredients and places of origin, enabling the reader to identify particular pigments and qualities of color. Because of the precise nature of the information provided for each of the colors, one can hardly avoid the impression that Pliny's list of four colors represents a perfectly straightforward account of an ordinary piece of technical information. In other words, the exclusion of blue and the substitution of black as the only complement of red and yellow is presented as part of what seems to be an uncomplicated and probably accurate description of the ancient Greek four-color palette. But since blue, not black, is the only color that in practice can function as a complement for red and yellow, its omission has certain drastic consequences.

As a part of the framework of art-historical information provided by the ancient literary tradition, the omission of blue seems to be an unavoidable fact, for though there are a number of other areas of uncertainty and disagreement in the statements that have come down to us on the subject, as we have seen, this is a detail on which all our ancient sources consistently agree. The colors given as primary colors by Democritus, for example, in the context of his discussion of the analogy of Empedocles, are white, red, green, and black, while Aëtius, writing in the late first or early second century A.D., in quoting from a pre-Socratic source, gives the primary colors as white, red, yellow, and black, substituting yellow for

green but again omitting blue in favor of the color black.[1]

Can one conceive of black being mixed with red and yellow, for example, in order to produce orange, green, and purple? Surely this seems very doubtful. Far easier to blame our difficulties on poetic license. In Democritus, the primary colors are not listed in accordance with artistic practice, but rather in accordance with some imagined resemblance (obscurely described in considerable detail, now almost impossible to interpret) between colors and the four primary elements of matter—fire, water, air, and earth. In any case we may be sure that the statements of the pre-Socratic philosophers on color, although they took the form of an analogy with painting, expressed the insights of metaphysical poetry, not the actual behavior of pigments.

If the philosophers were aware—as they probably were—of the sense in which the analogy actually applied to pigments, they evidently felt no compunction to be confined by the same conditions in the context of their own poetry. In describing the qualities of actual colors, the philosophers freely invented a kind of poetic inventory of metaphysical properties, strange combinations of material and supernatural attributes that characterized each of the colors.

On the other hand, the painters of the fifth century B.C. had no such freedom in naming the primary colors when it came to the pigments with which they worked, unless we are to assume that they, too, were guided by some strong aesthetic impulse, perhaps even something on the order of a revulsion against the colors in a certain portion of the spectrum, or perhaps an overwhelming preference for hues within a certain range. Such a thing, of course, is not impossible. It amounts to a kind of color abstraction, for such a process in painting would be just as abstract in character as it was for the field of poetic expression. As a matter of fact, there is every reason to suppose that painters in fifth-century Athens, like their contemporaries in science and literature, were perfectly capable of adopting an abstract principle with respect to color. We know that in both sculpture and architecture some highly abstract rules were being applied in the realm of proportion and the rhythmic use of forms. If that is true, then the omission of blue may very well reflect an abstract aesthetic formula deliberately aimed at restricting color in monumental painting, as it was restricted in the painting of Attic vases, to the earth reds and yellows and their derivatives, with the addition of white and black.

The only real alternative to this conclusion is that Pliny and other ancient writers were somehow all mistaken in naming black as one of the primary colors in painting. Unlikely though it may seem that so many authors could have made the same mistake, it is indeed very probable that such an idea might have gained wide acceptance in modern thought were it not for the fact that there is an important extant monument that obviously displays precisely the type of color restriction we might propose on the basis of the literature. This monument is the famous Alexander mosaic from the House of the Faun in Pompeii,[2] a large and

1. The list in Democritus is given in the account of his writings by Theophrastus (*De Sensu et Sensibilibus*, 73). In Aëtius I, 15, 8, we find the list agreeing with that in Pliny.

2. H. Fuhrmann, *Philoxenos von Eretria*, (Göttingen, 1931); F. Winter, *Das Alexandermosaik aus Pompeii* (Strasbourg, 1909); Swindler, pp. 280 ff.; B. Andreae, *Das Alexandermosaik* (Bremen, 1959); Rumpf, 148 f. (bibliog. 148, n. 2); *idem*, "Zum Alexandermosaik," *AM*, 77 (1962), 229 ff.

complex picture of a raging battle in which the colors are limited with surprising strictness to the earth reds and yellows plus white and black. However, in the Alexander mosaic, there is, in addition to the actual four colors, a subtle sequence of rather neutral browns and grays in the rendering of figures and horses, garments and weapons, and the trappings of the Persian and Greek armies. There are a great many figures moving dramatically in and out of space, and a system of shading that requires even more complexities of color and tone. The major harmony in the composition as a whole depends on a bold and extremely handsome contrast of dark browns and reds, and velvetlike black against a large expanse of cool gray sky. This major consonance is then wonderfully supported by an astonishing variety of soft yellows and lighter browns, of ochers and buffs, and of the most delicate combinations of grays. So multifarious is the array of these tonal modifications that we are momentarily under the illusion that we see a fuller range of colors than the picture actually contains. However, the fact is gradually forced upon us that all this incredible nuance has been achieved despite a scrupulously observed limitation of the palette, a limitation that involves the total avoidance of half the colors in the spectrum. Nowhere in the picture can we find a single touch of blue or a single detail rendered in a green or purple hue. Besides the elimination of all these hues, the palette employed in the picture has been restricted in yet another way. The reds and yellows involved in the design are not just any reds and yellows; they are not bright crimsons or brilliant saffrons, but only the softer ochers and umber reds that fall into the category of the earth colors. The result of all this in terms of an aesthetic response, when we dwell for some time upon the color, is a compelling sense of severity and power.[3] The restraint in color seems to evoke a heightened response to the excitement and drama of the action portrayed since the aesthetic emotion arising from an experience of color so obviously dependent on the use of black has in it an element of tension and starkness that seems to magnify our awareness of scale and impending tragedy.

The unique and extraordinary use of color in the Alexander mosaic, so apt a demonstration of the four-color method as we may visualize it from the indications in ancient literature, becomes all the more interesting as soon as one remembers that the mosaic is identified as a copy of a painting executed by Philoxenos of Eritrea, who was a pupil of Nicomachos, the same Nicomachos whose name appears in the lists of four-color painters in ancient writings.[4]

Faced with the evidence of the Alexander mosaic, many experts on ancient painting have been inclined to accept the exclusion of blue from the four-color palette in the literal sense. Yet several difficulties present themselves. One is that we can never be absolutely certain that the color restriction we see in the Alexander mosaic existed also in the original painting. Since the largest

3. Cf. Swindler, p. 283: "We have spoken of the severe coloring. All of the tones lie within a certain color scale—from white to yellow and red, through gray, brown, and brownish violet to black. No trace of blue is found, which accounts for the impression of restrained color. All of the intermediate tones from reddish and yellowish gray to deep brown and brownish violet are made of yellow, red and black with more or less addition of white."

4. Pliny, *NH*, XXXV, 110; Overbeck, 1775, 1777; cf. Fuhrmann. See also Fuhrmann's bibliography on the mosaic, p. 279. The painting was commissioned by Cassander, who was king from 305 to 297 B.C. Cf. Swindler, p. 281.

majority of our extant examples of ancient paintings show the presence of blue, one may wonder if the exclusion of blue in this case was not a peculiarity adopted by the mosaicist. Blues and greens also occur in most examples of Hellenistic color mosaics. The matter is further complicated by the fact that there is no record of where the Alexander mosaic was made.[5] In any case, to look for or expect a parallel performance on the level of color between paintings and mosaics implies assumptions for which there is as yet very little supporting evidence. Would the mosaicist have had the original painting before him? Would it have been possible to achieve a detailed copy of so complex a scheme from measured drawings and color notations? None of these questions may be answered with any assurance.

Despite such doubts, the evidence of the Alexander mosaic on the nature of color in classical painting is very hard to ignore. It is a major work of art that has been executed according to a principle of color answering perfectly the description of the four basic colors in Pliny's list. On these grounds it would seem quite justified to accept the evidence of the mosaic at face value—as a bona fide example of the kind of painting that the ancient writers had in mind when they spoke of the four-color artists of ancient Greece. If we proceed as though this were the case, our next question would have to be: How did the mechanics of the lost original painting differ from the execution of the mosaic copy? The mosaicist's task was a relatively simple one. He had merely to find groups of stones to match as exactly as possible the various hues and values he saw in the painting. For the painter, however, the problem was one of mixing pigments. The painting, moreover, undoubtedly displayed an even higher degree of nuance than the mosaic. The painter, then, was confronted with the task of mixing from only four colors all the hundreds of shades and gradations of tone that must have made up his picture. It has always been assumed by modern writers that because we see no blue or green or purple in the finished mosaic, the artist of the original painting must have proceeded without them. It is stated categorically by Swindler, for example, that "all of the intermediate tones" were mixed with the red, yellow ocher, white, and black that are named and identified by Pliny.[6] But this is probably a serious mistake. To a painter it must seem extremely unlikely that so many shadings of grays and blacks may be obtained on the palette without some admixture of the color blue. In fact, many of the grays in the picture have a definitely blue cast, so that the overall effect is rather cool, as Swindler herself points out.[7] Certainly the great variety of reddish browns that provide major color accents throughout the composition were never mixed in the painted version by combining only red and black. In order to avoid a monotony of tone, the painter would be far more likely to mix his browns by adding blue and ocher to his red, or perhaps by adding to his

5. Maiuri (*Roman Painting* [Geneva, 1953], p. 69) believes that the Alexander mosaic was made either in Alexandria or somewhere in the Greek islands. His conclusion that the mosaic could not have been produced in Italy seems to be based on the style or, rather, the sheer excellence of the work, presumed to be of too high a quality to be Italian. The fact is mentioned that ancient repairs use a different type of tesserae and are clumsy, but this is no proof that the piece was not made originally on Italian soil by trained artists and then repaired at a later date by amateurs. On the Italian origin of the Hellenistic color mosaics see K. M. Phillips, "Subject and Technique in Hellenistic-Roman Mosaics: A Ganymede Mosaic from Sicily," *Art Bulletin*, 42 (1960), 243 ff.

6. Swindler, p. 283.

7. *Ibid.*, p. 282.

palette a group of burnt and raw umbers in addition to his earth red. As for the yellowish grays and yellow browns that also run through the composition, it would be absolutely impossible to obtain such colors by the mixture of black and yellow ocher. Adding black to yellow ocher produces a particularly horrible shade of dirty-greenish mud. To produce the range of delicately neutralized shades of yellow ocher that we see in the Alexander mosaic, the painter would have had to employ mixtures of yellow, earth reds or umbers, and blue, with blue acting as the neutralizing agent, not black. In mixing these tones, one might be able to do without the umbers, for they too may be approximated by means of mixing the three primaries—red, yellow, and blue. But substituting black for blue would render it impossible to obtain the majority of the colors we actually see in the Alexander mosaic as it is preserved.

The moment one begins to doubt that the exclusion of blue in Pliny's list can be taken literally, it becomes necessary to seek an alternative explanation for his wording. One possible solution perhaps lies in the assumption that the ancients possessed a black that was capable of appearing blue, or a blue that for some reason was described by ancient writers as black. This explanation was among the suggestions to come out of French nineteenth-century criticism, for we find it recorded in the writings of Bertrand.[8] Confronted with the apparent contradiction between the ancient literary tradition and the realities of painting, Bertrand concluded that without the use of blue the entire concept of a four-color palette would have been impossible unless the Greeks had a black pigment that was "capable of giving blues," a solution which Pollitt recently cited as plausible.[9]

But can this suggestion stand up to reality, or will it, too, prove delusory? Let us examine the matter in further detail. In particular, let us now return to the extant examples of actual Greek painting at the ancient sites in order to study more closely the role of the color blue in obtaining the kind of nuance we have observed in the rendering of the Alexander mosaic.

8. E. Bertrand, *Études sur la peinture et la critique d'art dans l'antiquité* (Paris, 1893), pp. 132 ff.
9. Pollitt, *Ancient View*, p. 111.

9

The Use of
Blue in Shading

In considering the effect that the invention of shading may have had on color in early classical painting, we have already noted the manner in which the integrity of separate color areas must in a sense become contaminated or, to use Plato's term, adulterated[1] by other colors that are employed to render shadows and highlights. Thus the artist begins to differentiate between the "body" color of the object depicted and the actual colors of the brushstrokes he may apply to the surface of his panel in representing the object in an atmosphere of dark and light. In the work of some artists the color of an object seen in dark and light may be so broken up by highlights and shadows that the color intended as the body color of the object no longer fills very much of the area within its outlines. It is at this point that the whole aesthetic basis of the art of painting must alter, for the rhythms and harmonies belonging to the music of two-dimensional color arrangements must be replaced by a design in three dimensions. Once a more sophisticated method of handling the brush is achieved, however, an effect of a two-dimensional rhythm of body colors may be retained despite the adulteration of the several component colors in the design due to shading. Both Piero della Francesca and Raphael, in varying degrees, were able to achieve these results. In our ancient examples, the recently found stele at Verria (plate 5a), its color still freshly preserved, is strikingly Rafaelesque in this respect, showing that ancient painters had found similar solutions to the balance of shading and color. Among the painters of the classical period in Greece, Pausias was evidently famous for having accomplished a means of preserving an impression of strongly emphasized body colors without at the same time sacrificing the effect of three-dimensional form.[2] An often-quoted passage in Pliny[3] describes the manner in which Pausias rendered a black bull from the front, keeping the color entirely dark, at the same time giving the

1. Plato, *Philebus*, 51A–53B.
2. Swindler, p. 268.
3. Pliny, *NH*, XXXV, 126; Pausanias, II, 27, 3.

animal its "full relief upon the flat surface."[4] Nothing is more difficult to accomplish, even with the great versatility of the pigments and media in use today, than the task of varying an area of black in a painting sufficiently to reveal its form without creating unnaturally strong highlights that ruin the impression of a perfectly black color. Frans Hals was able to handle black successfully in this regard in the dresses of his Dutch women, and Manet occasionally experimented with the problem in the costumes of his early bullfighters; but examples of the handling of black as Pliny describes it in Pausias's bull are hard to find in all periods of Western art.

Whenever we look at a painting in which we receive the dual impression of chiaroscuro and a design of clearly defined body colors, it is possible to think of the color in a painting in two very different ways. Psychologically, the two distinct impressions of color may strike the imagination as inimical. If we stand at a distance from a painting represented in three dimensions by means of some coherent system of dark and light, we see that each garment, each chair, each head of hair—in short, each and every object in the entire composition—has a color, a body color or a local color, which we can easily discern and even name; we might call a cloak white, a dress red, a chair brown, a shield bronze-colored, the flesh tones pink, the hair black or blond. Accordingly, if one is asked to name the colors in such a picture, one might list each and every body color. The critic with special technical knowledge might amend this list, however, pointing out that the color of the pink flesh was actually mixed by combining red and white, of the brown chair by combining red and black, and so on. In this manner the list might eventually be shortened to include only our four basic colors, red, yellow, white, and black. Under these circumstances, for the purposes, let us say, of a contemporary critic who wished to discuss the overall aesthetic character of the major color harmony of a particular painting, there is nothing wrong with an analysis of the color that reduces the many variations of tone to a group of basic or "primary" color elements, as it were. It is perfectly true that the brown of the chair and the bronze of the shield may be considered as varieties of red. Yet the moment we were to step up closer to the picture, the entire situation would change, for it would soon become obvious that the real colors of which the picture is composed are not at all the same as those we named in our analysis of the overall design. It would become clear that the shadows of folds in the white of the cloaks were full of unexpected strokes of blue and violet, as we may see, for example, in the folds of the draperies in the white garments of the processional figures in the Kazanlak frieze (plates 11 and 12). A closer examination of the pink of the flesh tones may also result in a few surprises, for it would have to be admitted that the brushwork includes some strokes of the clearest blue, to say nothing of some accidents of green and purple where the strokes of blue overlap yellows and reds in the shadow, as in the head of Rhadamanthys at Lefkadia (plate 9) and in the head of the seated woman at Kazanlak (plate 14a). On the façade of the chamber tomb at Lefkadia, the yellow cloak worn by the seated old

4. A painting of a foreshortened black bull at Naples, Museo Nazionale, *The Punishment of Dirce* from the Casa del Granduca at Pompeii (cf. L. Curtius, *Die Wandmalerei Pompejis* [Leipzig, 1929], p. 284 and fig. 168), may be based on a work by Pausias. The original Pausias was in Rome in the first century B.C. in the portico of Pompeii. A mosaic at Corinth has been associated with Pausias's bull: T. L. Shear, "Excavations at Corinth in 1925," *AJA*, 29 (1925), 391 ff.

man (plate 5b) is in several places overlaid by a neutralizing pale-blue wash just as it is darkened in other places by bold strokes of earth red.

As an element in shading, blue is found in nearly all the fragments of ancient Greek painting we have discussed in our survey of the surviving examples. A highly instructive case in point is the use of blue in the tholos frieze at Kazanlak. Here is a composition strongly influenced by an early classical style. The approach to form is linear, as we found when we considered the problem of shading in an earlier chapter. In color, it is the kind of painting in which the body colors of individual objects are clearly identified and separable as elements in a rhythmic design. Nevertheless, among the figures in the funeral procession there are many examples of successfully rendered foreshortening, in which color and shading contribute as much as drawing to the impression of depth. This is particularly true in the quadriga group, where we see an empty wagon drawn by four nervously stepping horses led by a youth with a short stick or a whip, who grips their reins and tugs them into line behind the offerings bearers in the procession, leaning forward and extending his arm as he does so in order to give all four horses a better view of his whip hand as a warning.

All the foreshortened forms in this group—the wagon, the four horses, and the boy—are rendered in the transparent tones of a water color, allowing the white ground to show through the strokes of paint to form the highlights, while shadows are indicated by darkening the body color in a manner appropriate to each one. The darker accents naturally become more opaque, but there are no really densely painted areas—nothing that one might be able to describe as impasto, except the added white lines in the face of the seated woman (plate 14a), evidently intended to bring forward the forms of the nose and cheek. On the other hand, many of the deeper colors are rendered in brushstrokes that are not entirely absorbed by the plaster, so that a film of paint can be seen in places as a distinct layer lying on top of the plaster surface. Under these circumstances it is necessary to assume that the paint contained a binding medium, in which case we deal with a tempera rather than a fresco process, but one in which the transparency of colors is preserved.

The two outside horses in the quadriga scene are represented as having that wonderful dark-brown color with bluish-black reflections that is so characteristic a tone in certain chestnut pelts. The two chestnut browns frame two lighter horses, one white and the other a yellowish tan.

In addition to the white horse, there are white areas in the garments of the whipboy, and all these whites are obtained simply by allowing the background to show. All other areas of the composition seem to be underpainted with a thin, pale, transparent wash of earth red or what today we might describe as a kind of burnt sienna. With the strong white of the plaster showing through, the effect of this wash is a soft, rather neutral shade of slightly brownish pink. In the head of the boy, the suggestion of a darker flesh tone is achieved by a series of more fully saturated strokes applied on top of the transparent wash in areas of the chest, neck, arms, and face (plate 12).

The horse next to the boy, on the other hand, is overpainted not in deeper red or brown but in a wonderful shade of soft, dark blue, again transparently applied so that on top of the pale-red undercoat the strokes of blue are neutralized to form

an effect of velvetlike chestnut brown (plate 14b). Indeed, these strokes are applied in such a manner that every stroke achieves a slightly different color; the undercoat shows more in one place than in another, so that in some areas we see a neutralized red, in other places a violet blue. Touches of stronger red and blue are worked in here and there, intensifying and enriching the effect of color, and large, powerful strokes of dark, evidently a blend of the same red earth and dark blue, but now mixed first on the palette, give the pelt its fullest depth of tone. Finally come fully saturated, in some places quite opaque, strokes of the reddish brown, a color that appears dark when thickly applied, yet has the capability of producing much more redness when applied in transparency with more water. It is undoubtedly a true earth red, as true a red as it is possible to obtain from natural clay or earth. Used transparently on a pure white surface, or mixed with white, the color produces a clear but neutral pink as we see it in some of the flesh tones in the frieze. Used opaquely, or at its maximum strength, it is reserved for outlines and drawn details. In the horse's head, the artist has used it to draw the straps of the bridle and the reins (plates 10 and 14b). In addition, it is employed for lines around the ears and for the strokes which show the stiffly standing hair of the close-cropped mane along the back of the neck. In the boy (plate 12), the same opaque earth-red accents become a contour along the right side of the face, an outline of folds, the strokes in the hair, and finally the hatching lines employed to deepen the shadows along the left side of the nose, face, and neck.

In the rendering of human figures and horses, the color blue is nowhere seen in its purest state, although there is a blue transparency behind the red-brown strokes in the boy's hair, which achieves a high degree of clarity. Elsewhere, however, especially in the interior brushwork of the dark-brown chestnut horses, we sense the tinting power of the deep-blue pigment by its ability to neutralize the very rich, very deep brownish red of the earth color in order to produce a blackish tint, but we are not permitted to see the blue itself at full intensity.

Thus we may say that throughout the tholos frieze at Kazanlak, blue has been consistently employed as the complement of earth red and yellow in order to create the sense of variety in tone appropriate to a representation of local colors affected by the play of dark and light, exactly as the analogy of Empedocles suggests. The blue itself is a rather special one. It is a dark blue with a slight overtone of violet, and rather neutral when compared to a similar blue in modern pigments known as deep ultramarine. It is clearly not the same pigment employed in certain parts of the frieze to represent the body color of various small objects among the funerary offerings being placed before the seated couple. The folded cloth over the arm of one member of the procession (plate 11), an object on a tray being carried by another (plate 13a), one or two objects already placed on the offering table itself are all rendered in a much lighter blue, corresponding to the modern cerulean blue or cobalt blue.[5] Cerulean blue has sometimes a very slightly greenish cast and is very much lighter than deep ultramarine, so that both

5. Robertson, *A History of Greek Art* (Cambridge, Mass., 1975), p. 567, suggests that a special blue was reserved to represent metal, but to my eye it is the same blue used in the ceremonial cloth in plate 11. It seems more likely that a distinction was made by the ancient master between a blue employed as a darkener in shading and a brighter blue employed as the body color for certain sacred objects.

pigments are needed in order to give the painter a means of obtaining unlimited modulations within the band of the spectrum running from green to blue to violet.

That the ancient painter made use of both these standard varieties of blue cannot be doubted once we observe the coloring system in the Kazanlak frieze. Moreover, it is a fact, as we have already noted (see note 5), that except for those small touches of lighter blue that seem to be reserved for certain sacred objects, the entire frieze is carried out in a typical four-color scheme, like the Alexander mosaic, with a harmony of color based on the contrasts of dark reds and blackish browns with a subtly varied range of lighter ochers, grays, and whites. Of course, the chiaroscuro, the drawing, and the modulation and nuance of colors are nowhere near the highly accomplished level of the Alexander frieze, but we deal with a minor provincial town and a tomb decoration no doubt executed by journeymen artists, whereas in the case of the Alexander mosaic we have a copy of a major masterpiece of Greek art. Nevertheless, it is clear enough that despite the obvious differences in quality, the same controls have been observed in both paintings with respect to the use of blue. Aside from the minor role assigned to cerulean blue in the frieze, the major harmony in both these works restricts the use of blue to the role of a darkener in the process of shading, while the colors we actually see and identify as the body colors of the major forms may be grouped around just four color names—red, yellow, white, and black—as in the ancient literature.

This, then, provides an answer to our dilemma. The omission of blue in the four-color tradition refers not to the actual limitation of the palette itself, but to an aesthetic choice in which blue and its derivatives, green and violet, were excluded from playing an important role in the harmony of the overall composition, though they might occur here and there in the varied strokes of color making up the shadows and modulations of flesh tones, browns, grays, and other variants of what the ancient viewer took to be the body colors of the objects and figures in the design. But the sources of Pliny were not merely critics; some are presumed to be professional artists. In that case, we might ask the question differently: Why did Pliny not realize that the actual pigment involved in a four-color group (for he names pigments, not colors, and describes them in professional terms) had to include a dark blue rather than a jet black? Here we may recall the ingenious suggestion of Bertrand, referred to earlier.[6] Perhaps, indeed, the ancients were in the habit of thinking of the blue component of the four-color palette not as a color at all but as a darkener, in which case they formed the custom of referring to what all understood in reality to be a pigment "capable of giving blues" as the component of dark in a four-color system, ultimately the element employed in the process of painting to create the areas of black in the design.

Support for this rather strange-sounding idea actually comes from an unexpected quarter—namely, from Platnauer's analysis of the ancient color epithets in which the Greek word for "black" occurs.[7] Platnauer points out that the one Greek term that is most commonly translated into Latin and other languages as "black" *(niger)* cannot be construed as denoting an actual black pigment in most of

6. See ch. 8, n. 8.
7. M. Platnauer, "Greek Colour-Perception," *CQ*, 15 (1921), 153 f.

the passages in which it occurs. The word is μέλας, the broader meaning of which corresponds to "dark" in English. Platnauer lists a number of examples in various ancient Greek writings, in which the word μέλας occurs. In many of these cases it seems to denote not merely "dark" in the absolute sense, but any color that appears darker than its nearest surroundings. For example, from Homer on, many poets commonly use the word in reference to darkening blood, waves, clouds—in short, in any situation where a dramatic effect is produced by thinking of something as darkened or blackened, no matter what the actual color of that object might be. Presumably, Platnauer's later remarks notwithstanding,[8] the Greeks knew quite well that clouds are white or gray, waves are blue, and blood is red. But under certain conditions, all of these things may appear not actually black, but darkened, or having dark reflections; whenever this happens we are apt to feel a special quality about color, one that suggests, perhaps, the presence of danger or evil. In some instances, as when, in Theognis, the word μέλας is used in reference to rust,[9] the meaning would appear to be simply the deprivation of shine, or the absence of brightness. Metal rust is hardly ever truly black, but certainly the areas of rust on an originally polished blade might very well appear as darkened.

Although it thus seems perfectly clear that the poetic meaning of the word μέλας is not literally "black" but "darkened," it is also true that on occasion, especially in descriptive prose, the same word might actually refer to the color black per se. This is proven by a passage in Herodotus, in which he describes the walls at Ecbatana.[10] In that city, the palaces and the treasuries of Deioces, king of the Medes, were surrounded by seven circles of fortification walls, each one a different color.

This fortress is so planned [writes Herodotus], that each circle of walls is higher than the next outer circle by no more than the height of its battlements. . . . The battlements of the first circle are white, of the second black, of the third circle purple, of the fourth blue, and of the fifth, orange; thus the battlements of five circles are painted with colors; and the battlements of the last two circles are coated, these with silver, and those with gold.[11]

This passage is of the greatest value to us, since it contains an explicit reference to the color black itself. The Greek word used by Herodotus, however, is μέλας, the same as the word used by Homer and the other poets to mean "darkened." We may conclude that μέλας can, indeed, refer to a black pigment or paint, while at the same time it might be understood in less technical contexts to be a darker-than-normal shade of any other hue. It is easy to see how a Greek writer describing the colors in classical paintings might use the term in its broader sense to refer to the pigment that was employed, not as an independent color in a design, but rather as a *darkening agent*. And it is easy to imagine, also, that Pliny and others, reading this word in a technical treatise on color, might understand it to refer specifically to a black pigment. Pliny's passage in Latin can only refer to the color black itself, especially since he specifies that the pigment used was "atramentum," which elsewhere has been described as soot made by burning

8. *Ibid.*, 162.
9. Theognis, A. 451.
10. Herodotus, I, 98.
11. *Ibid.* (Loeb ed., trans. A. D. Godley).

various materials ranging from resins to ivory.[12] There can be no doubt that in employing these terms it is Pliny's intention to denote a jet-black color.

Actually, there is sufficient proof that a true jet-black, hard and opaque in character, acquired an important place in ancient art on many levels including the classical. The use of such a black in Greek vases has an aesthetic meaning far beyond that of an ordinary color. In red-figured vases, the uncompromising flatness of the black glaze around the figures, "its absolute insistence on a void,"[13] seems to magnify both the sense of life and the formal strength within the figures. Attic red-figure vases were popular in Italy throughout late Etruscan and early Roman times, where the polished black glaze of the Greek products repeated the black of Etruscan *bucchero* and was later echoed by a black-glaze ware widely produced in Italy in Roman centers. The use of dark, polished marble, which had been one of the new decorative ideas introduced into the monumental architecture of Periclean Athens, by the first century B.C. in Italy had been translated into the shiny black surfaces which were so characteristic a feature of interior decoration in the so-called Pompeian first style.[14]

As the dark marble of Eleusis was originally used by Mnesicles in the socles and stringcourse of the Propylaea,[15] the color black acts as a kind of framing device, and in that sense its use in architecture is analogous to the aesthetic meaning of black in Attic red-figure vases, where it also acts as a frame. The possibility that four-color artists such as Polygnotos employed areas of black as an element of design cannot, of course, be proven, but it seems likely that in monumental painting solid black may have served a framing function, at least as the socle for a frieze, while within the pictorial composition itself a bluish tone or "darkener" would have been used for shading rather than black and also for the mixing of the darker colors, as we have observed such a process at Kazanlak.

The dilemma in which we are placed by Pliny's exclusion of blue may be resolved in yet another fashion. In some cases, the difference between jet black and bluish "darkener" may have involved for the ancient craftsman no actual difference in pigment at all. Pliny, himself, speaks of a pigment that appears black in the lump or in powder form, but becomes a purplish blue when mixed with water and diluted: "cum cernatur nigrum, at in diluendo mixturam purpurae caeruleique mirabilem reddit."[16] The general sense of the passage seems to be that "on sight" or "when you first see it," this pigment appears black; thus "cum cernatur" may apply to the appearance of the pigment as it is seen in jars or bins in color shops prior to its being mixed with a liquid medium in the artist's work rooms. At Kazanlak, such a pigment, indeed, was used. In the painted socle in the dromos we see a jet black, but this same pigment, where it has splashed

12. Pliny, *NH*, XXXV, 41.

13. This phrase is a quotation from a classroom lecture on ancient painting by Otto Brendel.

14. L. Shoe, "The Use of Dark Stone in Greek Architecture," *Hesperia*, Supplement 8 (1949), 343 f., 348 ff.

15. *Ibid.*, 348 ff. Black-painted socles are found, for example, in the tomb at Kazanlak, in the Hieron at Samothrace, and in houses at Olynthus and at Morgantina.

16. Pliny, *NH*, XXXV, 46: "in the lump, black, but diluted it is transformed into a marvelous purplish blue" (trans. K. C. Bailey, "The Pigments of the Ancient Romans as Described in the Natural History of the Elder Pliny," *Chemistry and Industry*, N.S. 44/27 [November 20, 1925], 1136). The term "cum cernatur" has been variously translated. Rackham, in the Loeb ed., p. 295, wrongly uses the phrase "when it is sifted out." Cf. S. Augusti, *I colori Pompeiani* (Rome, 1967), p. 110.

accidently in transparent droplets onto the white of the picture field appears blue—the same dark and neutral blue that was used in the shading of the horses and figures of the tholos frieze.

In reality, almost any black pigment will behave in this manner—that is, it will appear bluish when diluted and black when opaque. Even ivory black, one of the blackest of modern black pigments, will not remain black when it is diluted sufficiently to allow a white surface to show through it. When it is mixed with white paint, the result will be a cold, bluish gray, which can only be made to look true gray by the addition of some complementary warm tone to neutralize the blueness in it.

Another clue to the fact that blue and black pigments were somehow connected in the minds of the ancients is provided by Vitruvius, who devotes a whole chapter to the color black.[17] After explaining that the use of black is often required in buildings, he tells us how a real black pigment may be produced by burning resins. But since this requires a special furnace with a vaulted chamber attached to it to catch the soot from the fire, and such a furnace is not always immediately available, Vitruvius provides us with a series of alternative recipes for making imitation black pigments, remarking that it is better to use a substitute for black than to hold up the construction of a building if the real thing is not to be had at once. The most pleasant of these imitation blacks, he says, is made by burning the dry dregs of wine:

et quo magis ex meliore vino parabitur [continues Vitruvius], non modo atramenti sed etiam indici colorem dabit imitari ["and the use of the finer wines will allow us to imitate not only black but indigo"].[18]

Since Pliny also describes an indigolike black pigment, as we have seen, we may reason that the existence of a black pigment that could be employed as an indigo blue for the shading process in painting may have been in common use.

If that is true, then the fact that Pliny does not explain the exclusion of blue from a palette ostensibly consisting of the four primary colors is no longer a mystery. He may simply have taken it for granted that his readers would understand that the bluish tones needed in the shading process could be derived from the most commonly known black pigments. Thus we need not disallow the validity of Pliny's statement. It is clear from the evidence of Kazanlak and from other examples like the Alexander mosaic that in the paintings of the four-color artists, blue, green, and purple were greatly reduced in importance, and this was what no doubt operated in the back of Pliny's mind. At the same time, blue might still play a role in the mixing of variations of yellows, reds, browns, and grays. As an independent color, it might also appear in the hatching that belonged to shading in a four-color design without reducing the overall effect of the picture as belonging in the four-color category.

In the white-ground lekythoi, Attic vase painters of the late fifth century B.C. evidently preferred to work in the red-yellow color range, and black, again, is important.[19] The fact that blues and greens do indeed occur in some of the

17. Vitruvius, VII, X.
18. *Ibid.*, VII, X, 4. The translation quoted is by F. Granger, Leob ed. (Cambridge, Mass., and London, 1945), p. 123.
19. W. Riezler, *Weissgrundige attische Lekythen* (Munich, 1914), pp. 78 f.

lekythoi[20] is proof that the limitation was arbitrary and not a technical necessity. In the latter part of the century, the lekythoi painters show a tendency to increase almost indefinitely the nuances of a single color, red.[21] So numerous do the various shadings of red become that, according to Riezler, the original sense of a clear, decorative color system is sacrificed to coloristic effects that are not, perhaps, appropriate to vase painting.[22] Thus, one cannot escape the impression that classical artists practiced deliberate color restrictions of the kind described in the literary tradition, experimenting with the nuances of individual colors and testing the expressive potentialities of various harmonies from which certain parts of the spectrum were definitely excluded.

An austere and probably highly symbolic four-color harmony, so well illustrated by the Alexander mosaic, was undoubtedly an invention of the earliest classical painters as they struggled to make successful inroads against the long-established two-dimensionality of color. In their efforts to simplify the coloring process and in order to emphasize shading and form they experimented with limiting color in various ways. Out of these experiments, a standard method of combining the basic or primary colors in order to create an atmosphere of depth thoroughly consistent with new ideals no doubt gradually proved its worth, to be seized upon by certain masters of great reputation because of its aesthetic as well as its methodological advantages. Eventually it would seem that the artists of even the later periods of classicism might deliberately return to the coloristic practice that by then had come to symbolize the simplicity and austerity of an earlier age, so that it might be brought into contrast with more elaborate styles as a means of aligning one's own talents with a tradition of restraint. In this way the four-color palette became a feature of recurring significance so that it was a matter still often discussed in the artistic and literary circles of Rome.

20. As in Arias and Hirmer, pl. XLV, a "group R" vase in Athens.
21. Riezler, p. 79.
22. *Ibid.*

10

Color Blending
in Plato's *Timaeus*

"It must be admitted," writes W. S. Hett in his introduction to Aristotle's *On Sense and Sensible Objects*, "that Greek views of the blending of colours are generally perplexing."[1] The difficulties arising from the interpretation of color designations are to be encountered not only in the poets, but also in Greek philosophy, as we have had occasion to observe.[2] In ancient philosophy perhaps the most perplexing statements occur in a long passage on color in Plato's *Timaeus*.[3] The *Timaeus* is one of the late Platonic dialogues and one of the most difficult to interpret;[4] indeed, the language of the passage on color often seems as obscure as it does in the fragments of Empedocles and Democritus. It has been said of the discussion of colors in the *Timaeus* that "this particular section of the dialogue is perhaps the one of all others that we must never expect to understand fully."[5] This much-discussed part of Plato's writing may well assume a different aspect, however, if we apply to it some of the findings of our preceding chapters concerning the special connotations of the colors black and blue in the context of ancient criticism.

The passage in the *Timaeus* is part of a discussion on metaphysics, and perhaps not every statement in it can be readily explained in terms of ordinary color

1. W. S. Hett, "Aristotle on the Soul," in Aristotle, *On Sense and Sensible Objects*, Loeb ed. (London, 1947), p. 210.

2. See ch. 8, *passim.*

3. Plato, *Timaeus*, 67C ff.

4. A. E. Taylor, *A Commentary on Plato's Timaeus* (Oxford, 1928), pp. 479 f. As Taylor points out, there are striking similarities between the *Timaeus* passage on color and the passage quoted from Democritus in Theophrastus (*De Sensu*, 73). In contrast to R. D. Archer-Hind's opinion, Taylor sees no difficulty in stating that *Timaeus* adopts an Empedoclean doctrine of color perception (*op. cit.*, p. 480).

5. Taylor, p. 479. Taylor's analysis of the difficulties that may impede us in any attempt to understand the *Timaeus* passage (*loc. cit.*) includes Platnauer's suggestion that we cannot be certain "whether a difference in color-names in Greek is meant primarily to indicate a difference in tint or one in brilliancy and lustre."

perception. Nevertheless, certain remarks on color mixing are interesting and are definitely related to practical experience. The following is the way the passage sounds in a Standard English version, that of Jowett:

A bright hue mingled with red and white gives the colour called auburn (ξανθόν). The law of proportion, however, according to which the several colours are formed, even if a man knew he would be foolish in telling, for he could not give any necessary reason, nor indeed any tolerable or probable explanation of them. Again, red, when mingled with black and white, becomes purple, but it becomes umber (ὄρφνινον) when the colours are burnt as well as mingled and the black is more thoroughly mixed with them. Flame-colour (πυρρόν) is produced by a union of auburn and dun (φαιόν), and dun by an admixture of black and white; pale yellow (ὠχρόν), by an admixture of white and auburn. White and bright meeting, and falling upon a full black, become dark blue (κυανοῦν), and when dark blue mingles with white, a light blue (γλαυκόν) colour is formed, as flame-colour with black makes leek green (πράσιον).[6]

Some of Jowett's color names have ambiguous meanings, even in English—for example, auburn. In Platnauer's catalogue of color names,[7] the word ξανθός, translated by Jowett as "auburn," is found in many and varied connections. Platnauer's list of objects to which this color is applied includes the hair of Achilles and of Menelaos, horses, flame, honey, wine, the color of the flowers of laurel and ivy, and apples; moreover, in Aristotle's *Metaphysics*, it represents one of the colors of the rainbow. The translation in Jowett of this term as "auburn" seems very strange, for in English *auburn* is usually defined as an orange-brown color with reddish or copper highlights, and it is thought of as a color of low saturation and brilliance. In Platnauer's article, the term is more accurately rendered as a yellow. If it is a color in the rainbow it would indeed have to be a yellow of full intensity. There are no browns in the rainbow. Within the color scale of the rainbow, this color might be a bright, fully saturated orange-yellow, corresponding to a deep cadmium yellow in modern terms. The word πυρρός seems to refer to a very similar yellow color. In the Jowett version of the *Timaeus* passage it is translated "flame-colour," although Bacchylides uses ξανθός for flame. The term does not occur in Homer, according to Platnauer, but is used later as the most frequent color name for blond hair. In addition, Aeschylus applies this term to a lion, Hippocrates and Galen to the yoke of an egg, and Moschus to a rose.

The lists for both of these terms include objects that might be both bright and dull. Yellows such as that of the color of the yolk of an egg or the color of a flame are bright, but, by comparison, the yellows of a lion's pelt or a horse's coat are rather muted colors. There seems little doubt, however, that in terms of an artist's pigments, both would have to refer to orange-yellow colors rather than to the pure yellows or the lemon or greenish yellows. In other words, we may exclude the yellows on the side toward green in the rainbow and keep those on the side toward red without going so far as to use a term like *auburn*, which implies a brown. One possibility is that one of the terms, ξανθός, because of its inclusion in the rainbow, is a pure yellow like our deep cadmium, while the other term, πυρρός, is an earth yellow like our yellow ocher. Under certain conditions,

6. B. Jowett, *The Dialogues of Plato*, II (New York, 1937), 47 (*Timaeus*, 68).
7. M. Platnauer, "Greek Colour-Perception," *CQ*, 15 (1921), 162. Cf. ch. 4.

yellows in a painting made with these two very different pigments are indistinguishable from each other. A transparent stroke of yellow ocher placed on a very white surface will look almost as bright as a transparency made with the brightest cadmium yellow. When used opaquely, at full saturation, however, the difference between the two pigments becomes obvious: one of these pigments would look rather dull and tawny, like a lion's pelt; the other would look as bright as a sunset in Turner's Venice. The point is that a yellow ocher mixed with white or placed transparently on a white surface can be used perfectly well to render the clear pale yellow of a yellow rose, so that the appearance of items like the rose in connection with the word πμρρός presents no difficulty. If we speak of pigments, πμρρός should be translated as yellow ocher, ξανθός as bright yellow. In poetry, everything "yellowish" can be described by either term. The English word *auburn* is of little help. More recent English translations employ the word *orange*, but this also is rather ambiguous.[8]

The word φαιός in the *Timaeus* passage, translated by Jowett as "dun," is also a controversial term in English, but it seems very unlikely that when Plato described this color as an admixture of black and white, he could have had anything in mind but a gray. A serious difficulty seems to arise, however, when Plato goes on to say that φαιός and ξανθός (translated "auburn") produce πυρρός (translated "flame-colour"), for it is patently impossible to imagine a mixture of brownish red and gray that would result in a bright yellow. If, however, ξανθός meant a bright yellow orange instead of auburn, as I have suggested, and πυρρός meant yellow ocher or earth yellow, it would certainly be very possible to combine φαιός with ξανθός to produce πυρρός (gray with bright yellow to produce yellow ocher). Indeed, if a painter wishes to soften a bright cadmium yellow to the more delicate yellow of a rose or a yellow apple, for example, he would, in fact, neutralize or "gray" the color. In the same way, the observation that pale yellow, according to Plato, consists of an admixture of white and ξανθός becomes much more credible if ξανθός is bright yellow rather than auburn.

With these corrections in mind, the list of color mixtures in Plato's *Timaeus* becomes far less troublesome. Another series of impossibilities is removed if we make a correction in our reading of the term μέλας. The principle to be applied to this passage is to read the term for black in its meaning not as a jet-black pigment, but as a darkening agent capable of appearing blue or of acting like blue in its role as the complement of red and yellow. More often than not, this term is used in literature in the sense of intensification of color or a darkening of color rather than for the color black itself. According to Platnauer:

in later Greek it seems to have been the usual 'intensive' colour prefix, e.g. (of figs) μελάμφαιος (as opposed to λευκόφαιος) in Athen. (3. 13); so μελαμπόρφυρος of dark purple in Pollux (4. 119), etc.[9]

The reading here proposed of the term μέλας as a kind of bluish "darkener" fits perfectly the formula at the end of Plato's color passage in the *Timaeus*, where he states that πυρρός (yellow ocher) and μέλας make πράσιος, or leek green.

8. For example, see the translation by Francis Cornford, in his *Plato's Cosmology* (New York, 1957).
9. Platnauer, 154.

This formula is repeated in an interesting manner in the *De Coloribus* of Aristotle:

In all plants the original color is herb-green: thus shoots and leaves and fruit begin by taking this color. This can also be seen in the case of rain water; when water stands for a considerable time and then dries up, it leaves an herb-green behind it. So it is intelligible why herb-green is the first color to form in all plants. For water in process of time first turns yellow-green on blending with the rays of the sun; it then gradually turns black, and this further mixture of black and yellow-green produces herb-green. For, as has already been remarked, moisture becoming stale and drying up of itself, turns black. This can be seen, for example, on the stucco of reservoirs; here all the part that is always under water turns black, because the moisture, as it cools, dries up of itself, but the part from which the water has been drawn off, and which is exposed to the sun, becomes herb-green, *because yellow mingles with the black.* Moreover, with the increasing blackness of the moisture, the herb-green tends to become very deep and of a leek-green hue. This is why the old shoots of all plants are much blacker than the young shoots, which are yellower because the moisture in them has not yet begun to turn black.[10]

This passage is most illuminating. First of all, for once we have no difficulty in understanding which colors are denoted by the color names because we can align them with leeks and other objects in our own experience. Roses and apples and the skins of lions and horses may be a hundred different shades of yellow, but here we can actually visualize the transition described from a pale yellow-green to the full, bright green of new growth to the shaded, darker, and deeper green of the mature leek. Nothing could be more specific than the term "leek-green," for the leek has a very special dark-green color, like a bright green somehow "blackened." The point is, of course, that the entire description would sound more plausible if here, again, the word μέλας, Aristotle's word for black, were thought of as denoting a bluish black rather than a jet black. That herb green is produced "because yellow mingles with the black" is a statement that seems to be completely obvious. Apart from the curious, but quite interesting, observation that the transition from light green to dark green occurs in plants as they grow older because of the darkening effect of water (a theory that need not concern us here), Aristotle's reasoning clearly rests on an experience of color that is self-evident and easily verifiable. It was evidently, for him, a matter of ordinary experience that when actual colors were mixed, as, for example, on an artist's palette or in the paint pots of the craftsmen who decorated buildings, yellow plus "dark" equaled herb green, and herb green plus more "dark" equaled leek green. Leek green can only be obtained in a mixture with yellow when a neutralized, darker blue is used, a blue that would be very close to the color of the "darkener" we have postulated as the correct translation of μέλας.

If a brighter blue, like Egyptian blue, is used instead, that special shaded quality of the green in the leek would not appear. And if jet black rather than dark blue is used, the result would be closer to muddy gray. The only possibility is to consider μέλας as the soft dark blue we have seen at work in the rendering of the quadriga scene at Kazanlak. With these changes, then, most of the difficulties encountered in understanding the color mixtures described in the *Timaeus* disappear. The passage, considered as a quotation from a pre-Socratic source,

10. Aristotle, *De Coloribus*, ch. 5, 794 b (in vol. 6 of the *Works of Aristotle*, ed. W. D. Ross, trans. T. Loveday and E. S. Forester, 2nd ed. [Oxford, 1952], pp. 19 ff.).

may be regarded as a valid piece of literary evidence that the Greeks of the period of Empedocles and Polygnotos were already quite familiar with the way pigments act in mixtures. For this reason, the *Timaeus* strengthens the supposition that a four-color theory involving a set of primaries from which a full range of colors could be mixed was perfectly within the grasp of Greek artists of the early classical period.

11

Conclusions:
The Dichotomy of
Form and Color

Il y a une division traditionelle, quand on
parle de l'art; celle des formes et des
couleurs. Division facile, division scolasti-
que en apparence, et, en réalité extrémement
profound. . . ,

—Réné Huyghe*

Precisely because they are scattered geographically and disparate in date, the
extant examples of Greek painting serve to demonstrate the fact that certain
principles of form and color became widely established in Greece in connection
with the invention of chiaroscuro in the fifth century B.C. and were so thoroughly
ingrained in the process of artistic training that by recognizing them for what they
are it becomes possible to reinterpret many of the literary passages that have
seemed difficult to translate or to align with our own experience of painting
methods. One of the points that emerges from such a study is that there are
obvious parallels between the problems that confronted painters in antiquity and
the problems that had to be solved by painters in the Italian Renaissance. Both in
antiquity and in the Renaissance, we see the same instinct for the limitation of
color, the same tendency to suppress decoration, the same preoccupation with
drawing and contour, all growing out of the artist's efforts to achieve an illusion of
space and light while compensating for the loss of artistic effects that had been
traditional in earlier art. Both in antiquity and in the Renaissance, the tendencies
and preoccupations resulting from experiments with three-dimensional form led

*From R. Huyghe, "La Couleur et l'espression de la durée intérieure en occident," in *The Realms of
Color*, ed. A. Portman and R. Ritsema, *Eranos Jahrbuch*, 1972, 41 (Leiden, 1974), p. 217.

to a kind of dichotomy between form and color that seems to have become a profound condition of Western art, as Réné Huyghe explains.[1] In his analysis, form at first seems to banish color, which then has to be reintroduced into art. But in antiquity, and in the Renaissance as well, color is reintroduced in such a way that a conflict or dichotomy becomes established between coloristic methods of rendering forms in space and a linear method combining chiaroscuro with a clear emphasis on outline. What Huyghe and other critics do not so far accept, however, is the fact that color had already been reintroduced into painting by Greek artists of the classical period itself, and that the fundamental dichotomy we recognize in later periods of art was already established at that early time.

It is true, however, that special conditions apply to the dichotomy of form and color in antiquity. One difference between the solutions achieved by ancient painters and those reached by artists in the Renaissance as they attacked the problem of inventing a coherent system for the representation of forms in space has to do with the color black. In antiquity, jet black, fully saturated and opaque, was a color that had a special history and an aesthetic importance far greater than in any other period in history. In Greece it was important not only in the vases, but also in wall decoration as an element of architectural design, as we may see, for example, in the widespread popularity of the black-background frieze (plates 16a and 16b), a feature of interior decoration found not only at Delos, but also in recent excavations at Knidos[2] and as far away as Etruria.[3] When shading was invented, and when a complement for the warm earth colors had to be found for the mixing of naturalistic flesh tones, it became necessary for the ancient artist to make a careful distinction between the opaque black he was accustomed to using in various parts of interior design and a color that could act as a darkening agent in rendering shadows and darks in representations of the human figure. Black could not be used in mixtures with reds and yellows without producing muddy colors. Instead, a dark-blue pigment capable of neutralizing reds and yellows was universally adopted. This pigment could be mixed with the warm range of tones, preserving the nuance that only a blue can give yet achieving the role of a darkener. This blue-black pigment thus made possible the famous four-color palette, a palette that omitted blue as an active color in pictorial compositions yet included a darkening agent capable of producing a high degree of nuance in chiaroscuro and in the variety of reds and yellows, browns and ochers obtainable. The resulting harmony was one that had been familiar to the Greeks for many generations, and now, by an adaptation to the requirements of three-dimensional representation, it became a hallmark of classical art. Thus in Greek painting, there was a special palette or harmony from which the hues in the green-blue-violet range that might occur as the actual body colors of objects in pictorial composition were entirely omitted. In Renaissance art, while there was undoubtedly an awareness of the earth colors as a group, and an understanding of the basic opposition between the *colores austeri et floridi*, there seems to have been more flexibility, less standardization, and perhaps less reliance on established

1. *Ibid.*, pp. 217 ff.
2. See Introduction, n. 6. For the Knidos examples, see p. 42, n. 8.
3. V. J. Bruno, "A Town House at Cosa," *Archaeology*, 23 (1970), 273, color ill.

convention in the categorization of pigments and in the selection of complementary colors for shading. For example, in his San Marco frescoes, Fra Angelico omits all traces of the bright and decorative colors he favored in his panel pictures. In the frescoes, his palette is, indeed, austere, restricted predominantly to earth colors. Yet, delicate and neutral shades of green and violet are often included among the subdued, restricted tones of the frescoes, as, for example, in the Crucifixion in cell 43, where a rectangle of pale green sets off the figure of Christ on the cross.[4] In other words, the reaction of Greek painters to the dichotomy of form and color that arose as a result of the invention of shading, the same dichotomy of which Réné Huyghe has written, and the same that seems to have affected Italian artists in the *quattrocento*, appears to have been more severely felt in ancient Greece than in the Renaissance.

As a matter of fact, a dichotomy had already existed in earlier Greek art on yet another level. As early as the Minoan-Mycenaean period, we may observe a tension created by the opposition of color and drawing that invests the experience of painting in Greece with a certain excitement and with certain expressive possibilities that are not always present in the Oriental styles, where internal formal conflict is often neutralized. For example, in the room of birds and lilies at Thera,[5] the artist's delight in lavish color is confined below the irregular and rhythmic groundline of the rocks, where a sequence of red, yellow, and blue areas with variegated veining evidently repeats in an unexpected manner the conventions established for the representation of colored stone in Minoan architectural decorations and floors.[6] In this room, conventional colors are employed pictorially to suggest a rocky landscape; yet the areas of color form at the same time a definite zone, an abstract design, such as those that are based on architectonic motifs. Above this zone, however, where we see the flowers and birds, the forms represented are expressed not in broad color areas, but entirely, or almost entirely, in drawing. Calligraphic strokes of deepest black, or of fully saturated earth red, are skillfully and deftly applied to a polished surface of gleaming white, describing in a kind of linear shorthand the lifelike forms of the lilies and the breathtaking movements of the hovering birds. This division of calligraphy and color into separate zones within the same mural composition in Bronze Age Greece is symptomatic of what is in store for us later. Throughout the various forms of early Greek painting, in wall paintings, panels, and vases, we sense the conflict between a craving for the beauty of color and a desire to discover a different kind of beauty that can only be expressed in line. Both kinds of beauty are strongly felt in all Greek art and seem strongly desired by the artist, yet they are somehow kept apart. In vase painting, chromatic effects, although they became popular at Corinth, never overpowered the black-figure style at Athens, a fact that is often noted but almost never appreciated for the kind of art-historical miracle that it is. For the desire for color was always present, in Athens as in other parts of Greece. In Attic black-figure vases, it is a desire that is sublimated, but not suppressed. Exekias, instead of adding colors to his vases, showed how the artist can suggest profusions of color by means of almost magical

4. J. Pope-Hennessey, *Fra Angelico*, rev. ed. (London, 1974), p. 181.
5. S. Marinatos, *Excavations at Thera* (Athens, 1971), IV, color pls. A, B, C.
6. E. Hirsch, "Painted Floors at Gournia," *Archaeology*, 28 (1975), 260–266.

arrangements of contrasting textures, minute patterns fluently laid on by means of meticulous incision. The Amasis Painter, Exekias's contemporary, seemed to make the color of his clay take on the brilliance of scarlet by means of the lavish, Matisselike curves of tendrils and the vivid clarity of his figures, his quick and graceful lines applied to a clay surface unexpectedly brightened by the application of a pale orange slip beneath the picture.

The invention of the red-figure technique in the late sixth century B.C. had already familiarized Greek artists with the alternatives of adding or restricting color in special contexts. But it could easily be discerned that the addition of white and purple in a red-figure design had the effect of reducing the energy of the contour line and the suggestiveness of transparencies and interior detail. Undoubtedly the same lessons were to be learned in parallel examples of monumental painting as three-dimensional rendering developed by means of the foreshortened drawings of limbs and draperies. This long experience in the art of the early fifth century B.C. provided a special background for the artists of the classical revolution. At the same time, the ancient love of decorative color lavishly applied, still so much a part of architectural surroundings, evidently remained undiminished throughout the classical period.[7] Because a conflict of interests between color and drawing had been a reality for the practicing artist in Greece for so long, the dichotomy of form and color must have become an instinctual part of the awareness of the Greek artist when, sometime near the mid-fifth century B.C., he was at last ready to paint three-dimensionally. The invention of shading created a crisis in art, especially for the role of color, and the step from instinctual knowledge to the explicit rule was an only natural one to take. The four-color palette, as a practical solution to a real and traditional conflict, was an invention intimately bound up with the technology of three-dimensional representation in monumental art, a manifestation of the initial reluctance of Greek artists to sacrifice contour and calligraphy. By limiting color, a convincing spatial atmosphere could more readily be obtained. And within that atmosphere, the absence of brilliant hues allowed the artist to exploit more fully the subtle and easily disrupted play of the contour line and the calligraphic accent as supplements to chiaroscuro.

The four-color method thus probably began as a practical safeguard. But it developed as an aesthetic law, a permanent and recurring feature of classicism. Perhaps its significance as an aesthetic choice can only have been realized in later generations, in the fourth and third centuries B.C., when artists became familiar with a method of showing form that might embrace a wider chromatic scale. Once a choice was made possible between a coloristic and a drawing method, the full realization of the aesthetic characteristics of the restricted palette in three-dimensional representation became possible also. When the reintroduction of color assumed the character of full-scale revolt against traditional practice, the advantages of an older restriction became clear.

It is, of course, extremely difficult to fix a date for this critical moment in the history of classical painting, but it is my belief that a basis for controversy over the dichotomy of form and color came into being at an early stage of classical

7. P. Dimitriou, "The Polychromy of Greek Sculpture," Ph.D. diss., Columbia University, 1951 (with bibliography).

art—certainly not long after the end of the fifth century B.C. After that, exponents of color, such as Euphranor,[8] seem to alternate with exponents of the four-color method, the use of which, by the late fourth century B.C., must have carried with it the significance of an explicit artistic position, an aesthetic attitude that involved participation in ongoing and evidently heated conflicts of interests, attitudes, and tastes. Euphranor wrote a book on color, and Lucian records an anecdote in which the painting of Euphranor is contrasted with that of Parrhasios.[9] The latter is said to have painted a hero, Theseus, in such a way that he appears to have been fed on roses, while Euphranor's picture of Theseus makes the hero look more like he was fed on beef. This story may easily represent a reflection of the controversy between the colorists on the one hand and the advocates of draftsmanship and line on the other in Greek painting of the classical period.

In later periods, artists may have experimented with the four-color palette for a variety of purposes, both aesthetic and symbolic in character. In that case we might entertain the possibility that the four-color harmony may on occasion have been reserved for certain kinds of subject matter, such as a warfare, as in the Alexander mosaic, where the austerity of the earth colors seems perhaps more appropriate than a brighter range of hues.

Another contrast between ancient and Renaissance solutions to the dichotomy of form and color lies in the evident importance in Greek art of the elements of spontaneity and calligraphy. In the Renaissance and in later, so-called neoclassical styles, the linear approach to form has often been associated with a certain quality of formalism and rigidity, so that it is rather surprising to find that in ancient Greek paintings the more linear performances can also show the most astonishing spontaneity. In the tholos frieze at Kazanlak, for example, where the painting performance is one that we have classified as a linear or "drawing" method (see Chapter 1), the rendering of the youth leading the horses (plate 12) shows that, contrary to our expectation, in ancient practice the linear approach to form need not exclude the quality of spontaneity and immediacy. The broad, sketchy quality of the rendering of this figure vividly suggests a moment of action. The horses of the quadriga resist the turn they must make to join the procession. The boy leans forward and shows his whip, his hair caught by a gust of wind; the nearest horse is nervous and tense and tugs against the reins. Throughout this passage, the outlines are broadly accented with big, quick, deftly brushed strokes. Swiftness of execution and a reliance upon accidents brought under control are the hallmarks of great calligraphy, and it is by such means that the sense of the momentary episode in the frieze is captured. Calligraphy as part of figure drawing was undoubtedly a much-admired accomplishment of Greek painters for a very long time, if we may judge by the many beautifully calligraphic renderings to be found in the paintings on Attic white-ground lekythoi of the fifth century B.C. The lekythos shown in plates 15a and 15b, for example, illustrates this quality in a special manner, in the way the rich, heavy, dark-brown lines on the cloak of Hermes are seemingly quite independent of other contours in the picture. They are applied in a kind of calligraphic

8. Pliny, *NH*, 128; Vitruvius, VII, Praef., 14.
9. Lucian, *Imag.*, 7.

flourish, more for the sake of the calligraphy itself than for any appropriateness the strokes might have in making clear the form of the cloak. Once we realize that the unexpected spontaneity of these few spectacular brushstrokes are the life and soul of the entire painting performance in this vase, we may find numerous other indications in the rendering that show how highly valued the idea of spontaneity truly was in Greek draftsmanship of the classical period.

Spontaneous rendering evidently belonged in later periods of Greek art to the coloristic rather than to the linear approach to form. We may even speak of a kind of impressionism in the lightness of touch and in the richly varied color in the rendering of light and dark in the head of Rhadamanthys at Lefkadia (plate 9), an example from the fourth century B.C. In the later Hellenistic examples, a contrast is established between a strongly geometric formalism and a highly spontaneous, color-oriented rendering of the figure. This contrast is especially clear in the two stelae represented in plates 4a and 4b. Both the originals are at Volos and belong to the group that once formed part of a third-century Greek cemetery at Pagasae (see Introduction, note 3). In plate 4b, the Stele of Protos, the painting performance is one that suggests the spontaneity of a momentary gesture. A young man holds out his right hand just high enough to make his dog jump with excitement, while in his left he holds the leash. The fields in which the scene takes place were originally a clear and vivid green, though only the faintest suggestion of the color remains trapped here and there in the textured surface of the stone. The colors in the figure are somewhat better preserved, however, and we are able to see that the figure is rendered by means of many sketchy strokes and accents in a profusion of slightly different hues. It would seem as though this artist took special care to make sure that no two strokes in the delineation of the figure were exactly the same color. To do this he must have varied the basic flesh-tone mixture of white, red, and yellow, neutralized by blue, so that sometimes a violet-pink or red, sometimes a yellow hue, predominates. It is as though he touched his palette in a different place for each and every stroke, making some strokes slightly greenish and some more on the violet side. In this way he avoided the stiffness and artificiality of form that often results from hatching in the more linear styles. The effect of broken color in this stele coincides with an effect of broken contour. Spontaneity is heightened here, as elsewhere in the Greek examples, by means of calligraphy and a deliberate rapidity of execution. Although the way the figure seems to stare into the distance implies a certain passive kind of sorrow (the only indication that might suggest that we deal with a funerary subject), there is a sense of accidental movement in this representation that is paraphrased by the swiftness of the strokes and by the casual and variegated tonality of the brush-work.

In the Stele of Olympos (plate 4a), we receive a very different impression. The forms of the figure are almost Polykleitan in their stability and calm and in the precise impression of weight conveyed to the ground. The weight of the hand on the stick is also precisely felt, while the figure is broken up into broad, almost equal and rather geometric areas of white and neutral grayish blue, a harmony that strikes a distinctly somber note at the outset. The forms of the figure are sculptural and firmly outlined, so that the figure attains a degree of monumentality. The youth in this stele stands before us like a statue, whereas in the Stele of

Protos the figure is caught in the midst of a movement so convincingly rendered that we can feel the continuing turn of the body into space.

The development of a new role for color in the art of painting, the invention of new relationships between color and shading in various kinds of composition, provided the principle challenge of classical art in the late fifth and early fourth centuries B.C., and it is probably quite true that something resembling a final solution was achieved by Apelles and his contemporaries in the second half of the fourth century B.C., as the literary tradition suggests. Gombrich, in a number of recent statements,[10] correctly emphasizes the importance of the so-called "dark varnish" invented by Apelles, for it seems extremely likely that the problem of *oscurità* would have been important to this artist, who must have inherited the problems of form and color from his predecessors. Euphranor may very well have brought the controversy on color to its highest moment of crisis, so that it was possible for Apelles and an important group of younger men to return in reaction to the use of a four-color palette while experimenting not only with chiaroscuro in the ordinary sense, but with an atmosphere of actual darkness, as Leonardo seems to have understood it in the Renaissance.[11]

Looking upon the technical problems of form and color through the eyes of the ancients in the manner suggested in the foregoing chapters, it is astonishing how many parallels suggest themselves in the art of the *quattrocento*. Not only in Italian art, but also in the paintings of Flemish masters the balancing of color and chiaroscuro seems often to follow the indications in ancient descriptions. The color in the figures in the Philadelphia Diptych with the Crucifixion, by Roger van der Weyden, for example, is so restrained as to appear almost an example of a grisaille technique.[12] The color in Roger's figures, while not an example of the four-color harmony of the Greeks (for the robes of the Virgin are definitely tinted with blue in accordance with a Renaissance tradition), nevertheless exemplify an attempt by a Renaissance painter to restrict color in the most dramatic way in order to focus our attention on a tour-de-force rendering of shading in a three-dimensional representation. In order to describe his performance here, we must make use of exactly the same terms that we find ourselves using in our attempts to describe the "painting with shading" of Apollodorus and Parrhasios. How close to ancient works of art Roger's results might actually be is, of course, a tantalizing question that we will probably never be able to answer.

Nevertheless, we occasionally come upon an example of ancient painting that seems so close to Renaissance art that it almost forces us to believe that the painters of the Renaissance must have known and studied ancient prototypes that

10. E. Gombrich, "Controversial Methods and Methods of Controversy," *Burlington Magazine*, 105 (1963), 90 ff. This article summarizes earlier discussions, most of which are cited in the notes. Especially important are recent studies on Apelles by W. Lepik-Kopaczynska, "Colores floridi und austeri in der antiken Malerei," *JdI*, 73 (1958), 79 ff., and *Apelles, der berühmteste Maler der Antike* (Berlin, 1962).

11. K. Weil-Garris most recently has documented Leonardo's reliance on an ancient tradition for his development of *oscurità* as a major aspect of his style: *Leonardo and Central Italian Art: 1515–1550* (New York, 1974).

12. According to P. H. Jolly, "Roger van der Weyden and Fra Angelico at San Marco" (forthcoming), Roger deliberately made his color scheme somber in order to have his painting accord with the atmosphere of the monastery for which it was painted, along with the Crucifixion of the Escorial near Madrid.

have since vanished. In reality, it is clear that they had nothing to guide them in reconstructing the formulas of ancient classicism but written descriptions, some ancient reliefs, some carved gems, and their own intuition. Even so, we may sometimes wonder, as when we see the incredibly Raphaelesque head of a woman in the painted stele of the third century B.C. discovered recently at a site in Macedonia and now at the Archaeological Museum at Verria (plate 5a). I was present at Verria when this stele was brought in from the field after having come to light that morning. The surface of the stele was still damp from the moisture of the soil, and the colors were fresh and bright, and I remember that the similarity between the head of the woman in the ancient work and a Renaissance madonna was so striking that everyone present remarked upon it. Yet we could only marvel at the coincidence.

Since that time I have come to suspect that perhaps basic designs may actually be produced independently of one another when a given cannon of beauty is applied to a subject. The ancient solutions thus emerge as somehow natural and inevitable, so that their continuing validity and relevance in the context of later art may perhaps seem less surprising.

APPENDIX

SELECTED BIBLIOGRAPHY

INDEX

Appendix:
The Supports
and Media of
Classical Painting

Extant examples of ancient Greek painting provide concrete evidence for the use of four different types of painting supports in Greece. From the early fifth century B.C. onward, examples now exist of paintings on wood, stone, plaster, and terra cotta.[1] On the basis of literary and pictorial evidence, two other supporting materials may perhaps be added to this list. One is parchment, explicitly named by Pliny in connection with the drawings of Parrhasios.[2] It is likely, however, that parchment was employed for drawings only, or for paintings in line with a limited palette. The second is woven cloth, or canvas, which seems to have been employed in the form of painted hangings in the stage sets of the classical period.[3] The evidence for the use of canvas for easel pictures in the classical period seems inconclusive. There is no direct evidence of any kind for the use of cloth canvas as a support for easel paintings before the Roman period. The so-called Fayum portraits, the earliest of which are of the first century A.D., form a special class.[4] Within this group, cloth was by no means the only support for painting. Many examples are on wooden tablets.[5]

In discussions of the classical period, the interdependence of stylistic and technical innovation is frequently noted. It is undoubtedly true, as Carpenter

1. For examples, see the notes in the Introduction.
2. Pliny, *NH*, XXXV, 68: "Et alia multi graphidis vestigia extant in tabulis ac membranis eius, ex quibus proficere dicuntur artifices."
3. K. Lehmann, "Eine Skenographie," *Berliner Winckelmannsprogramm*, 94 (1934), 13 ff.; M. Bieber, *The History of the Greek and Roman Theater* (Princeton, 1961), pp. 66 ff.
4. C. C. Edgar, "The Dating of the Fayum Portraits," *JHS*, 25 (1905), 225 ff. H. Drerup, *Die Datierung der Mumienportrats* (Paderborn, 1933).
5. Linen is the support for the famous Hermione in Girton College Library, Cambridge. The Graf Collection examples in Vienna (P. Buberl, *Die griechische-ägyptischen Mumienbildnisse der Sammlung. T. Graf* [Vienna, 1922]), including the so-called Invalid Woman, are on wood, as are examples in New York. Cf. R. Delbrueck, *Antike Portraits* (Bonn, 1912); G. Hanfmann, *Roman Art* (New York, 1964), pls. XLV–XLVII; E. Dow, "The Medium of Encaustic Painting," *Technical Studies in the Field of the Fine Arts*, 5 (1936–1937), 3.

explains, that the medium of black-figure vase painting was not adaptable to the ideals of classical drawing,[6] and that only the invention of a new technique, the red-figure, gave Greek vase painters the flexibility to express themselves in a new stylistic idiom.[7] In sculpture, too, classical artists seem to have profited greatly by technical changes, especially in bronze casting.[8] Yet, among the materials used for supports by the painters of the fifth century B.C., no obvious innovation seems to have been introduced, some being as old as the earliest periods of art in the Eastern cultures. Gessoed wooden panels were in common use for easel paintings during the Old Kingdom in Egypt,[9] while painting on stone, on plaster walls, and on terra cotta all predate the classical age in Greece.

The actual pigments in use during the classical period likewise were essentially the same as in the preceding periods. Some, indeed, like Egyptian blue, had been employed for thousands of years previously.[10]

It cannot be doubted, however, that technical changes of other kinds, aside from supports and pigments, accompanied the changes taking place in classical Greek painting in the areas of color theory and in the modeling of forms. Though the evidence is sketchy and incomplete, there is sufficient reason to suppose that important innovations on the level of format, media, and methods of application of paints were indeed due to the painters of the fifth and fourth centuries B.C. Pliny's description of the finish applied by Apelles to his pictures suggests that by the late fourth century B.C. the surface quality of paintings, and the general

6. R. Carpenter, *Greek Art* (Philadelphia, 1962), pp. 129 ff.

7. *Ibid.*, p. 132.

8. Hollow casting of life-sized figures began in the late archaic period (D. G. Mitten and S. F. Doeringer, *Master Bronzes from the Classical World*, catalogue of an exhibition at the Fogg Art Museum [Boston, 1967], p. 21) but was a process "brought to perfection by Polykleitos" (Pliny, *NH*, XXXIV, 55); bronze was employed almost exclusively by the most famous classical sculptors after 480 B.C. It was still the favorite medium of Lysippos. Cf. R. F. Tulecote, *Metallurgy in Archaeology* (London, 1962); R. J. Gettens, technical section in the catalogue of bronzes in the Freer Gallery in Washington, D.C.

9. P. Duell, "Evidence for Easel Painting in Egypt," *Technical Studies in the Field of the Fine Arts*, 8 (1940), 175 ff. About parchment, too little is known to form any definite conclusions. Examples of other types of support in preclassical Greek art are as follows: wall paintings on plaster dating from the archaic period are known at Gordion (R. S. Young, *AJA*, 59 [1955], 1 ff.; *idem*, *AJA*, 60 [1956], 250 ff.) and other sites in Turkey, and there are no important technical differences between these examples and those of either the earlier Minoan period or the later Macedonian tombs. In other words, the technology of painting on plaster had undergone little change from prehistoric times up to the advent of the mural styles of Hellenistic Greek and Italian cites. On stone, the Greeks of the archaic period did not often paint upon a flat surface, but the painted low reliefs of grave monuments of the archaic period, which are in three or more colors, provided ample experience of the behavior of pigments on a stone surface; especially in the scenes of racing often found on the bases of archaic grave monuments, the relief is so flat that it gives the impression of painting rather than sculpture. For a list of color traces in archaic grave stelae, see A. C. L. Conze, *Attische Grabreliefs* (Vienna, 1848), IV, 142. For archaic paintings on terra cotta, the metopes of Thermon provide our best example (Rumpf, 34 and bib., n. 2). The colors in archaic terra cottas, however, are fired, whereas in some of the examples that occur in the classical period, tempera paints are added after firing. Cf. G. E. Rizzo, "Ritratti di Eta Ellenistica," *Monumenti*, sez. 3, fasc. 1, p. 18. Rizzo regards the choice of terra cotta for the Centuripe portraits as accidental, since marble might have been used had it been available.

10. P. Duell and R. Gettens, "A Method of Painting in Classical Times," *Technical Studies in the Field of the Fine Arts*, 9 (1940–1941), 102. With regard to the paintings of the Tomb of the Funeral Couch and related tombs (the Tomb of the Leopards, the Tomb of the Triclinium) at Tarquinia, the authors state that "there is nothing unusual or novel about the pigments." Their analysis of the blue color employed in these tombs revealed it to be the same artificial compound of copper, calcium, and silica that was the formula for Egyptian blue (*op. cit.*, 95).

appearance of the tones, had undergone a complete transformation of a kind which can only be ascribed to the use of a new medium.[11]

A problem of format seems to arise as a direct result of the changing character of architectural decoration in the fifth century B.C. Painted wall surfaces were always, in ancient cultures, an important part of architectural aesthetics. However, in Greece, interior wall surfaces acquired special characteristics apparently dictated by a growing aesthetic awareness of the beauty of stone-masonry construction. By the fifth century B.C., a refined vocabulary of stone-carved ornaments divided the wall into an architecturally rationalized composition, leaving less room for painting. Eventually, even in painted plaster decorations, relief was adopted in imitation of stone-carved motifs. In such decorations, the only pictures occur in the narrow space of the stringcourse.[12] How and where were pictures displayed when large murals no longer were painted directly on walls?

The exact form in which monumental picture cycles were produced and the manner in which they were displayed in the classical period are questions that have remained so far unanswered. The mural cycles painted by Polygnotos and his circle in the years following the Persian invasions are described in ancient writings as appearing on the walls of buildings that are named. Some of these buildings have been identified and studied by modern archaeologists—for example, the Lesche of the Knidians at Delphi and the Stoa Poikile at Athens. Robert believed that Polygnotos painted his murals directly on the marble walls of monumental buildings,[13] but this no longer seems likely. It is now considered almost certain that the murals were painted on wood, and that they were portable.[14] In the case of the Polygnotan pictures that Pausanias saw in the Pinakotheca at Athens[15] (which had not been built in the period of Polygnotos), Dinsmoor explains that they were probably fragments of a set of murals painted originally on wood by Polygnotos for the Old Propylon of the Acropolis, restored by the Athenians after the destruction of the Persians in 479 B.C.[16] The Old Propylon ruins prove beyond doubt, according to Dinsmoor, that the walls were intended to receive a covering of wooden panels above a projecting socle

11. Pliny, *NH*, XXXV, 97: "inventa eius et ceteris profuere in arte, unum imitari nemo potuit, quod absoluta opera atramento inlinebat ita tenui ut id ipsum repercussu claritas colorem album excitaret custodiretque a pulvere et sordibus, ad manum intuenti demum appareret, sed etiam ratione magna, ne claritas colorum aciem offenderet veluti per lapidem specularem intuentibus et a longinquo eadem res nimis floridis coloribus asuteritatem occulte daret." See W. Lepik-Kopaczynska, *Apelles, der berühmteste Maler der Antike* (Berlin, 1962), for discussion and bibliography. For additional references see ch. 11, n. 10.

12. M. Bulard, *Peintures murales et mosaïques de Délos*, *MontPiot*, 14 (1908), 133 ff., pl. 6C. For a discussion of the Greek examples of this relief style in plaster, see V. J. Bruno, "Greek Antecedents of the Pompeian First Style," *AJA*, 73 (1969), 305–317.

13. C. Robert, "Die Marathonschlacht in der Poikile und Weiteres über Polygnot," *Hallesches Winckelmannsprogramm*, 18 (1895), 104; *idem*, "Die Nekyia des Polygnot," *Hallesches Winekelmannsprogramm*, 16 (1892), 37.

14. R. E. Wycherley, "The Athenian Agora III," in *Literary and Epigraphical Testimonia*, The American School of Classical Studies at Athens (Princeton, 1957), pp. 31, 40. With regard to the Polygnotan paintings in the Stoa Poikile, this was apparently the case since, according to Synesios (*Epist.*, 135), "the proconsul took away the boards to which Polygnotos of Thasos committed his art." Cf. Wycherley, p. 43.

15. Pausanias, I, 22, 6. The north wing of the Propylaea, built by Mnesicles, was a picture gallery and has received the name "Pinakotheca" in modern literature.

16. W. B. Dinsmoor, in a letter to M. Swindler, published in the latter's *Ancient Painting* as n. 14a on pp. 434 f.

and stringcourse made of marble, and these wooden panels were certainly painted. In the north wing of Mnesicles' Propylaea, the arrangement of socle and stringcourse, the latter of dark Eleusinian marble,[17] suggests that an arrangement similar to the paneling in the Old Propylon was intended; but this was never carried out, and instead of a continuous mural cycle, the walls received a collection of smaller works of art, including, perhaps, fragments of the Polygnotan composition, which were later seen by Pausanias among other works of "old masters" in the Pinakotheca.[18]

The fact that the Greeks practiced not one, but a variety of methods for covering masonry walls with wooden panels is proved by some preserved wall blocks belonging to the Stoa of Attalus II at Delphi. In this building, the panels would have rested on a projecting stringcourse, similar to the arrangement in the Old Propylon at Athens; but whereas in the Old Propylon the uprights of a wooden framework were actually embedded in the walls, in the stoa at Delphi a slot was cut at a downward angle into stones higher up in the walls so that a metal hook attached to the wooden panels might slip down into the slots, holding the panels securely in place.[19]

The Lesche of the Knidians at Delphi was imagined by early architectural historians such as Lenormant[20] to be a lofty structure in which the grandiose Polygnotan composition of the Iliupersis could be taken in from various points of view as one walked through the interior space; but here again our ideas have had to be revised to accord with the realities of the building, which has been found and identified by an inscription at Delphi.[21] The ruins show a floor plan in which there is no point in the interior space that could have provided an uninterrupted view of the walls. Moreover, there is no concrete evidence that the building was designed especially to receive murals, as Lenormant believed.

Thus, the evidence indicates that Polygnotan murals were entirely independent units, painted on sets of wooden tablets, probably with no specific architectural setting in mind. They could be moved from one building to another, and perhaps even set up as free-standing screens. The practice of painting large and important works not on plaster walls but rather on portable tablets or panels of wood can be dated to the beginning of Polygnotos's career, and there is little sign of a revival of mural painting directly on plaster walls in monumental art until the Roman period. In the intervening centuries, examples of large figure compositions painted directly on plaster walls are rare and are found primarily in tombs. During the classical period, the chief format of painting was the easel picture, the support was probably wood, and the activity was carried on in the private studios of artists. It seems evident that under these circumstances, the painting media

17. For the use of "dark marble" or Eleusinian stone in the Propylaea and other classical buildings, see L. Shoe, "The Use of Dark Stone in Greek Architecture," *Hesperia*, Supplement 8 (1949), 343 ff.

18. Dinsmoor (see n. 16).

19. G. Roux, *BCH*, 76 (1952), 183 f. (illustrated).

20. C. Lenormant, "Notes sur La Lesche," *Le Moniteur des architects* (posthumous), vol. 6, no. 1 (January 15, 1872), vol. 6, no. 5 (March 15, 1872). Lenormant saw the building as an oval, a form that would have enabled Polygnotos to create a continuous composition with no breaks due to the corners of an ordinary room. But the building is in fact a rectangle.

21. J. Pouilloux, *Fouilles de Delphes, topographie et architecture*, Tome II, *La Région nord du sanctuaire* (Paris, 1960), 120 ff., plans 18–21. The building, in its existing form, was restored in the fourth century B.C. between the time Polygnotos painted the pictures and Pausanias saw them. Had the paintings been on the walls, they would in all likelihood have been destroyed by the earthquake that severely damaged the building in the fourth century B.C.

employed might have varied greatly, each artist adapting them to his own special purposes and inclinations, as in the Italian Renaissance. Thus it is probably in the science of media, in the processes of applying pigments to a given surface, that classical Greek artists revolutionized painting technology.

The chemical analysis of ancient painting media in modern laboratories has until now produced disappointing results. Duell and Gettens, in a series of experiments at the Fogg Museum at Harvard University, have proven that because excavated fragments of ancient paintings are always coated with a film of chalcedony, it is almost impossible to reach the paint layer without destroying whatever minute quantities of organic matter may still be contained in the media of the paints. Even where well-preserved examples are numerous and have been preserved under ideal conditions, the difficulties of analysis are enormous and conclusions are difficult to reach. The exact ingredients of the encaustic medium of the Fayum portraits are still unknown. Although many efforts to analyze them have been made, the type of wax employed cannot be conclusively established.[22]

On the question of the painting media of panel painting in the classical period, it is difficult even to speculate, since no examples have been preserved. Certain observations can be made on the basis of literary evidence, however, and it may be possible at least to define the range of possibilities. Basically, there are three different media that classical artists may have employed in painting on wood: tempera, encaustic, or an emulsion of oil and water-based media. The term *tempera* refers to any medium in which the binding agent is soluble in water. The binding agent is a glue or gluelike substance, which is organic. Such a glue may be an animal or fish glue,[23] or it may be a glue derived from plant secretions, such as gum arabic. Other possibilities include a strong, sticky substance made from milk or curd, today called casein. An excellent tempera medium may also be made from either the yolk or the white of egg. All these substances were in use throughout antiquity for the various purposes of painting and craftsmanship.[24]

In modern terminology, a distinction is made between tempera media that will allow the artist to employ transparencies and other media that are by nature more opaque, not lending themselves, therefore, to anything but the application of flat, opaque areas of color or techniques employing hatching. Tempera paints employed opaquely are called gouaches to distinguish them from ordinary temperas which are capable of forming transparencies.[25] Since archaic paintings on wood are painted in uniformly opaque colors, this medium, like that of the Egyptians, may be termed *gouache*.

In the classical period, just as the vase painters, in the words of Carpenter, invented a medium that provided the opportunity "to teach themselves how to draw,"[26] the panel painters quite possibly developed alternatives to gouache,

22. Dow, *op. cit.* (n. 5), 3 ff.

23. Pliny, for example (*NH*, XXVIII, lxxi), mentions a glue, known to the ancients, that was made of bulls' ears—obviously a cartilage glue.

24. Cf. R. J. Forbes, *Studies in Ancient Technology*, III, rev. ed. (Leiden, 1965). Gum arabic and possibly egg as well as casein are known among the tempera painting media of Egypt (N. de Garis Davies and A. H. Gardiner, *Ancient Egyptian Paintings* [Chicago, 1936], III, xxxi ff.). The Egyptian invention of a mixture of gum arabic and white of egg was still being used as the adhesive for gilding as late as the medieval period. See Cennino Cennini (ed. D. V. Thompson [New Haven, 1932–1933], p. 102).

25. R. J. Gettens and G. L. Stout, *Painting Materials* (New York, 1942), p. 28.

26. See nn. 6 and 7.

which provided the opportunity to apply pigments with greater freedom. This could have been done, of course, by simply thinning the old formulas, employing them more transparently, and without changing the basic ingredients. But the fact that Pliny speaks of an encaustic medium introduced in the classical period suggests that new materials were, in fact, adopted. The encaustic medium in panel painting represents one important new contribution—perhaps the chief contribution—of painting technology in the classical period. Then the questions arise: Was encaustic made manageable for painting by means of melting or by means of a solvent? Did the ancients understand the principle of an emulsion? Did they ever paint exclusively in oils?

Forbes, in his exhaustive analysis of the ancient literary evidence with regard to painting technology,[27] decided that the ancients could not have known the use of the so-called drying oils. This assumption rests upon Forbes's impression that the literary tradition, complete in all other details with regard to the various uses of oils and resins, would include mention of the use of drying oils in painting had it been a common practice. Since the drying oils are nowhere mentioned in ancient writings until the sixth century A.D., it seemed to Forbes that they must have been earlier unknown.[28] This reasoning cannot be regarded as conclusive, especially if we remember that formulas for media may well have been kept secret by classical painters.

The possibility that emulsions were known in antiquity is suggested by the probability that there had been long experience of a yolk-of-egg medium. Egg yolk contains a natural emulsifier; it is a substance in which oil particles are suspended in a solution of albumen, which is water soluble. In modern analyses of the yolk-of-egg tempera medium, it was discovered that an egg yolk contains a quite mysterious fatty substance called lecithin, which, according to Gettens and Stout, acts as an emulsifying agent, causing the water albumen to blend smoothly with an oil content that may be as high as 22 per cent.[29] The suspended oil in this medium is a "drying oil," hardening eventually to form a smooth, water-resistant surface. According to A. P. Laurie, a drying oil may be added to the yolk of egg drop by drop without changing the water-soluble character of the medium,[30] and, he points out, there are no less than four recipes in medieval manuscripts for such mixtures.[31] It does not seem impossible that ancient artists, in handling egg media for various purposes over so many centuries, may have already known such mixtures.

While we may never find the evidence to reach a final conclusion,[32] it seems probable that the classical painters knew more different painting media than has so far been deemed likely. Their knowledge of the encaustic medium cannot be

27. Forbes, *op. cit.* (n. 24).

28. *Ibid.*, p. 256.

29. Gettens and Stout, p. 20: "When egg yolk is used as a painting medium it dries to a strong film, first by evaporation of the water and then by a slow hardening of oil which remains suspended in the albuminous matrix. This oil content is greater than that of the albumen and, in consequence, the ultimate film is very little affected by water."

30. A. P. Laurie, "The Use of Emulsion as a Painting Medium," *Technical Studies in the Field of the Fine Arts*, 2 (1933–1934), 11 f.

31. *Ibid.*, 13.

32. P. Duell and R. Gettens, "A Review of the Problem of Aegean Wall Painting," *Technical Studies in the Field of the Fine Arts*, 10 (1941), 179 ff.

doubted. This fact may well have involved experiments that included the use of oils and emulsions, though there is little evidence to support such a supposition.

One problem of media remaining to be considered is that of "fresco" painting. Among our extant examples there are two important groups of paintings on the plaster walls of tombs.[33] Both groups of paintings show striking similarities to modern fresco painting, yet there is reason to doubt that they are true frescoes.

The key factor in the definition of true fresco concerns the chemical action of slaked lime. The plaster support for fresco painting must be made of pure slaked lime plus an inert substance such as marble dust or sand to give it added strength. As it dries, the slaked lime in the mixture tends to rise to the surface of the wall, enveloping each and every particle of sand or marble dust with a transparent film, thereby incorporating all into a single, rock-hard mass. If pigment is applied to the surface in the form of powder suspended in water, the lime will envelop the pigment particles also, incorporating the colors into the mass of the wall along with the other ingredients of the plaster. For this process, two special conditions must be observed. First, only those pigments that do not react chemically with lime may be employed. Second, only a thin, transparent application of pigment may be applied so as not to overload the plaster with more particles than can be physically absorbed by the action of the lime during drying. This excludes all reds and yellows except the ochers or earth colors, and limits the artist to a rather muted harmony, for vermilion and crimson pigments are too heavy and require the use of an *al secco* medium when applied to a plaster surface.

In a pure fresco process, the whiteness of the plaster wall itself is employed in lieu of white pigment. The artist simply allows the plaster to show through his colors wherever he needs white. Once an area has been darkened, it can be lightened again only by adding touches of pure lime or other white pigment to the wall, a procedure that usually results in unsightly dull spots which seem out of key with the painting as a whole (for the added white has a texture very different from the gleaming, polished surface of the wall). If the purity of the process is maintained, the fresco is characterized by a special brilliance of surface caused by the luminous white plaster showing through the transparent colors, a brilliance that can never be matched by premixing colors with white paint before their application to the wall. When white pigment is employed, the paint layer must be thicker, a binding agent or glue must be added, and the process becomes not fresco, but gouache or tempera. In that case, since there is no advantage to working on a wet wall, the plaster may be allowed to dry, and the paints are applied *al secco*.

In ancient tomb paintings of the fourth to the third centuries B.C. (plates 7–14), the pigments seem to have been applied in transparencies, and the way the tones sometimes run together suggests that the walls may have been still wet during application—in other words, there are all the outward signs of true fresco painting. However, there is no assurance that ancient Greek artists understood the lime action of true fresco or that they actually and knowingly relied on it. Painting on plaster was not one of the methods adopted by famous classical artists in centers such as Athens. Our examples are all in tombs, and they were

33. See Introduction, nn. 4 and 5.

obviously not executed by masters. Thus, there is no reason to suppose that the problems of painting on plaster were approached in a scientific spirit in Greek art of the classical period. What seems more likely is that provincial craftsmen, faced with the necessity of painting on plaster, simply employed the same tempera medium used in earlier periods for this purpose, only diluting their paints to a greater extent with water so as to produce an effect more appropriate to the classical idiom of three-dimensional representation. The fact that all our extant examples of Greek painting on plaster are in tombs which were to be buried within tumuli after completion may account for the fact that the plaster in some places received its painted decorations before it had finished drying. It seems very likely that the distinction between transparent and opaque painting methods in ancient art corresponds to our distinction between tempera and gouache rather than to a distinction between the highly refined *al fresco* and *al secco* painting techniques of the Renaissance.

The possibility that this might be so was suggested to me during my visit to the tholos tomb at Kazanlak, the paintings of which look more like modern frescoes than any other ancient examples. Here, the tomb has been entirely sealed within a modern structure. This structure is air-conditioned so as to control the humidity level and the temperature. After these precautions had been taken, an experiment was conducted to measure the rate of deterioration of the paintings in the tholos. Pieces of glass were placed on the floor of the tholos. After some time the glass was removed and examined under a microscope. It was obvious at once that flakes of pigment of several colors had fallen from the tholos frieze. Had the pigment particles been absorbed by the lime in a true fresco process, there could have been no such flaking unless parts of the plaster had come away also, which was not the case. A fresco has no paint layer that is separate from the plaster itself. Only colors added *al secco* or colors held together by a binding agent will form a film on top of the plaster which may afterward flake off. Thus, at Kazanlak, in my judgment, a painting was executed on a wet plaster surface, to be sure. But in spite of that, a binding agent was undoubtedly used. It seems very likely that such a procedure was characteristic in the painting of ancient chamber tombs. This is not a true *al fresco* process. Indeed, it is becoming increasingly clear that at no time in the history of ancient painting was the *al fresco* method of the Renaissance scientifically understood and systematically employed.[34] Similarities to the Renaissance process are isolated and seem entirely accidental.[35]

34. Attempts to show that examples of ancient painting in other periods might be "frescoes" have failed. Cf. Duell and Gettens, "A Review of the Problem of Aegean Wall Painting," 179 ff. N. Heaton sought to establish that the paintings at Knossos are frescoes ("The Mural Painting of Knossos," *Journal of the Royal British Society of the Arts,* 58 [1910], 206 ff.; *idem,* "Minoan Lime Plaster and Fresco Painting," *Journal of the Royal Institute of British Architects,* 18 [1910–1911], 697 ff.). Cf. A. Evans, *The Palace of Minos* (New York, 1964), I, 532. One of the first to question the fresco theory in regard to Minoan-Mycenaean examples was A. Eibner, *Entwicklung und Werkstoffe der Wandmalerei vom Altertume bis zu Neuzeit* (Munich, 1926), but his tests seemed to Duell and Gettens inconclusive ("A Review . . . ," 201 ff.). According to the results of their experiments at the Fogg there is almost no possibility of finding traces of nitrogenous organic media such as glue and egg in examples of painting that have been buried for centuries (209 f.), and the only valid conclusions are based on visual evidence achieved through microscopic studies (221). The applicability of visual evidence in the case of the Minoan examples seems convincing (208, 213, and fig. 11); a thick paint layer independent from the plaster ground and revealed by microphotography rules out the possibility of an *al fresco* technique.

35. Likewise, the similarities noticed between Pompeian and Italian wall paintings by L. Tintori and M. Meiss, "Additional Observations on Italian Mural Techniques," *Art Bulletin,* 46 (1964), 377 ff.

To summarize these observations, we may say that it would seem reasonable to suppose that Greek artists of the classical period did, indeed, make technical innovations of the sort which would have been required to support the stylistic ambitions of the period and the changes of painting requirements in general when shading and aerial perspective were involved. A new medium was surely part of this development. Its character must have been that it offered the artist an opportunity to employ more delicate shadings of color than had been possible previously, especially through the use of transparencies, perhaps even glazes.[36] The literary record shows that from the fifth century B.C. onward, artists actually sought motifs that gave them an opportunity to demonstrate the flexibility and skill with which transparencies could be obtained: for example, Pausanias (II, 27), describing a painting by Pausias of Meth (Intoxication), is especially impressed by the fact that "you can see in the picture a glass cup and through it the woman's face." Thus, although there is a complete absence of archaeological evidence to support the implications of the literary evidence, it would seem, on the whole, legitimate to discuss coloring and modeling in the classical period in a way that assumes that the artists concerned had the use of a medium capable of producing an unlimited variety of nuance[37] through the glazing and fusing tones. Ancient descriptions of paintings imply a range of subtleties in coloring and finish in most ways equivalent to what is possible today.

36. L. Borrelli, in "Qualche Scheda sulla Tecnica della Pittura Greca," *Bollettino dell'Istituto Central del Restauro* (Ministeri della Pubblica Istruzione), 2 (1950), 55 ff., discusses the literary evidence for "glazing."

37. Such an assumption is made, for example, in a recent discussion of the use of color in a painting by Appelles by P. Mingazzini ("Una copia dell'Alexandros Keraunophoros di Apelle," *Jabrbuch der Berliner Museen*, 3 [1961], 7 ff.), the discussion being based partially on literary evidence and partly on what we may surmise from a painting at Pompeii which seems to reflect a composition by Apelles —the "Alexander Keraunophoros" in the House of the Vettii.

Selected Bibliography

Books

Andreae, B. *Das Alexandermosaik* (Bremen, 1959).

Arias, P., and M. Hirmer. *The History of One Thousand Years of Greek Vase Painting* (New York, 1962).

D'Arzago, A. de Capitani. *La Grande Pittura greca dei Secoli V e IV AC* (Milan, 1945).

Augusti, S. *I colori Pompeiani* (Rome, 1967).

Bertrand, E. *Études sur la peinture et la critique d'art dans l'antiquité* (Paris, 1893).

Bianchi-Bandinelli, R. *La Storicità dell'arte classica*, rev. ed. (Florence, 1950).

Bielfeld, E. *Von griechischer Malerei*, Hallische Monographien, 13 (Halle, 1949).

Bulard, M. *Peintures murales et mosaïques de Délos, MonPiot*, 14 (1908).

Dimitriou, P. "The Polychromy of Greek Sculpture," Ph.D. diss., Columbia University, 1951.

Dugas, C. *Aison* (Paris, 1930).

Forbes, R. J. *Studies in Ancient Technology*, III, rev. ed. (Leiden, 1965).

Kober, A. "The Use of Color Terms in the Greek Poets," Ph..D. diss., Columbia University, 1932; extracts in *CW*, 37 (1934), 189–91.

Lepik-Kopaczýnska, W. *Apelles, der berühmteste Maler der Antike* (Berlin, 1962).

——— *Die antike Malerei* (Berlin, 1963).

Löwy, E. *Polygnot, ein Buch von griechischer Malerei* (Vienna, 1929).

Mansuelli, G. A. *Ricerche sulla pittura ellenistica* (Bologna, 1950).

Micoff, V. *Le Tombeau antique près de Kazanlak* (Sophia, 1954).

Petsas, P. *O Taphos Ton Lefkadion* (Athens, 1966).

Pollitt, J. J. *The Ancient View of Greek Art: Criticism, History, and Terminology* (New Haven, 1974).

Reinach, A. *Recueil Milliet* (Paris, 1921).

Riezler, W. *Weissgrundige attische Lekythen* (Munich, 1914).

Robertson, M. *Greek Painting* (Geneva, 1959).

——— *A History of Greek Art* (Cambridge, Mass., 1975).

Rumpf, A. *Handbuch der Archäologie*, ed. W. Otto and R. Herbig, VI, 4, 1, *Malerei und Zeichnung* (Munich, 1953).

Schuhl, P. M. *Platon et l'art de son temps* (Paris, 1933).

Schweitzer, B. *Xenocrates von Athen* (Königsberg, 1932).

Swindler, M. *Ancient Painting* (New Haven and London, 1929).

Trendall, D. *The Red-Figured Vases of Lucania, Campania, and Sicily* (Oxford, 1967).

Vasiliev, A. *The Ancient Tomb at Kazanlak* (Sophia, 1960).

Wallace, F. E. *Color in Homer and in Ancient Art*, Smith College Classical Studies, No. 9, (Northampton, Mass., 1927).

Weickert, C. *Studien zur Kunstgeschichte des 5. Jahrhunderts v. Chr.*, Abhandlung der Deutschen Akademie der Wissenshaften zu Berlin, I, *Polygnot* (Berlin, 1950).

Winter, F. *Das Alexandermosaik aus Pompeii* (Strasbourg, 1909).

Zhivkova, L. *Das Grabmal von Kazanlak* (Recklinghausen, 1973).

Articles

Andronikos, M. "Ancient Greek Paintings and Mosaics in Macedonia," *Balkan Studies*, 5 (1964), 267–302.

Arvanitopoulos, A. S. "Grapti Stelai Demetrias-Pagasae," *Archaiologike Ephemeris* (1928), 1 ff.

Azevedo, M. Cagiano de. "Il Colore Nell Antichita," *Aevum*, 28 (1954), 151–167.

Bailey, K. C. "The Pigments of the Ancient Romans as Described in the Natural History of the Elder Pliny," *Chemistry and Industry*, N.S., 44/27 (November 20, 1925), 1135–1137.

Borrelli, E. "Qualche Scheda sulla Tecnica della Pittura Greca," *Bollettino dell'Istituto Central del Restauro* (Ministeri della Pubblica Istruzione), 2 (1950).

Bothmer, D. von. "Enkaustes Agalmaton," *Metropolitan Museum Bulletin* (1950–1951), 156–161.

Bruno, V. "Greek Antecedents of the Pompeian First Style," *AJA*, 73 (1969), 305–317.

Dow, E. "The Medium of Encaustic Painting," *Technical Studies in the Field of the Fine Arts*, 5 (1936–1937), 3–18.

Duell, P., and R. Gettens. "A Method of Painting in Classical Times," *Technical Studies in the Field of the Fine Arts*, 9 (1940–1941), 75–104.

Ducatti, P. "La Pittura delle Tombe Leonesse e dei Vasi Dipinti," *Monumenti*, sez. I, Tarquinia, fasc. (Rome, 1937).

Farnsworth, M. "Ancient Pigments: Particularly Second Century B.C. Pigments from Corinth," *Journal of Chemical Education*, 28 (1951), 72–76.

———— "Second Century B.C. Rose Madder from Corinth and Athens," *AJA*, 55 (1951), 236–239.

Gombrich, E. H. "Controversial Methods and Methods of Controversy," *Burlington Magazine*, 105 (1963), 90 ff.

Heaton, N. "Minoan Lime Plaster and Fresco Painting," *Journal of the Royal Institute of British Architects*, 18 (1910–1911), 697 ff.

———— "The Mural Painting of Knossos," *Journal of the Royal British Society of the Arts*, 58 (1910), 206–212.

Ippel, A. "Wandermalerei und Architektur," *RM*, 29 (1914), 90 ff.

Karouzou, S. "Bemälte attische Stele," *AM*, 71 (1956), 124 ff.

———— "Scherbe einer attischen weissgrundigen Lekythos," *Antike und Abendland*, 5 (1956), 71–74.

Keuls, E. "Skiagraphia Once Again," *AJA*, 79 (1975), 1–16.

Kinch, K. F. "Le Tombeau de Niausta, tombeau macedonien," *Danske Videnskabernes Selskab. 7 Reeke Historiski-Filosofiske Skrifter*, Afd. IV, 3 (Copenhagen, 1920), pp. 283 ff.

Kraiker, W. "Das Kentaurenbild des Zeuxis," *Berliner Winckelmannsprogramm*, 106 (Berlin, 1950).

———— "Aus dem Musterbuch eines Pompeijanischen Wandermalers," in *Studies Presented to David M. Robinson* (St. Louis, 1951), pp. 801–807.

Laurie, A. P. "The Use of Emulsion as a Painting Medium," *Technical Studies in the Field of the Fine Arts*, 2 (1933–1934), 11–14.

Lepik-Kopaczýnska, W. "Colores floridi und austeri in der antiken Malerei," *JdI*, 73 (1958), 79 ff.

Matz, F. "Die Stilphasen der hellenistischen Malerei," *Archäologischer Anzeiger* (1944–1945), 89–112.

Mellink, M. "Excavations at Karatas-Samayuk and Elmah, Lycia, 1970," *AJA*, 75 (1971), 245–255.

———— "Excavations at Karatas-Samayuk and Elmah, Lycia, 1971," *AJA*, 76 (1972), 257–269.

———— "Excavations at Karatas-Samayuk and Elmah, Lycia, 1972," *AJA*, 77 (1973), 293–303.

———— "Excavations at Karatas-Samayuk and Elmah, Lycia, 1973," *AJA*, 78 (1974), 351–359.

Mingazzini, P. "Una copia dell'Alexandros Keraunophoros di Apelle," *Jahrbuch der Berliner Museen*, 3 (1961), 1 ff.

Moreno, P. "Il realismo nella pittura greca del IV secolo A.C.," Revista dell'istituto nazionale d'archeologia e storia dell'arte, N.S. XIII–XIV (Rome, 1965), pp. 22–79.

Osborne, H. "Color Concepts of the Ancient Greeks," *British Journal of Aesthetics*, 8, 3 (July, 1968), 269 ff.

Pemberton, E. G. "A Note on Skiagraphia," *AJA*, 80 (1976), 82–84.

Petsas, P. "Macedonian Tombs," *Atti del Settimo Congresso Internazionale di Archaeologica Classica*, I (Rome, 1961), 401 ff.

Pfuhl, E. "Apollodorus, O Skiagraphos," *JdI*, 25 (1910), 12 ff.

Phillips, K. M. "Subject and Technique in Hellenistic-Roman Mosaics: A Ganymede Mosaic from Sicily," *Art Bulletin*, 42 (1960), 243–262.

Platnauer, M. "Greek Colour-Perception," *CQ*, 15 (1921), 153–162.

Rhomaiopoulou, K. "A New Monumental Chamber Tomb with Paintings of the Hellenistic Period near Lefkadia (West Macedonia)," *AAA*, 6 (1973), 87–92.

Richter, G. M. A. "Polychrome Vases from Centuripe in the Metropolitan Museum of Art," *Metropolitan Museum Studies*, 2 (1929–1930), 187–205.

———— "Polychrome Vases from Centuripe in the Metropolitan Museum," *Metropolitan Museum Studies*, 4 (1932–1933), 45–54.

Robert, C. "Die Nekyia des Polygnot," *Hallesches Winckelmannsprogramm*, 16 (1892).

———— "Die Iliupersis des Polygnot," *Hallesches Winckelmannsprogramm*, 17 (1893).

———— "Die Marathonschlacht in der Poikile und Weiteres über Polygnot," *Hallesches Winckelmannsprogramm*, 18 (1895).

Rodenwaldt, G. "Zu den Grabstelen von Pagasae," *AM*, 35 (1910), 118 ff.

Rostovtzeff, M. "Ancient Decorative Wall Painting," *JHS*, 39 (1919), 144–163.

Rumpf, A. "Diligentissime Mulieres Pinxit," *JdI*, 49 (1943), 6–23.

———— "Zum Alexandermosaik," *AM*, 77 (1962), 229 ff.

———— "Classical and Post-Classical Greek Painting," *JHS*, 67 (1947), 10–21.

———— "Parrhasios," *AJA*, 55 (1951), 1 ff.

Scheibler, I., "Die 'Vier Farben' der griechischen Malerei," *Antike Kunst*, 17 (1974), 92–102.

Shear, T. L. "Color at Corinth," *AJA*, 32 (1928), 330 ff.

Simon, E. "Polygnotan Painting and the Niobid Painter," *AJA*, 67 (1963), 43–61.

Stevens, R. G. "Plato and the Art of His Time," *CQ*, 27 (1933), 149–155.

Trendall, D. "The Lipari Vases and Their Place in the History of Sicilian Red-Figure," *Meligunis-Lipara*, 2 (1965), 296 ff.

Webster, T. B. L. "Plato and Aristotle as Critics of Greek Art," *Symbolae Osloniensis*, 29 (1952), 8–32.

Young, D. C. "The Greeks' Colour Sense," *Review of the Society for Hellenic Travel*, 4 (1964), 42 ff.

Index